ROOTS OF ART

A STUDIO BOOK

ROOTS

ANDREAS

OF ART

The Sketchbook of a Photographer

FEININGER

THE VIKING PRESS NEW YORK

I dedicate this book to

Loren Eiseley

who, by his thoughts and writings,
has given me more than any other
person, dead or alive.

Grateful acknowledgment is made to the Collector's Cabinet, 1000 Madison Avenue, New York, for making the specimens on pages 81–87, 150 and 151 available for photographing.

Copyright 1975 in all countries of the International Copyright
Union by Andreas Feininger
All rights reserved
First published in 1975 by The Viking Press, Inc.
625 Madison Avenue, New York, N.Y. 10022
Published simultaneously in Canada by
The Macmillan Company of Canada Limited
SBN 670-60807-6
Library of Congress catalog card number: 74-6998
Printed in Japan

Contents

Introduction

art = human ability to make things . . . making or doing of things that have form and beauty . . . any craft or its principles . . .
— *Webster's New World Dictionary,*
College Edition, 1966

It is in this wider sense that I use the word "art" in the title of this book. Because it seems to me that, in the last analysis, everything made by human hands and most things conceived by the human mind have their prototype in nature. The original of the ball-and-socket joint is the hip; a complex sound navigation system like sonar was "invented" aeons ago by bats.

But not only can we do *no better* than learn from nature by studying its manifestations, actually this is the *only* way in which we can progress. This is easily proved: The fertile minds of science-fiction writers have created any number of strange worlds populated by the most fantastic monsters. But every single one of these monsters is nothing but a composite of parts of objects of nature found right here on earth, be it human, animal, or vegetable. This is equally true of gods, angels, devils, mermaids, dragons, unicorns, or purple polyps. Not one of these creations of the imagination has features which its originator had not known or seen or heard of before; not one of the colors in which some unearthly landscapes glow is unknown on Earth—because the human mind is inherently incapable of imagining anything of which it has no previous knowledge. The only way to expand our minds is by gaining additional knowledge through further study of nature.

It is in this spirit that I present the following collection of photographs.

There are many ways of looking at objects of nature. From the viewpoint of the merchant whose only interest is in monetary values—can he sell it, and for how much? Or from the point of view of the economist, whose main concern is whether the objects of his investigation are beneficial or harmful to man. The scientist looks at objects of nature in a totally different way from that of the artist, the collector in a way different from that of the camera fan, whose hobby is nature photography. And so on.

I look at objects of nature primarily with the eye of the structural engineer who is fascinated by the interrelationship of function and form, and with the eye of the artist in pursuit of what, for lack of a more precise definition, is commonly called beauty.

These interests of mine go back to the days when, as a boy in my early teens, I roamed the hills in Thuringia, Germany, in search of fossils and insects. These interests were reinforced when, studying to become an architect, I investigated the connection between function and form from a more utilitarian point of view. And they became a full-time avocation when I finally retired after twenty years of work as a staff photographer for *Life.*

Like all *Life* photographers, I had traveled extensively in the course of my work. As a result I had encountered many opportunities to pursue my interests as a sideline. I had photographed objects of nature that attracted me whenever I had a chance, gradually accumulating a collection of photographs that I consider outstanding in two respects: in regard

to subject matter, because it is very comprehensive—rocks and plants and animals photographed both outdoors on location and indoors under controlled conditions; and in regard to the way in which these objects are "seen," because my engineering background, art studies, and professional photographic training enabled me to present them in what I believe is a particularly informative and, at the same time, aesthetically pleasing form.

This is the third time that I have published a collection of nature photographs in book form. My first effort was *The Anatomy of Nature,* a picture-and-text book of 168 pages published in 1956 by Crown Publishers in New York. In 1966 The Viking Press published my second collection of nature photographs, *Forms of Nature and Life,* a larger and more ambitious volume of 170 pages of pictures and 68 pages of text. Both books emphasized the scientific-documentary aspects of their subjects.

In contrast to these earlier works, in the present volume I approach essentially similar objects from a different point of view—the viewpoint of the artist, the poet, the dreamer, who sees a face in a piece of wood or a crucifix in the skull of a fish. This time I gave my imagination free rein, feeling that I had proved with my other books that I was capable of producing high-quality documentary nature photographs. As a result the present picture collection should appeal primarily to readers in search of beauty and the more fundamental aspects of our world.

In the course of this work I was struck again and again by the inextricable relationship of cause and effect, beauty, function, and form. To give some examples: The photograph on page 128 shows the maze of tunnels which bark beetles carve out of wood. Because intersections would be detrimental to the welfare of the grubs, these tunnels almost never cross one another, producing as a result a design

which, because of its high order of organization, is aesthetically attractive. Or consider the nautilus shell depicted on page 79. As the animal grows, it adds new sections to its home; this is a perfectly functional process, the result of which, because of the geometrical precision with which it is executed, strongly appeals to our sense of beauty. Or take the water-worn pebbles shown on pages 30 and 31: the longer they have been processed—tumbled and ground against each other by the surf—the more geometrically perfect and hence beautiful their forms. It is these aspects of nature—cause and effect, function, form, beauty, and their interconnections—that form the dominant theme of this book.

But in addition to the beauty of the function-derived form, another kind of beauty exists in nature which defies explanation. This kind of beauty expresses itself in the geometrically precise ornamentation of shells, in the symmetrical designs of butterfly wings, and in the color shifts and changes of thin sections of minerals seen in polarized light, to name only some of its manifestations that immediately come to mind. As far as we know, this kind of beauty is not related to function—the linear ornamentation of some shells is straight-lined, of others curved, and in still others takes the form of rows of dots, and there seems to be no explanation why one is this way instead of that. But the fact remains that designs of this kind are, almost without exception, extremely pleasing to the appreciative eye, conveying a kind of beauty that transcends utilitarian aspects like camouflage or mimicry and appeals directly to the mind and the heart. I have seen and enjoyed innumerable examples of this transcendental kind of beauty and am happy to be able to present some of them in this book.

I consider this volume the equivalent of the sketch-book of the artist—a random collection of observations, notations, impressions, conclusions, and

thoughts. Readers who look for organization will probably be disappointed — there is very little. For this is not a book that has a beginning and an end, nor was it conceived to lead the viewer from the general to the specific. Rather, it is an invitation to browsing where looking should be followed by contemplation. Each picture was chosen with this goal in mind: to stimulate the viewer, show him familiar objects in a new light, and make him ponder. I want the reader to become aware of the fact that there are universal principles in nature that apply equally to people and beasts; that the atoms and molecules that form his body are identical with those that constitute the rocks and plants and animals. And I want him to feel related to all the objects of nature without which none of us could exist — we, dependent human beings, ephemeral fragments of nature, yet parts of the Universe.

1 Sculpture

Science tells me that the piece of stone shown on the opposite page consists largely of the mineralized remains of crinoids—sedentary, flowerlike marine animals of the class Echinodermata which lived during the Devonian Period some four hundred million years ago.

So what?

So this: This lump of rock once was alive—beautiful, flowerlike, tentacled animals which lived and breathed, assimilated food, propagated, and, probably, in some unimaginable fashion felt hunger, pain, and a state of happiness when conditions were good, aeons ago. These remains are *not* the stern reminder of an avenging flood that all but wiped out sinful humanity a few thousand years ago, as the Bible would have us believe. This is truth. And to me, truth is the one immutable rock in an ocean of uncertainty and change. Because, like any other human being, I need the reassurance of something permanent. Some people find this reassurance in God. Others, like myself, are still searching. To find this ultimate truth we must be free spiritually—free from taboos and superstition, free from dogmas laid down in fear and ignorance and never revised in the light of added knowledge, free to continue the search wherever the chase may lead. And I am sure—as sure as anyone can ever be of anything—that in the end there will be light, an all-pervading insight illuminating the immense structure of the cosmos, revealing the rightful place and purpose of man.

But besides this awesome thought I read another message in this humble piece of stone. It speaks of change—from life to death, from death to burial under mountainous layers of sediment, and from the tomb to resurrection through uplift and erosion. After millions of years the crinoids once more are brought to life, for the final time. For if I had not collected this specimen, erosion would have destroyed it grain by grain—*not* to be lost forever, but to be recycled in life's never-ending drama. Eventually its atoms of carbon and calcium would have found their way into the tissues of living organisms. They would have been taken up by plants which would have been decomposed by fungi and bacteria or eaten by animals which in turn would be consumed by other animals or by people, furnishing the building blocks for new forms of life. And the reassuring thought occurs to me that nothing is ever lost—that somewhere in my body there are atoms that might once have been part of a sigillaria tree in a carboniferous forest, a dinosaur, or prehistoric man; that I live on borrowed material, mine to use but not to waste; and that, when I'm gone, the elements of my body may again become part of a future plant, an animal, or serve to sustain another human life, a form of resurrection. . . .

And still another thought occurs to me as I contemplate this beautiful fossil which now, exquisitely carved by erosion, lies in front of me on my desk: that change is a process that involves both accretion and erosion. Accretion is equivalent to adding—a tree adding a new ring every year and thereby increasing its girth, a sculptor building up a head by adding clay to clay. Erosion is equivalent to taking away—a stream carving a canyon out of a mountainside, a sculptor chipping away on a marble block to free the form that already exists in his mind. Change—a succession of accretion and erosion, of adding and taking away—becomes a tool of creation. Nature as a creator, a sculptor on a cosmic scale—what a beautiful thought. Is it possible that primitive man, inspired in a dumb, semiconscious way by fossils or faces seen in a piece of wood, took his first, faltering steps on a road that ultimately led to Michelangelo?

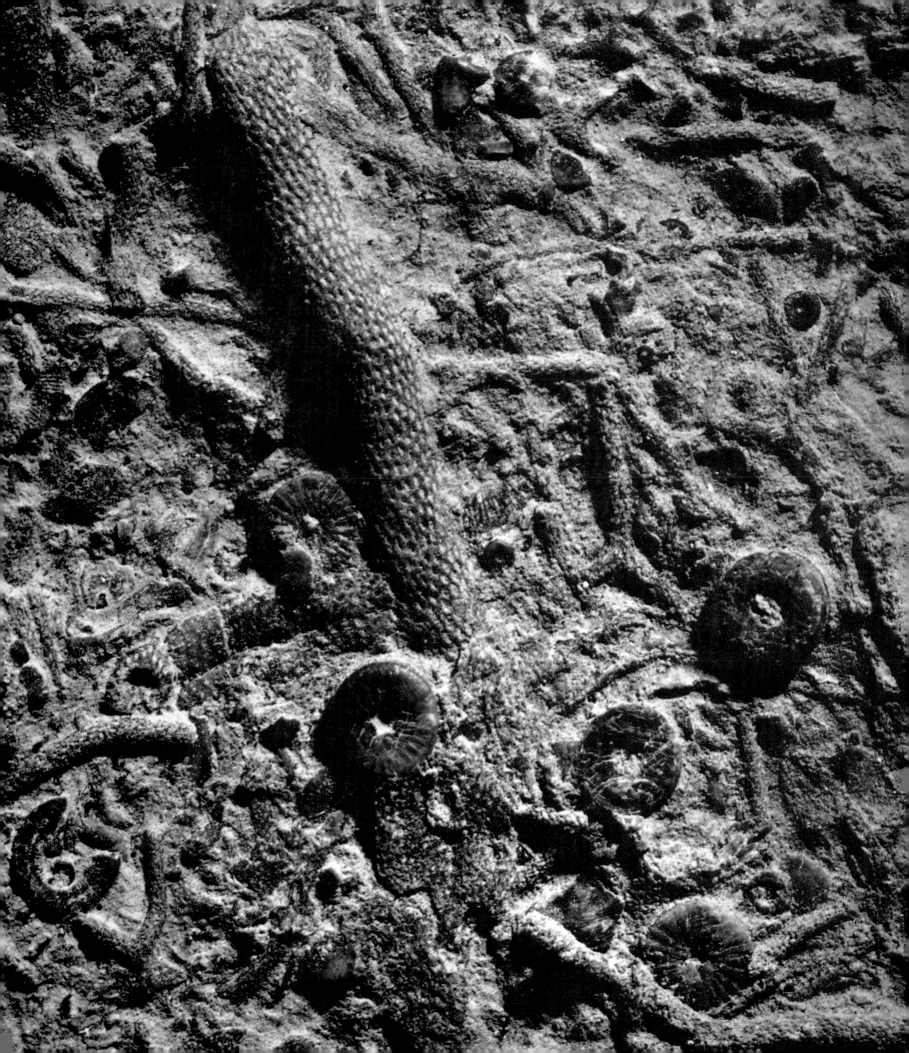

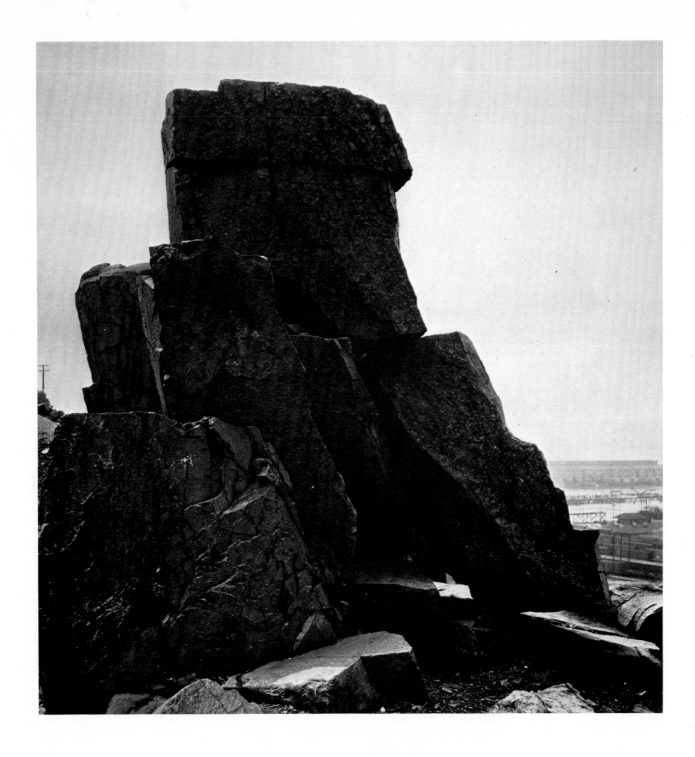

I see the statue of a king sitting on his throne in this pile of basalt, a conqueror overlooking his realm, brooding, menacing. . . . In prehistoric times such a natural form may well have inspired reverence and awe, for who but a god could have created a rock pile in the form of a man?

Right: This malevolent face, complete with eye, nose, and wart, obstinate chin, mouth like a slash—what else could it be but the embodiment of an evil spirit of the forest? Grown naturally, completely untouched by human hands, it formed part of a hollow tree, and I photographed it without changing anything.

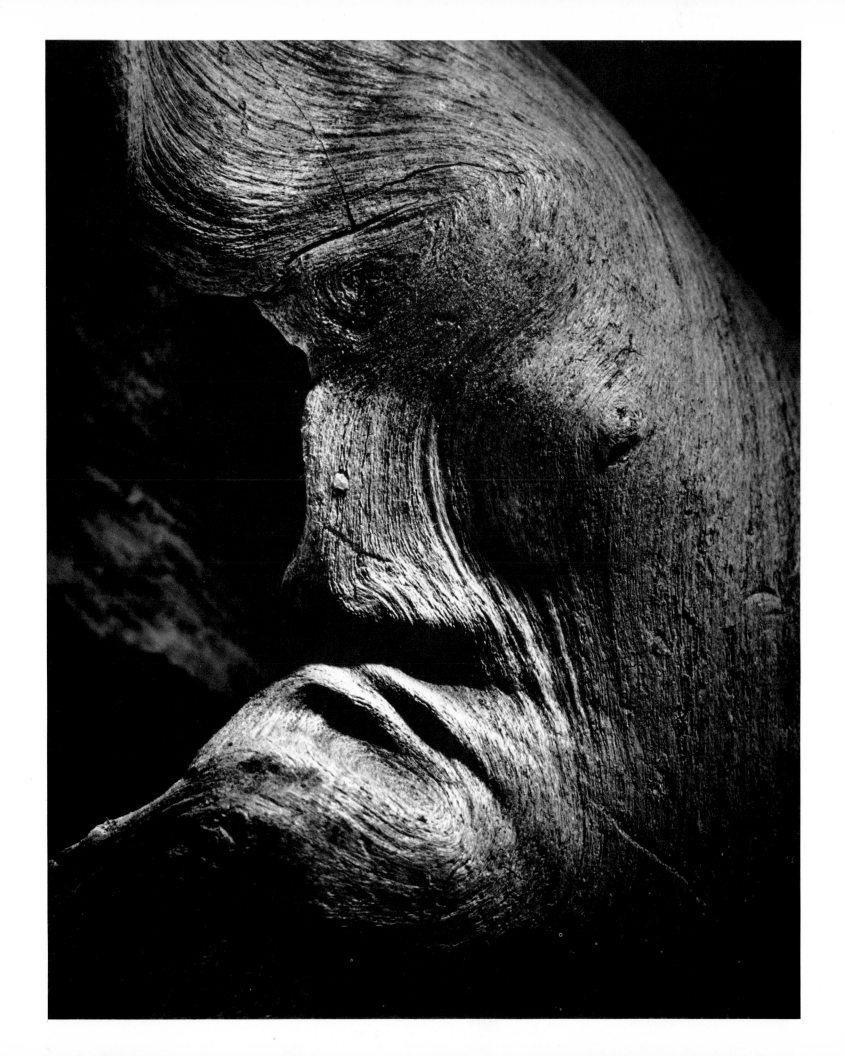

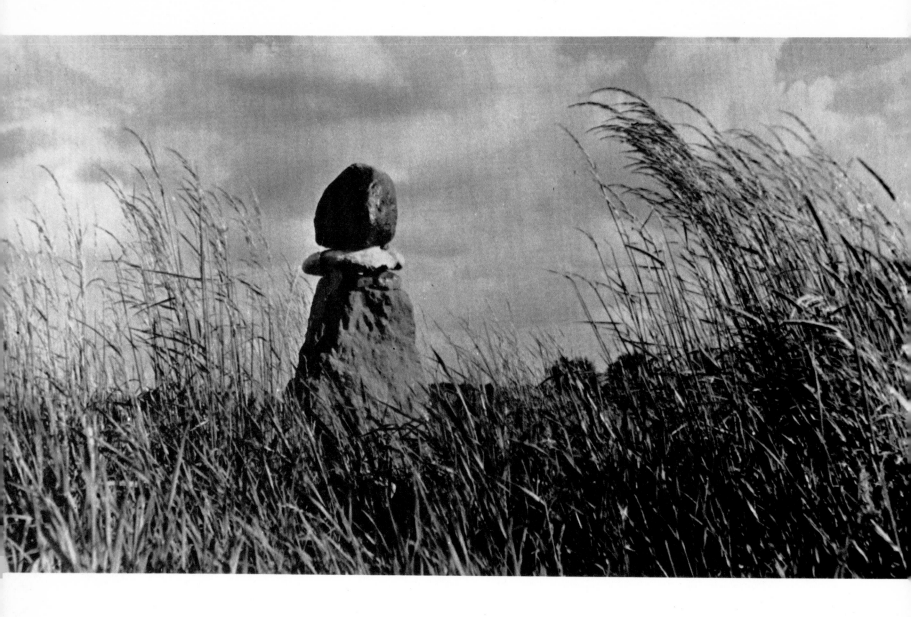

Crude stones piled high and painted black, white, and red form a phallic symbol the roots of which reach back thousands of years into prehistory. It stands outside the little village of Rödsten in Östergötland, Sweden, originally erected as a tribute to Frö, the Norse god of fertility. Tradition demands that it is repainted every time the farmer paints his barn; otherwise the crops will fail.

Right: Menhirs from the megalithic "alignments" in the Morbihan community near Carnac in Brittany, France. Man's first use of stone on a cyclopean scale was neither for housing nor for defense nor for any other prosaic purpose, but to express some transcendental concept. What this was is lost in the abyss of time. What we know is that these gigantic monoliths have withstood the ravages of millennia, sometimes standing on tiptoe, the hard way; that they still proclaim their message, although we can no longer understand the language; and that they will probably outlast anything built by modern man. Rough forms of nature, organized by man with thought and purpose, are transformed into works of art.

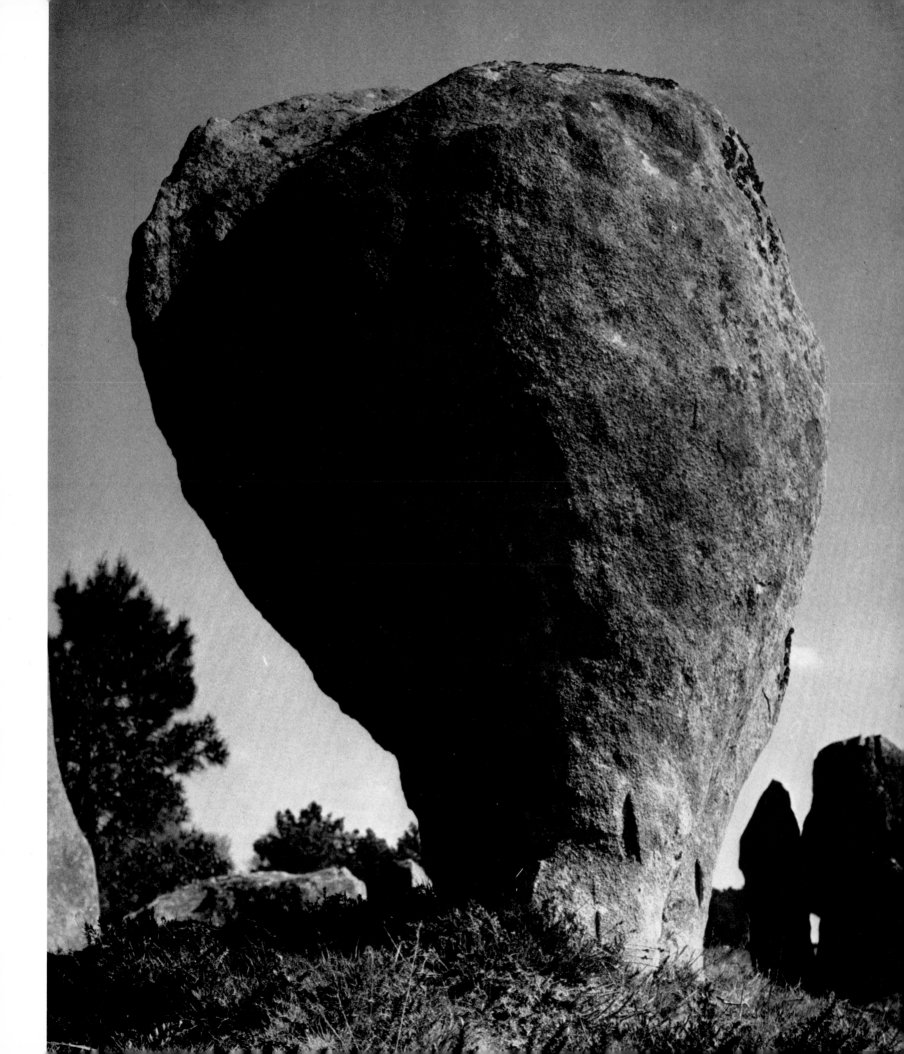

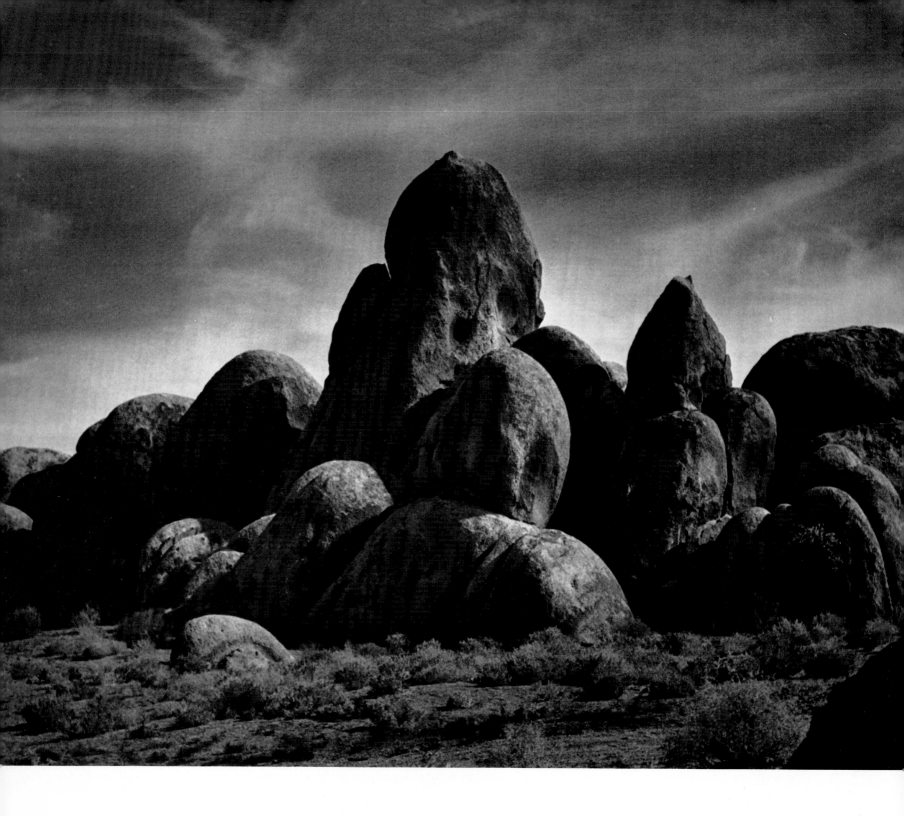

Jointed granite in the Rockies, split by heat and frost, worn by wind and weather, assumes organic, almost phallic forms. In feeling, these forms are related to those of the ''Venus of Willendorf'' shown on the opposite page, the most famous of all the little Ice Age figurines carved by the mammoth hunters of the Upper Pleistocene some thirty thousand years ago. Its generous proportions, round and rich and bountiful, suggest fertility, abundance, and earthiness—the image of a mother goddess glorifying the continuity of life.

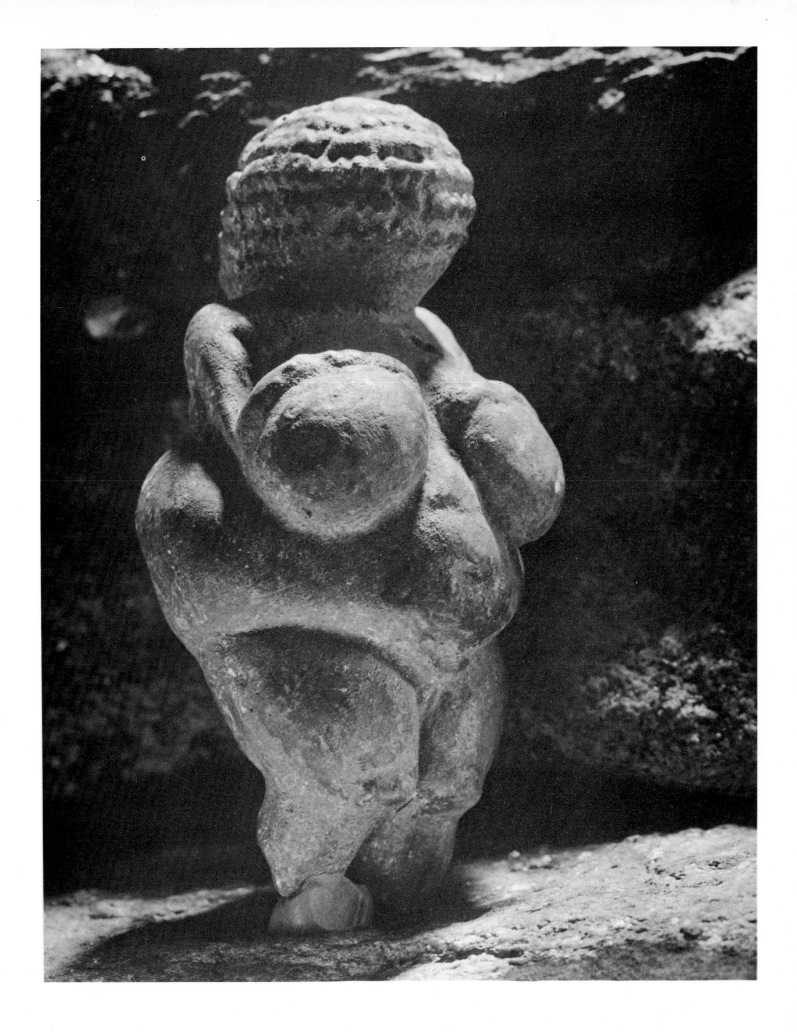

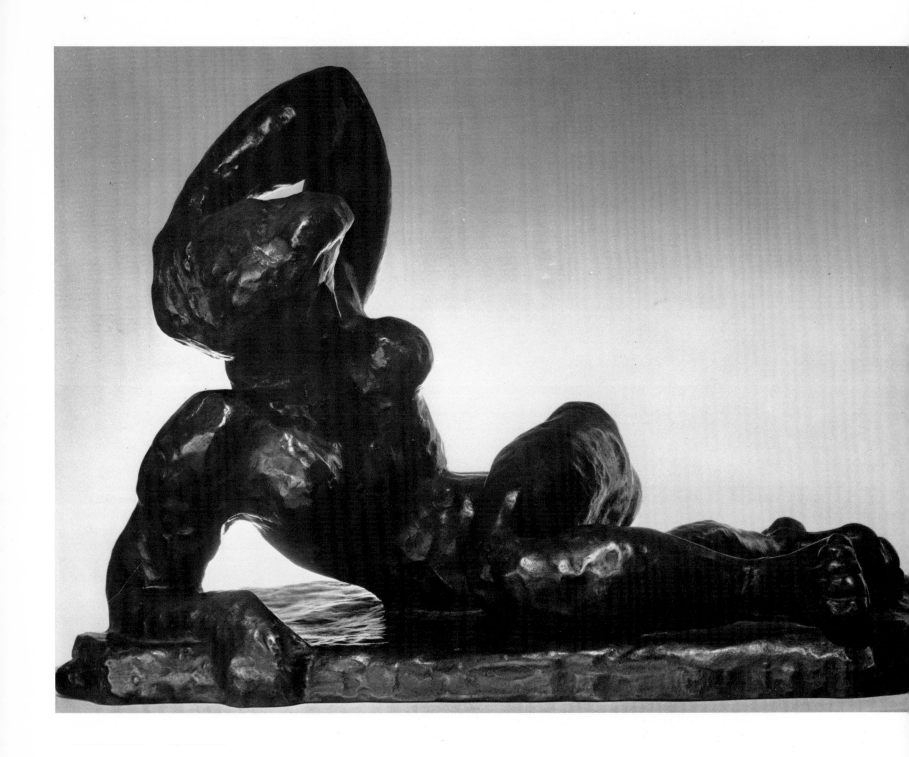

Reclining figure by Henri Matisse and a statue by Gaston Lachaise. These are the modern versions of the prehistoric "Venus"—slicker, more sophisticated, yet spiritually identical concepts of mature femininity created by sculptors whose reaction to woman seems identical with that of Ice Age man.

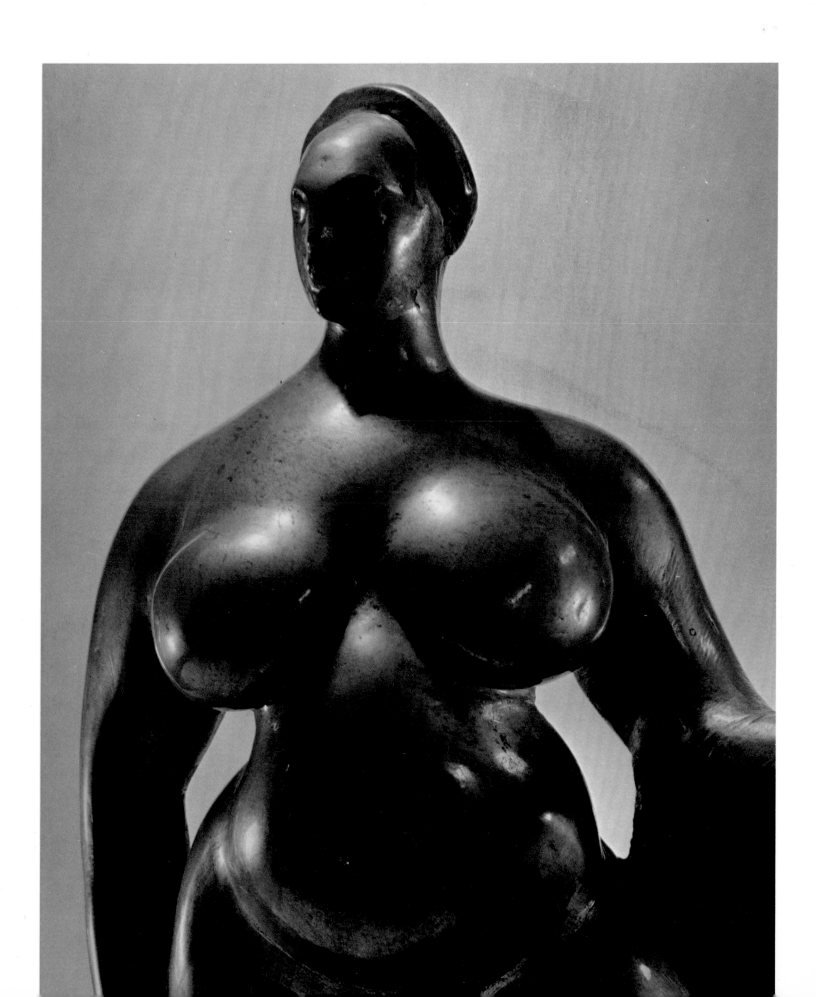

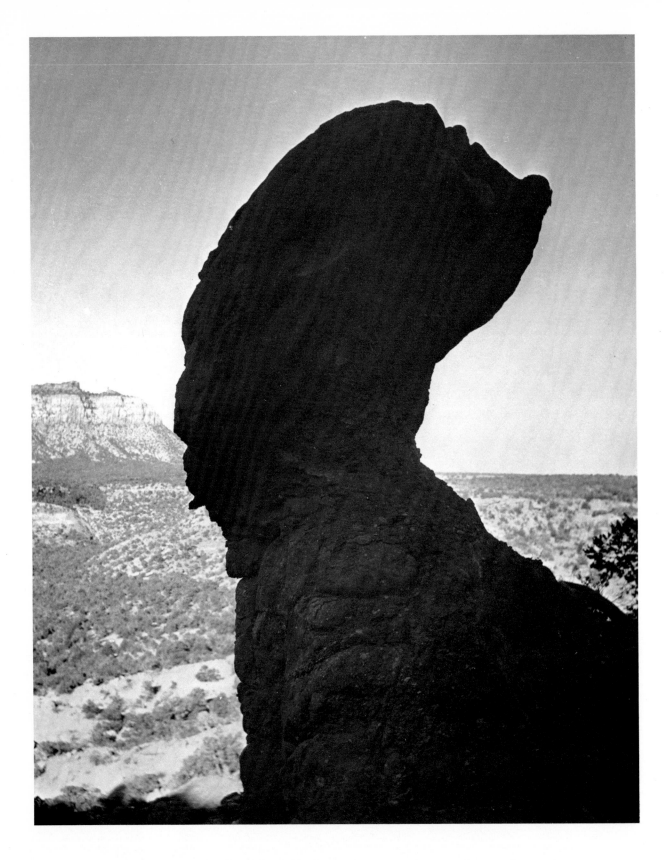

A pre-Columbian clay head from Mexico and a cap rock protecting a column of softer conglomerate in Utah. The resemblance is striking, even though the little head is only one and a half inches high and the natural formation fifteen feet.

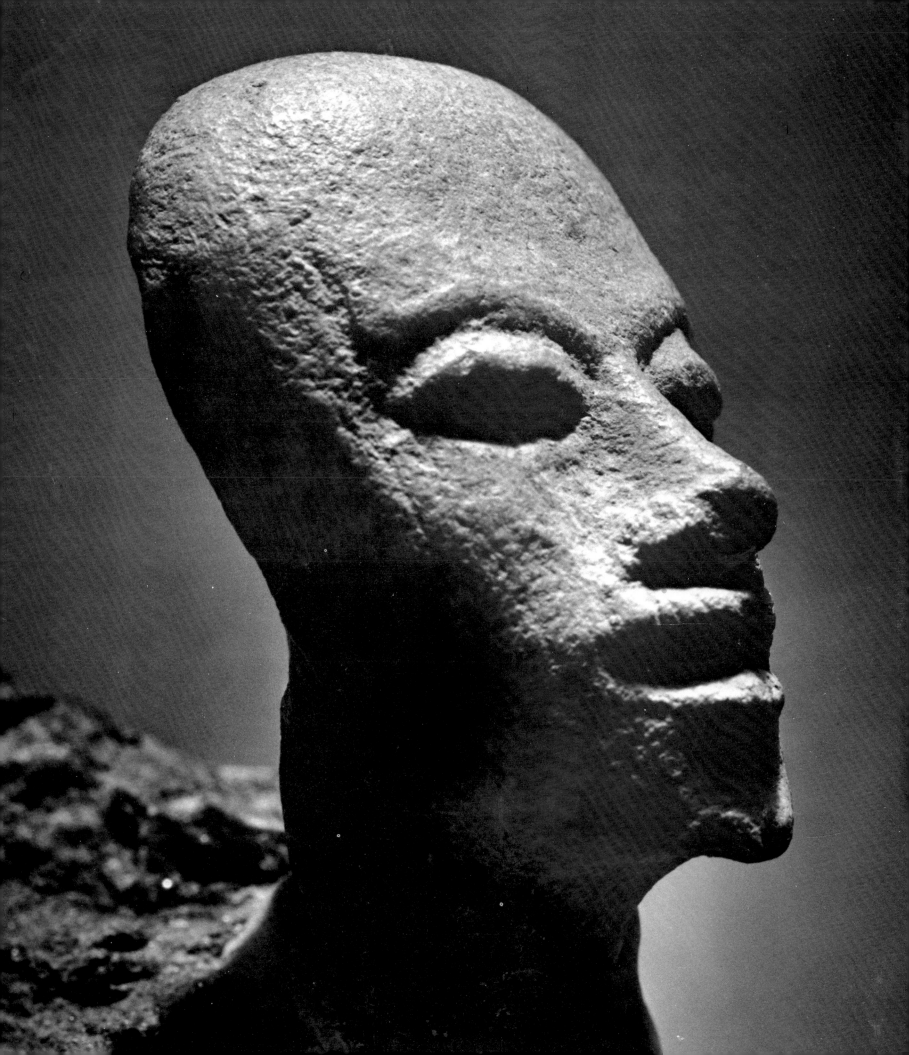

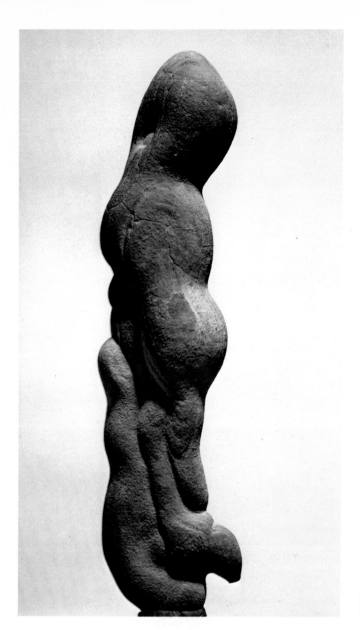
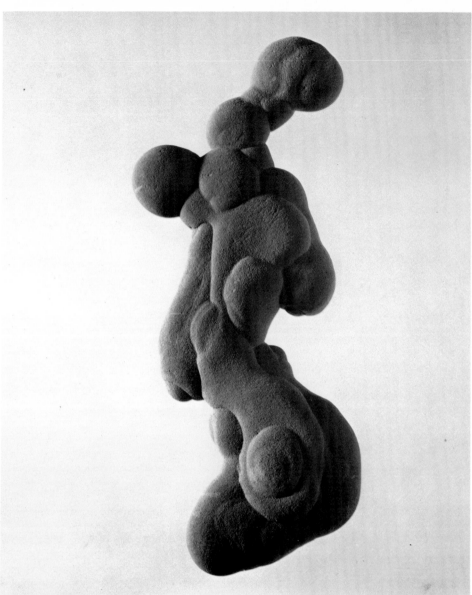
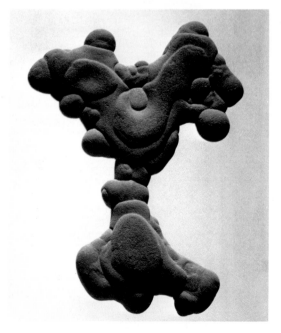
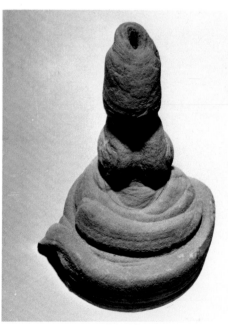
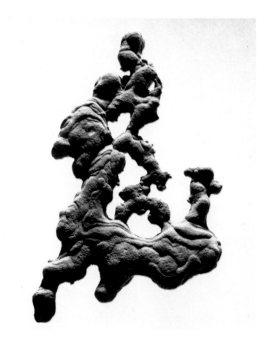

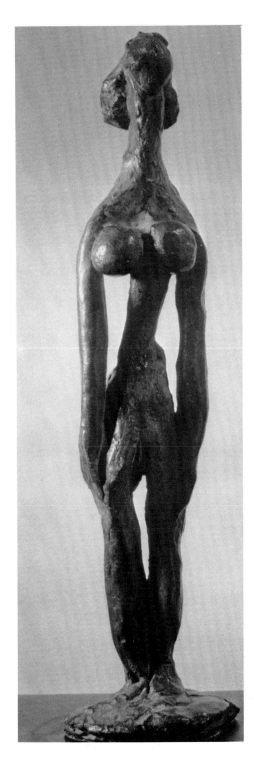 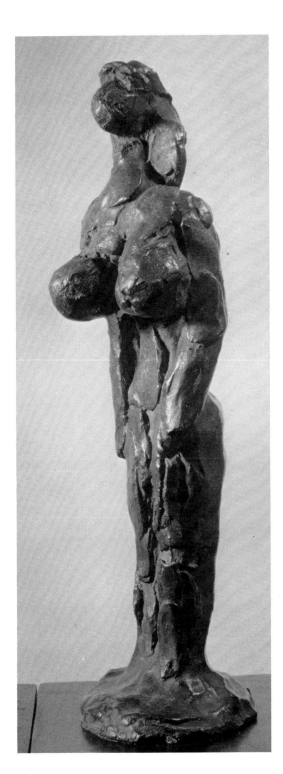 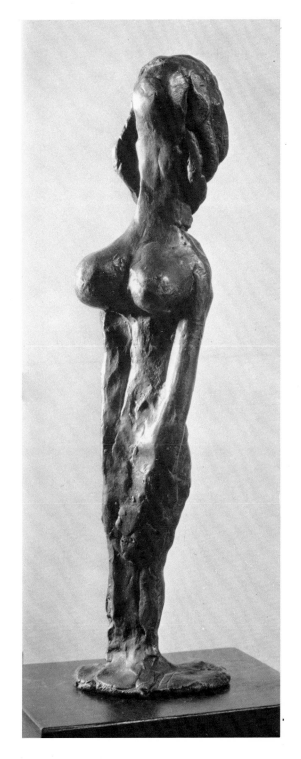

The fascinating objects on the opposite page are made not by man but by nature. They are concretions—natural aggregates consisting of hardened clay or lime-cemented grains of sand. How they derived their interesting shapes is still not completely understood.

To me, concretions are a source of never-ending stimulation, like three-dimensional Rorschach tests. I see in them people, objects, and events, knights in heavy armor, dragons, male and female figurines . . . and I feel a strong emotional relationship to the three sculptures by Picasso shown above.

23

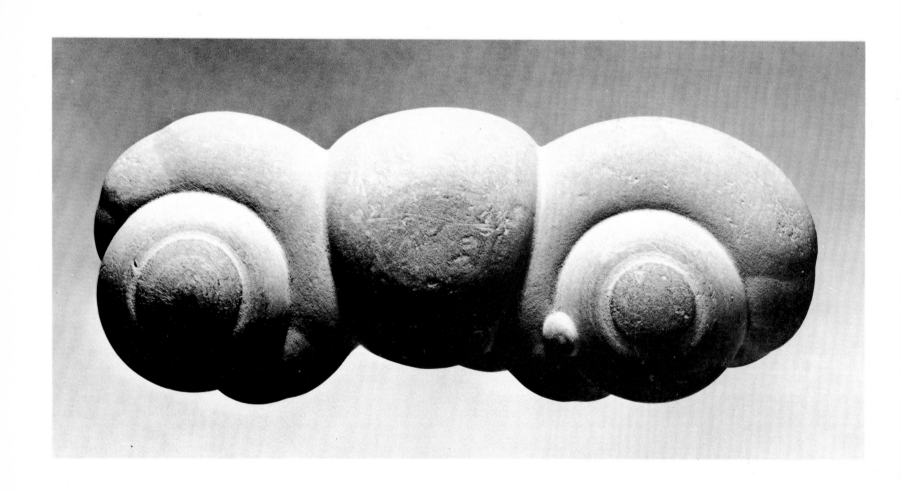

Above: A concretion, a natural form consisting of hardened clay or lime-cemented grains of sand. *Right:* Female alabaster figurine from Tepe Hissar, Iran, c. 1500 B.C. (University Museum, Philadelphia, Pennsylvania; 33-22-92). Evidently abstract creations are neither new nor a prerogative of man.

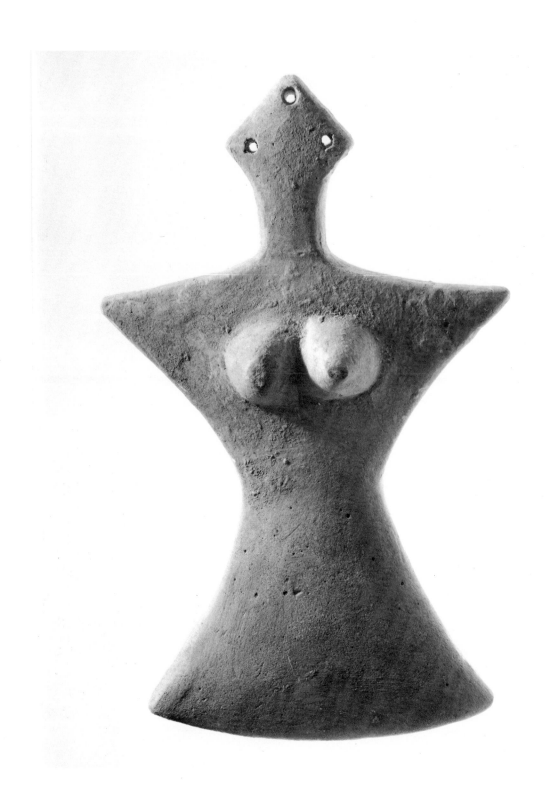

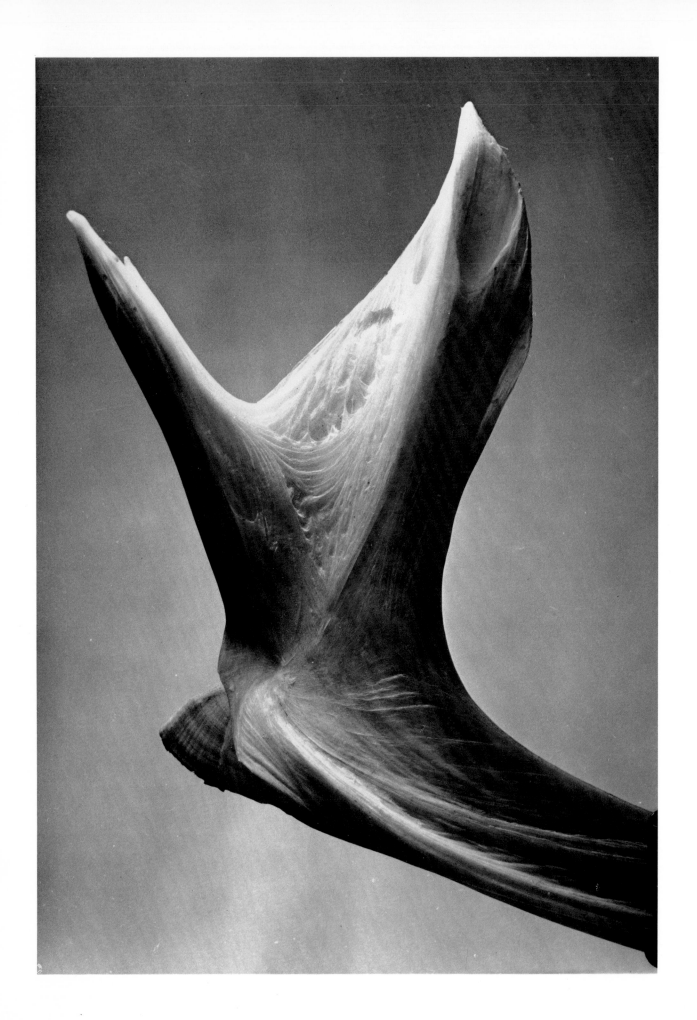

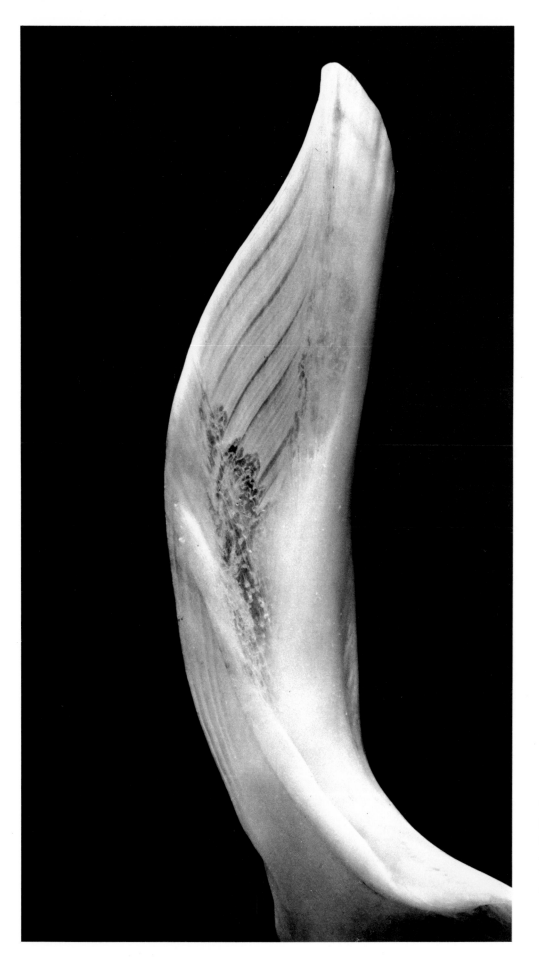

Two fishbones. These strictly functional, stress-derived forms bring to mind certain works of modern abstract art. A sculptor whose work is strongly influenced by skeletal forms is Henry Moore.

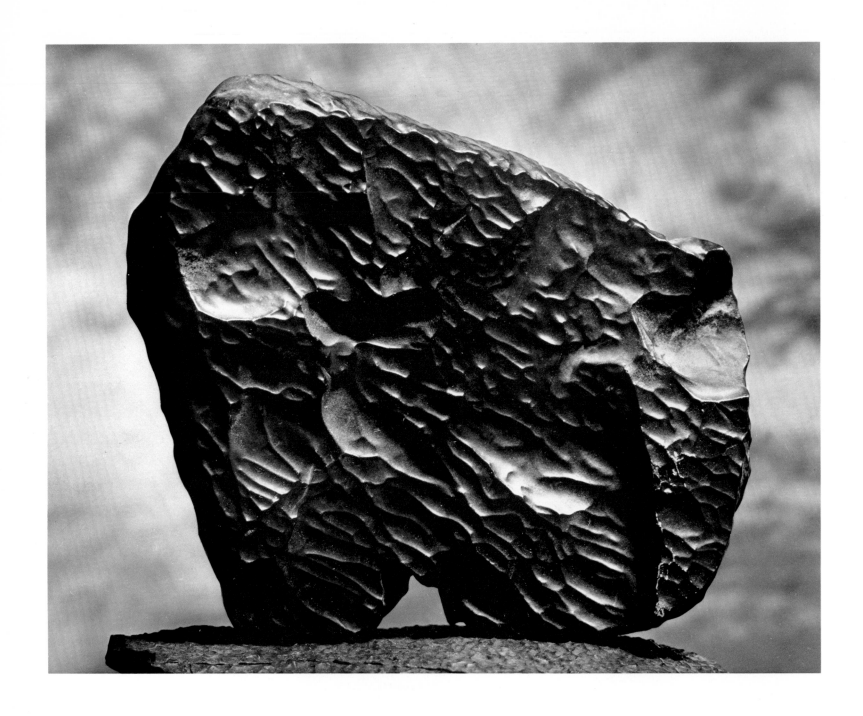

I found this strangely sculptural rock in California's Death Valley where it was carved by ceaseless winds and driving sand. The individual gouges look like chisel marks, as if nature had been anticipating man.

Right: Skull of a catfish. This is the crucifix to which I referred in the Introduction, endowed with halo and a swirling, cloudlike design, a natural functional form of great beauty, the product of aeons of evolution, a sculpture worthy of reverence.

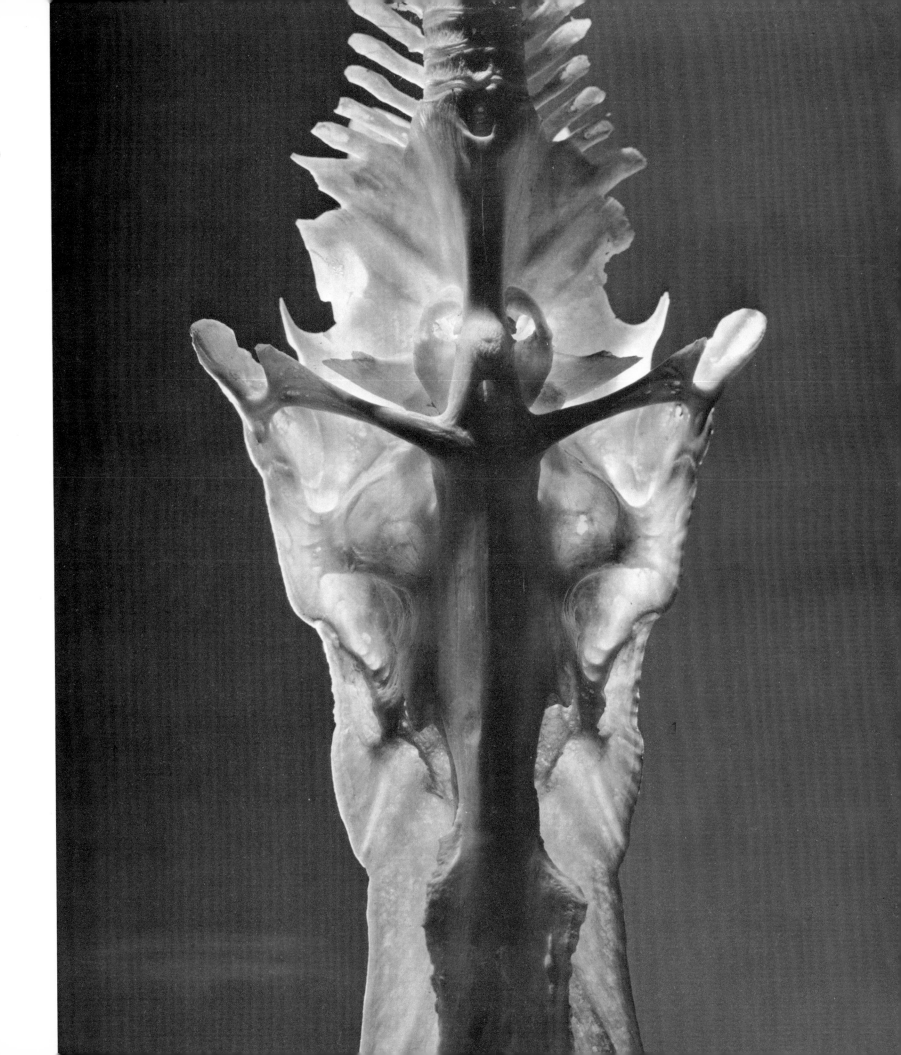

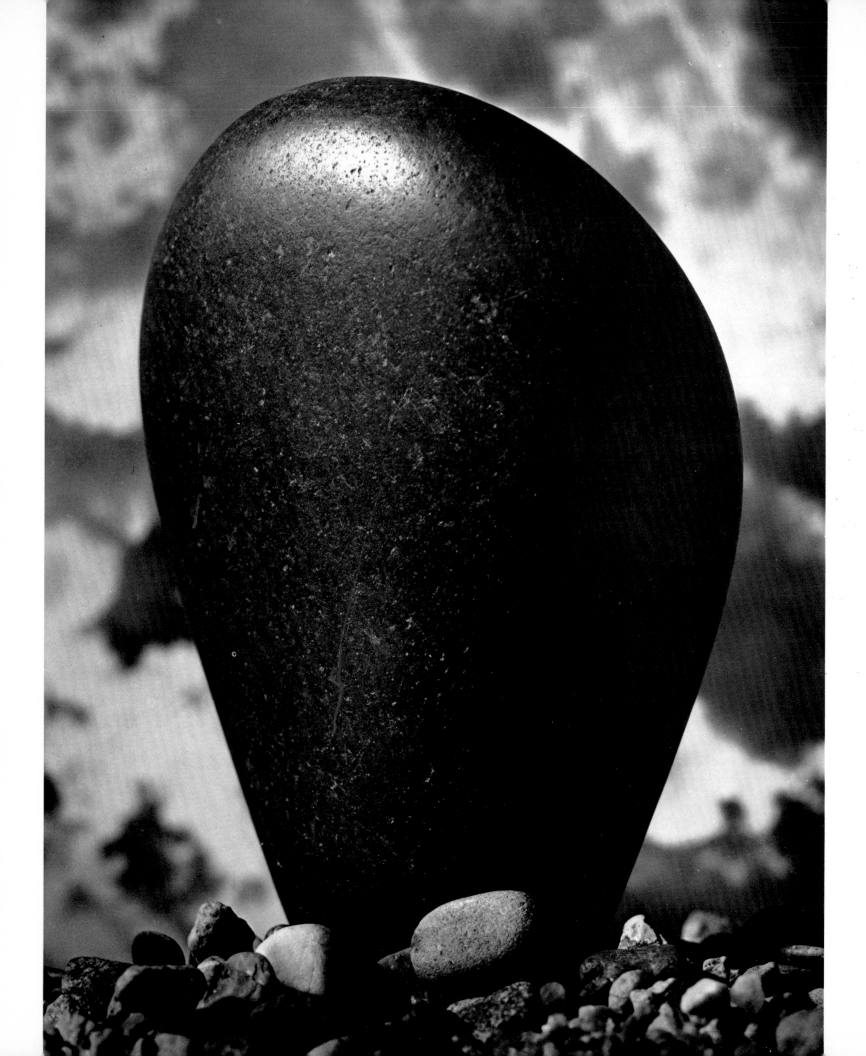

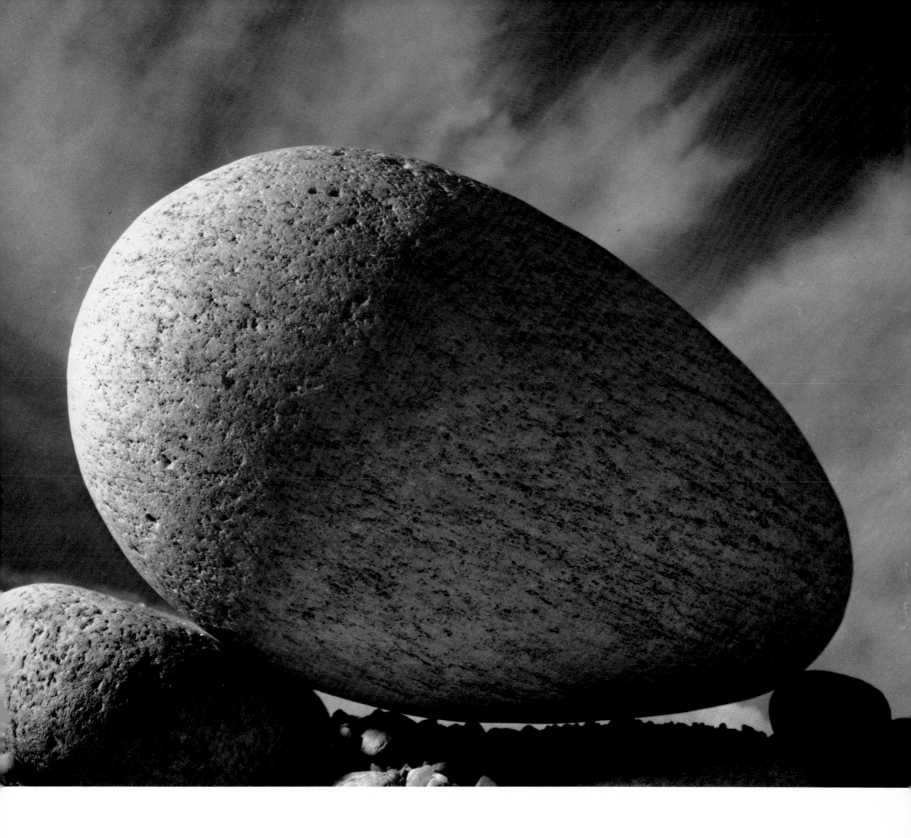

Waterworn pebbles from Long Island, New York. The precise curves, silky finish, and geometric purity of these natural forms are the result of years of abrasion, of rock grinding against rock in the pounding, restless surf off Montauk Point. Is it too much to assume that the work of sculptors like Arp and Brancusi was influenced by forms like these?

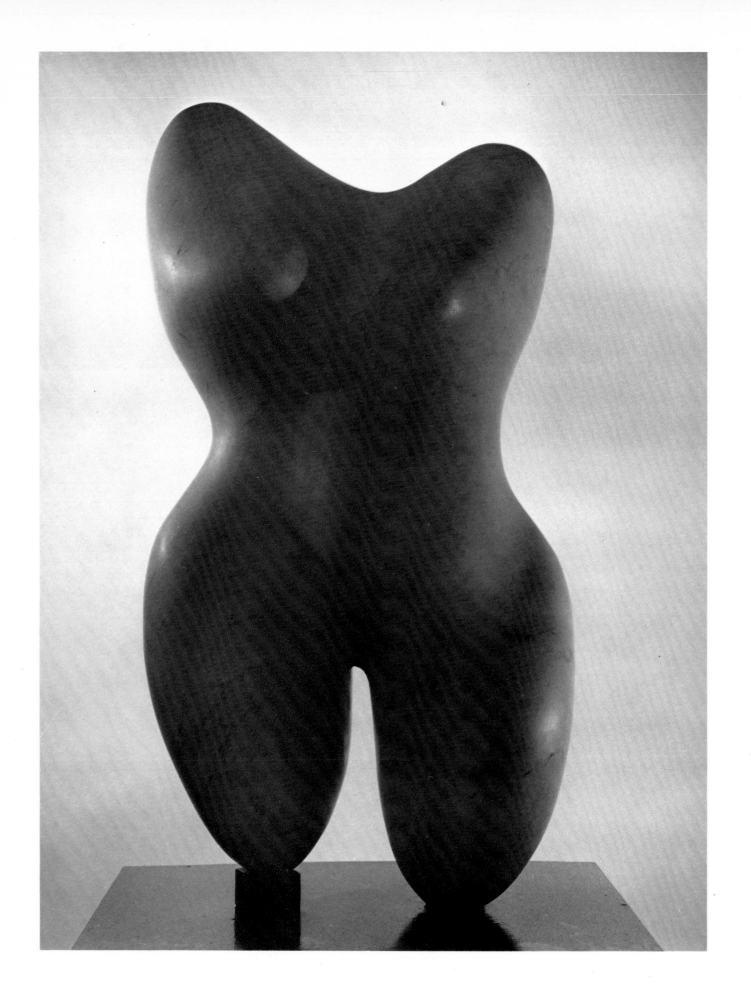

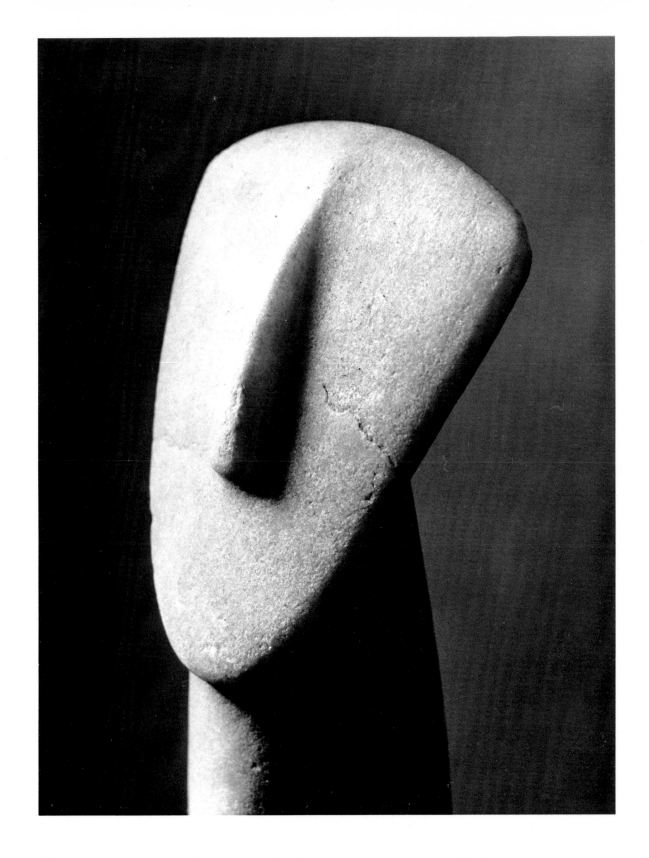

Left: "Torso" by Alberto Viani (Museum of Modern Art, New York). *Above:* Marble head from the Cyclades, Greece, second millennium B.C. (Metropolitan Museum of Art, New York; Guennol Collection). The roots of modern abstract sculpture reach very deep indeed.

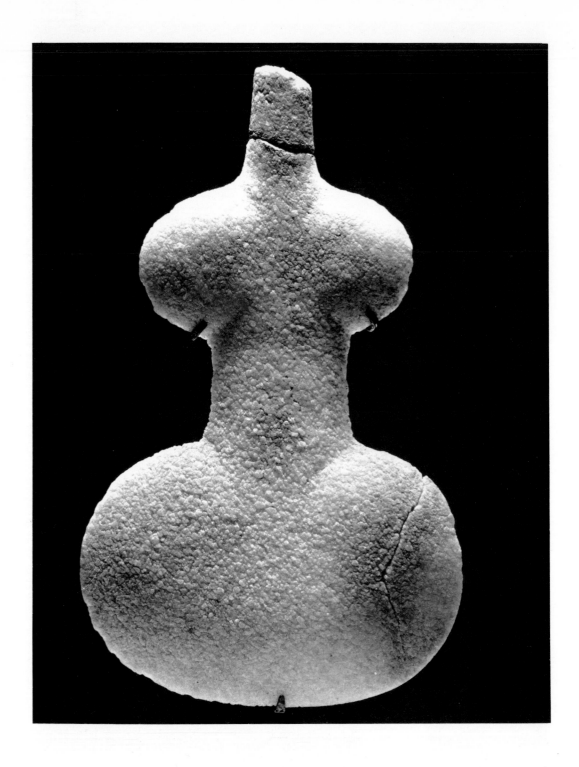

Above: Marble idol from the Cyclades, c. 2000 B.C. *Right:* "Venus I of Dolní Věstonice," Czechoslovakia; late Aurignacian, c. 20,000 B.C. These two female figurines from the dawn of humanity are anything but "primitive." On the contrary, their highly sophisticated abstract forms speak of a degree of conceptual insight and artistry that may have been equaled by more recent works but has never been surpassed. Is it only coincidence that, if turned upside down, the thighs of the "Venus" resemble a phallus and the breasts testicles, suggesting that this idol may have been used in a fertility cult?

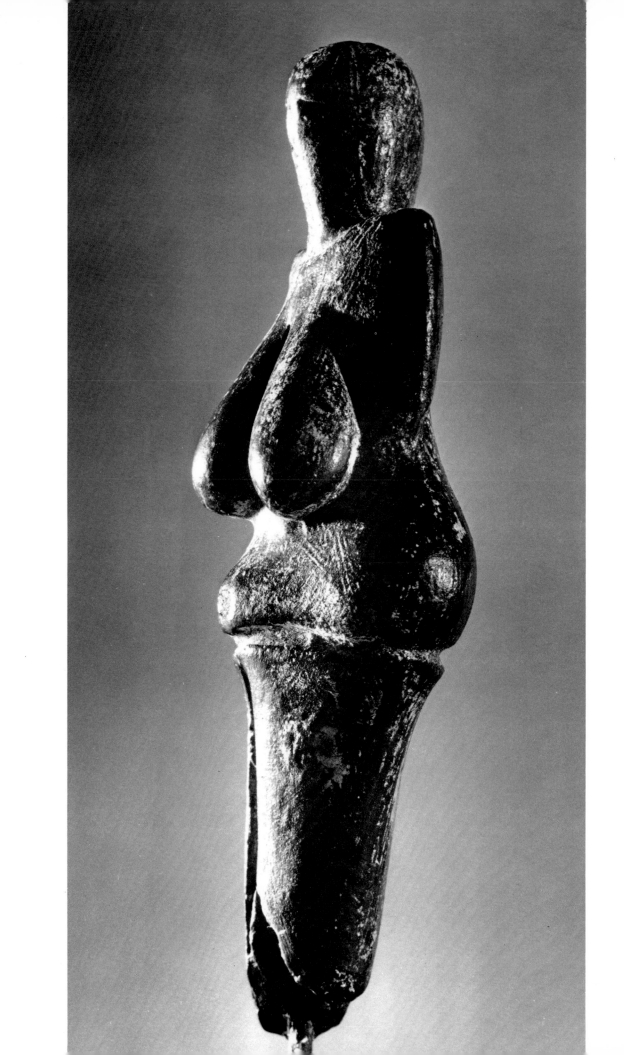

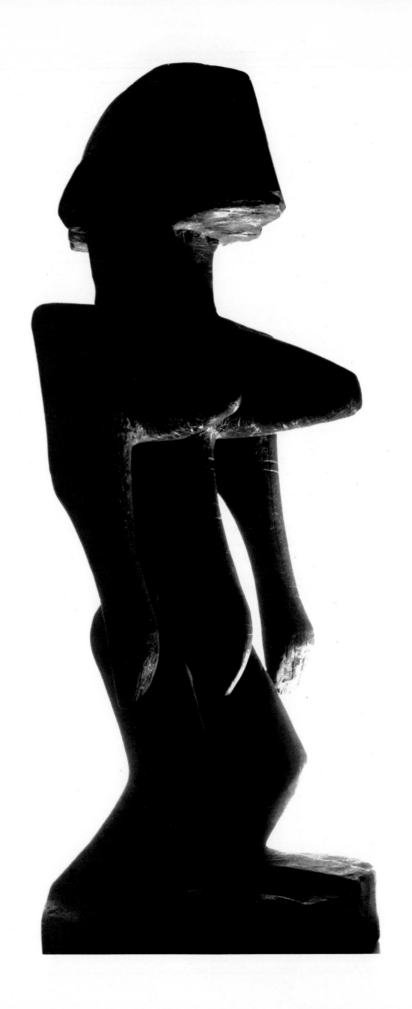

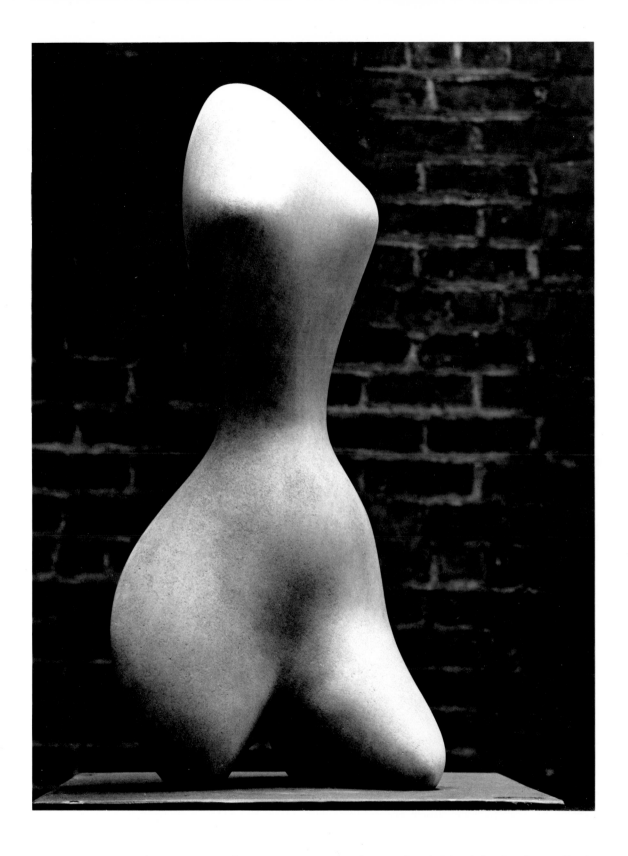

Above: "Torso" by Guitou Knoop. *Left:* Wooden fetish of the Bambara tribe in Western Sudan, Africa (Museum of Primitive Art, New York; 56-222). The high degree of abstraction, by emphasizing essential characteristics and deleting unimportant detail, creates particularly compelling images.

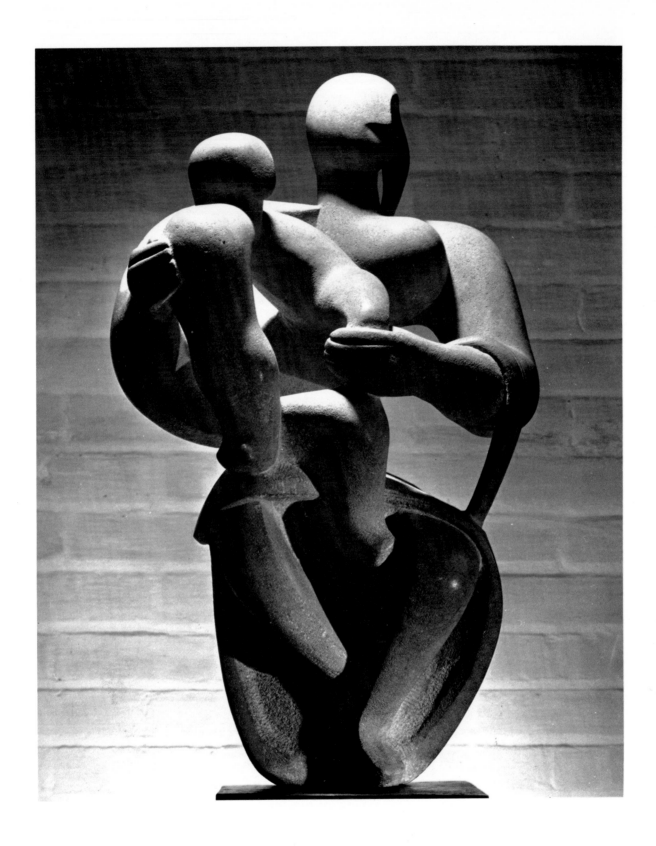

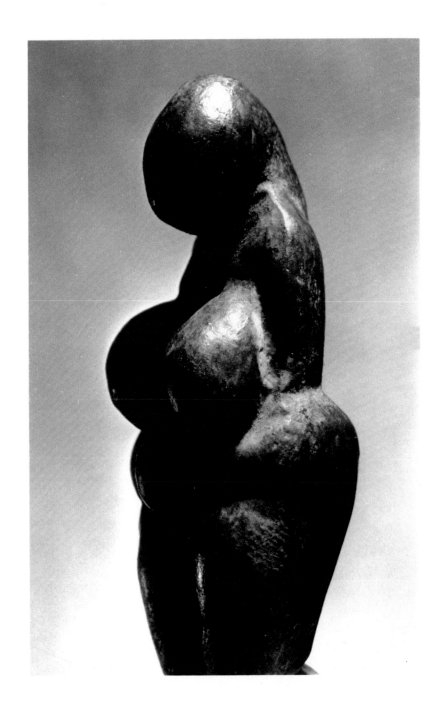

Above: Early Stone Age figurine, c. 30,000 B.C. (University Museum, Philadelphia, Pennsylvania; EU/2565). *Left:* ''Mother and Child'' by Robert Moir (Whitney Museum of American Art, New York). Both works seem to symbolize evolving and growth, their voluptuously curving forms bringing to mind images of tubers and fleshy plants. This feeling is especially strong in the Stone Age figurine, which reminds me of a germinating seed, the head representing the curving tip of the cotyledon ready to penetrate the soil and rise toward the light.

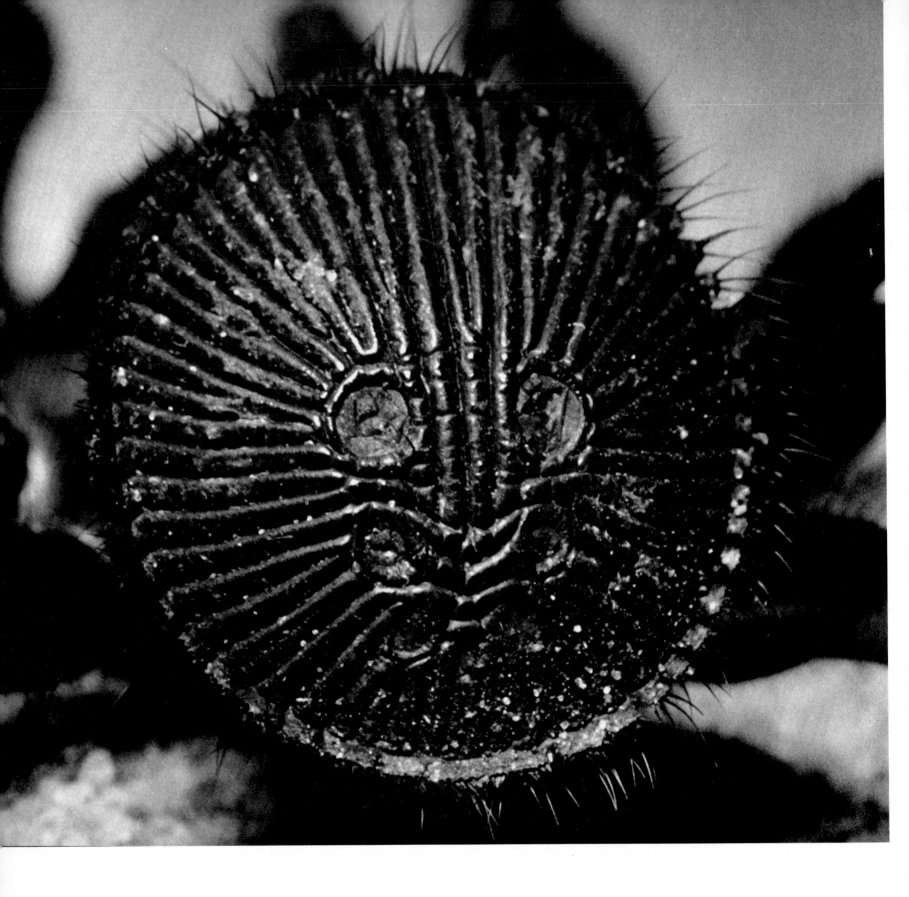

Above: Rear view of a trap-door spider. *Right:* Head of a gargoyle from the Great Pyramid near Mexico City. The "face" on the armored shield of the spider is only an illusion, the purpose of its design unknown. But it is not difficult to surmise that a pattern similar to this might have inspired the Aztec artisan who carved this monstrous stony head.

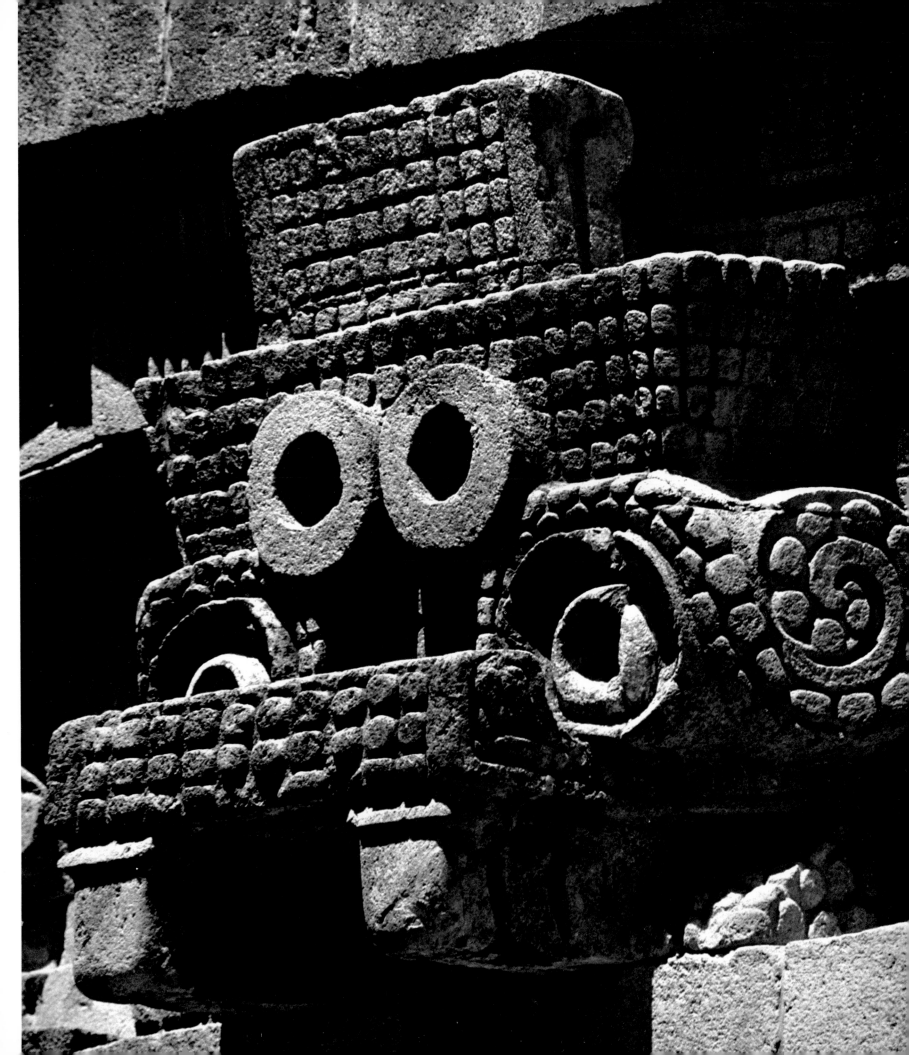

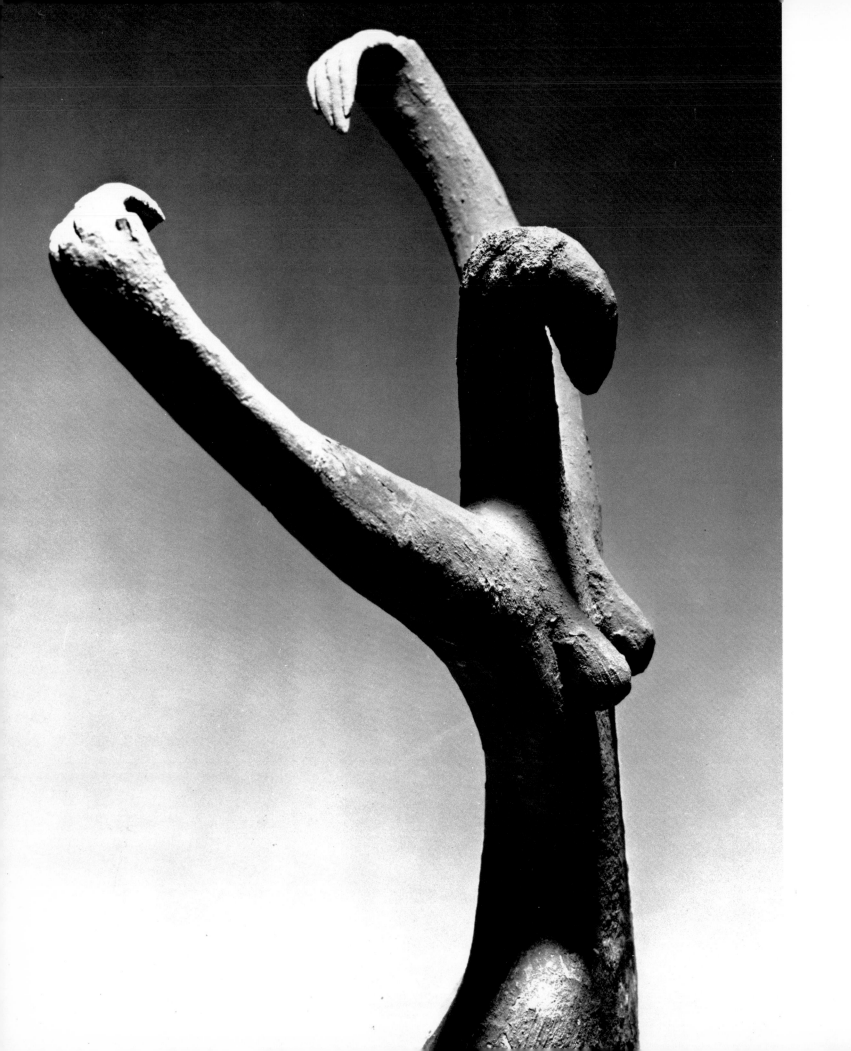

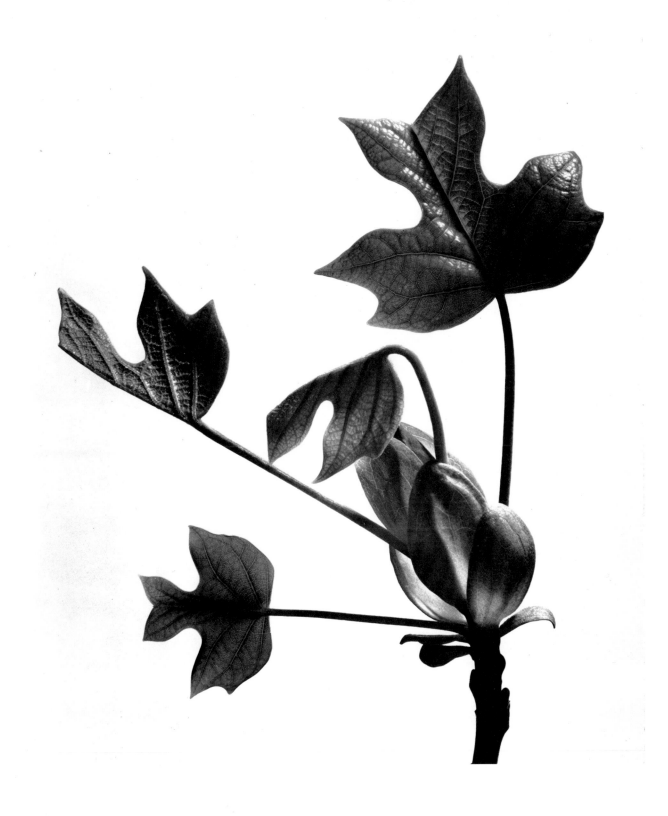

Left: Egyptian terra-cotta figurine of the predynastic period, c. 3000 B.C. (Brooklyn Museum, New York; 07-447-502). *Above:* Tulip-tree leaves unfolding in spring. The graceful curves of the unfolding leaf stems have their counterpart in the sinuous curves of the little figurine, the head of which suggests a germinating seed about to penetrate the soil. Although the purpose of this little statue is not known, its plant-like forms bring to mind harvesting rites and thoughts of spring and growth.

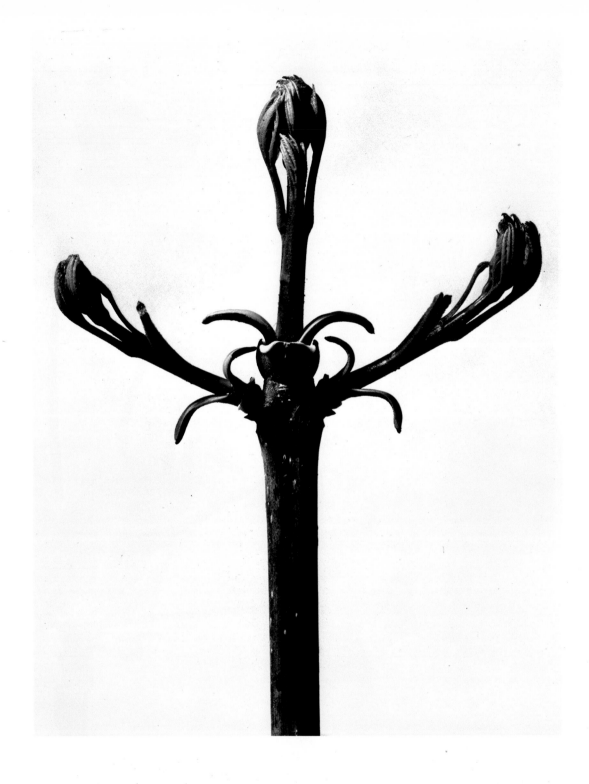

Above: Shoots of white ash in spring. *Right:* Iranian figurine from a Bronze Age tomb at Turang-Tepe, c. 2000 B.C. (University Museum, Philadelphia, Pennsylvania; 32-41-25). As I look at these two photographs, my thoughts begin to wander: I realize that symmetry occurs in nature as well as in the works of man, but nature was first. I see leaves that look like hands and fingers, I see hands devoutly joined in prayer. I see a mouthless face and think of silence (strange, that the face of the Ice Age girl shown on page 169 is mouthless, too). I see arms spread wide in welcome and joyous assertion of life — and think of hands *n*ailed to a cross.

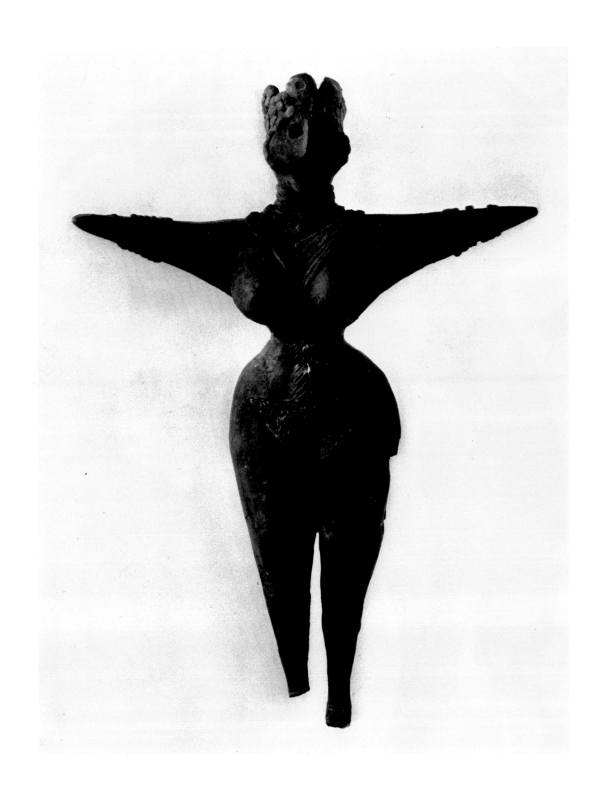

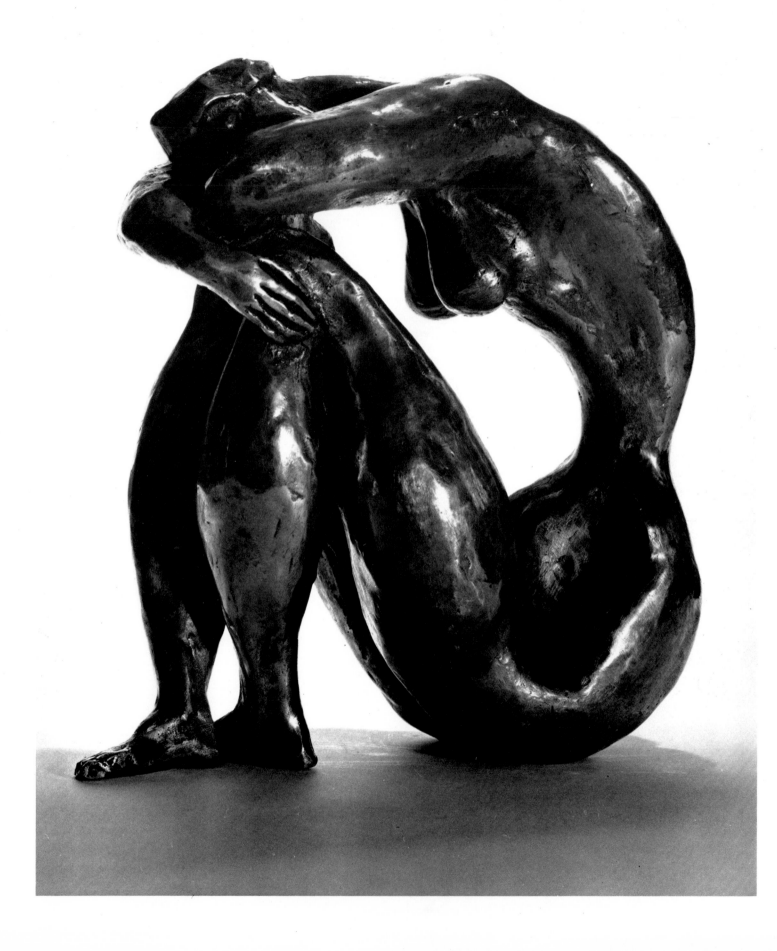

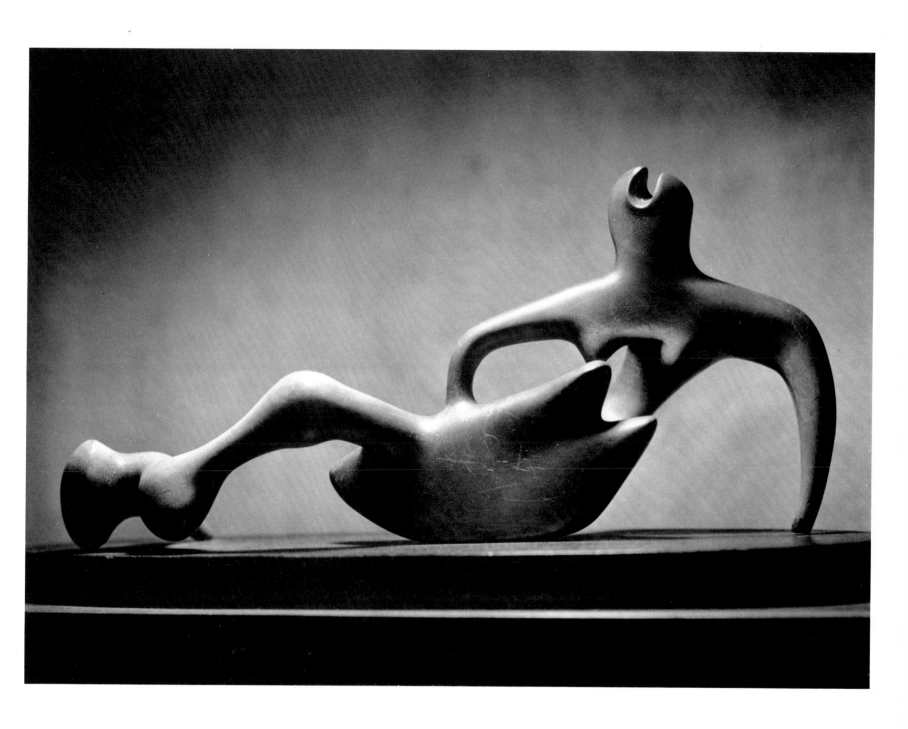

Above: "Woman Reclining" by Henry Moore (Museum of Modern Art, New York).
Left: "Ellipse" by Doris Caesar. To my mind, both works were strongly influenced—perhaps subconsciously—by plant forms. I see in their curves and swelling shapes bulbs, tubers, and roots growing and expanding; I sense the dynamic pulsing of life.

II Design

The word "design" has many connotations. To me, it suggests primarily two concepts: order and beauty. Order implies simplicity, clarity, and function; beauty sense-appeal. Perhaps I am prejudiced, but I find these qualities much more often in objects of nature than in the works of man. In nature nothing is ugly, although many of her creations are unfamiliar to many people—and unfamiliarity, particularly in conjunction with lack of intelligence, easily evokes suspicion, revulsion, and hate. Nor is there anything meaningless, inefficient, or nonfunctional in nature, while badly functioning and senseless man-made creations abound. And nature never wastes, while man still squanders on a frightful scale.

Although it may appear that nature makes poor use of her resources when one considers, for example, the number of seeds that reach maturity relative to those that perish at an early stage, this is only an illusion. Those seeds are not wasted. Seeds—kernels of grain or corn, acorns, peas, nuts—as well as immature plants and animals that are eaten by other animals or man are not wasted. They serve to nourish other forms of life, organisms which, without this sacrifice, could not survive. And those that die a natural death decay, which is only another way of saying that their substance is recycled, reverting to the common fund of nourishment on which all living things depend. In contrast, man is a genuine waster, because he takes nonrenewable raw materials *permanently* out of circulation—burying the tin of toothpaste tubes and galvanized cans in dumps, rusting away iron and steel, promulgating erosion that flushes life-giving topsoil out to sea, consuming energy in senseless wars on a terrifying scale.

The only way to stop this trend toward global disaster is to realize that space on earth is *not* unlimited, nor is the supply of nonrenewable raw materials. Practically, this means that man must learn to give up temporary profits for the sake of future lasting gains. This in turn requires a change from a crassly materialistic attitude in regard to his approach to nature to a more idealistic one—to "Spaceship Earth," its soil, its animals and plants. One way of bringing about this change is through education—by showing people, and in particular the young people who someday will have to make the decisions and live with the results, that rocks and plants and animals are not only useful but also *beautiful,* a never-ending source of enjoyment, spiritual stimulation, and renewal. It is in this sense that I present the following photographs exemplifying design in nature.

The stunning rosette on the opposite page is not the inspired design for a window in a great cathedral, but the flower-supporting structure of Queen Anne's lace, one of the most common of all the wildflowers that grow in my part of Connecticut. Other aspects of this beautiful plant are shown on pages 120 and 121.

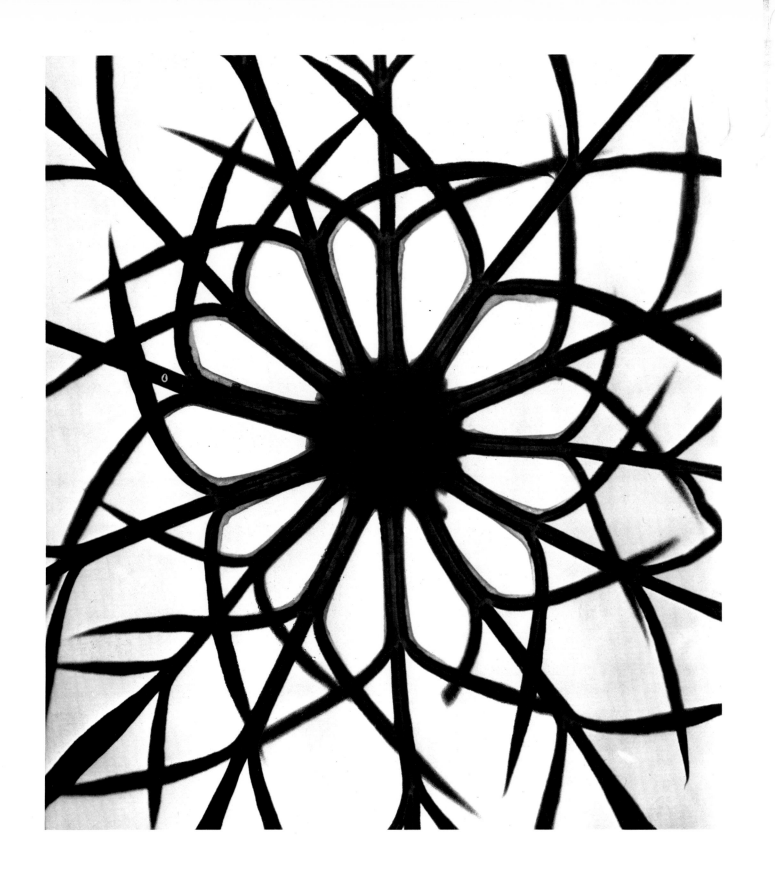

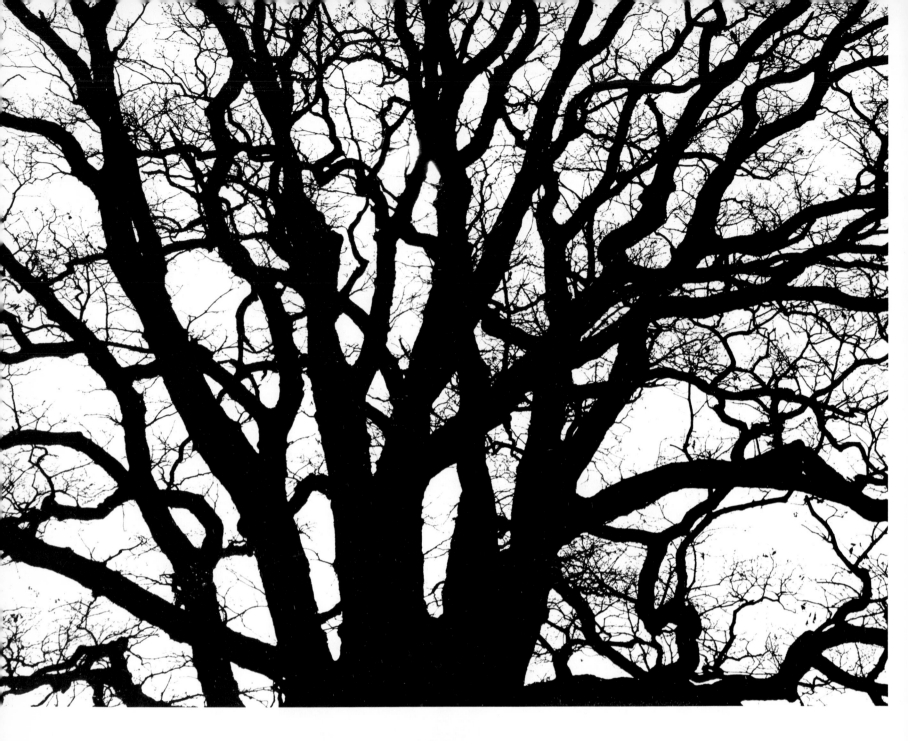

50

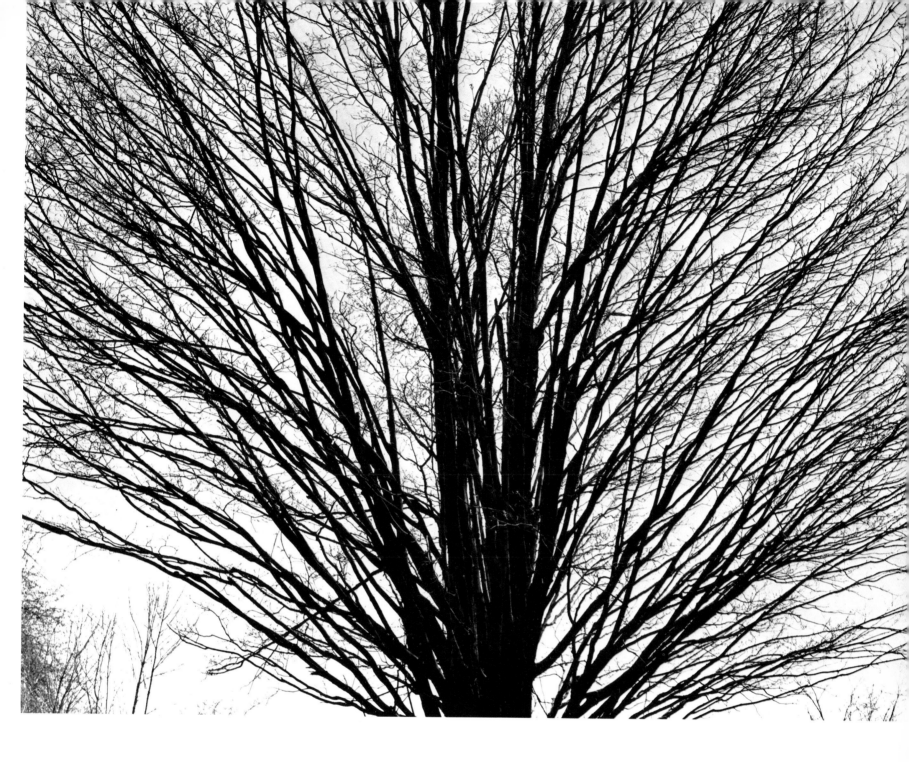

Each species of animal or plant has its own design—a collection of unique characteristics that set it apart from all the others. This design permeates the entire organism to such an extent that an expert can recognize and name correctly, for example, a tree even in winter, despite the absence of flowers and leaves.

The photograph at the top of the opposite page shows a white oak in Maryland; the one above, a sugar maple in Connecticut. The difference in the design of these two trees is as evident in their growth pattern as it is in the form of their leaves.

At the left, an ornamentally pruned or pollarded sycamore in France—man's design forcibly superimposed on that of nature.

SWEET BIRCH

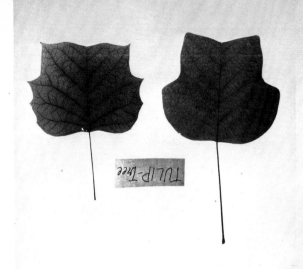

TULIP-Tree

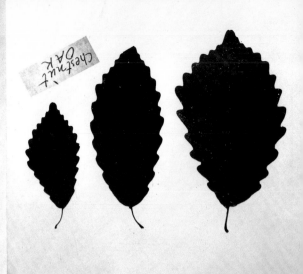

Chestnut OAK

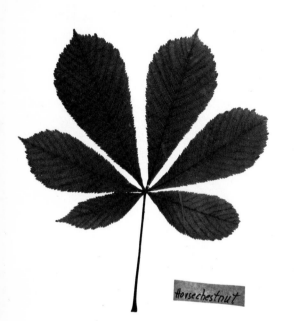

Horsechestnut

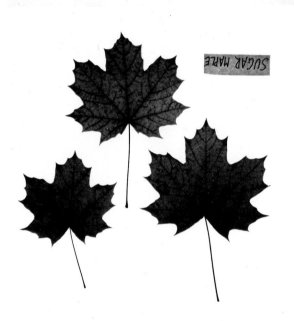

SUGAR MAPLE

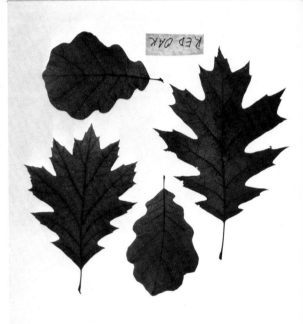

RED OAK

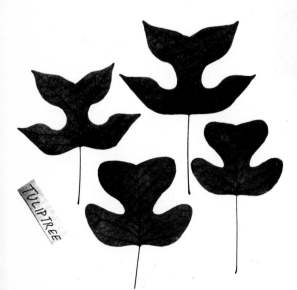

TULIPTREE

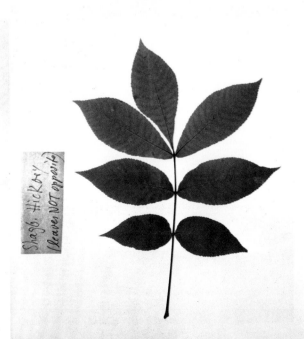

Shagb. HICKORY
(leaves NOT opposite)

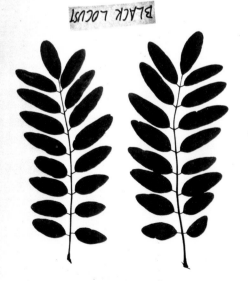

BLACK LOCUST

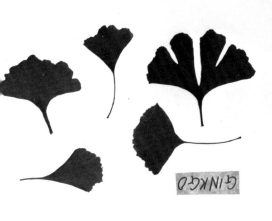

GINKGO

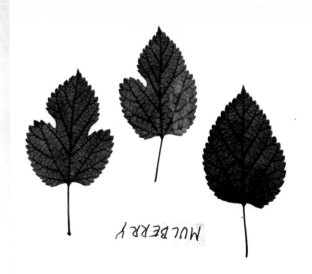

MULBERRY

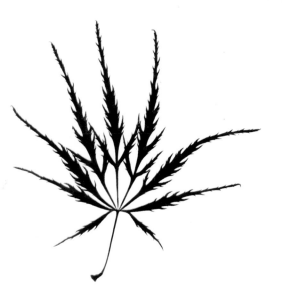

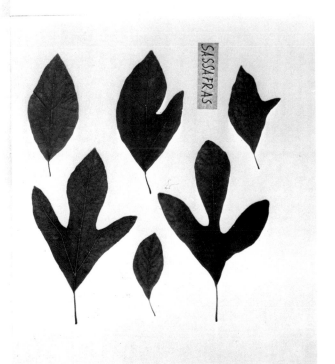

SASSAFRAS

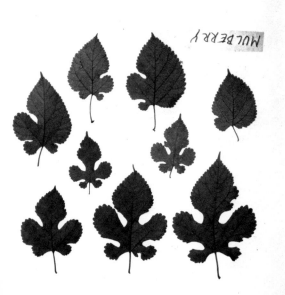

MULBERRY

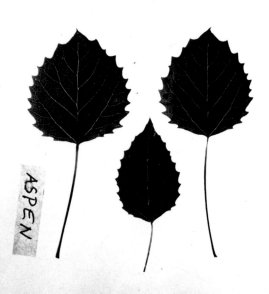

ASPEN

Two pages from my photographic sketchbook. Leaves from different species of trees testify to the boundless inventiveness of nature, which has varied one basic design to an infinite degree—taking into consideration the fact that probably no two leaves from even the same tree are ever exactly alike.

Marvel at the beauty of the individual designs, each attractive in its own way: edges smooth or wavy, serrated, toothed; leaves roundish, pinnately or palmately lobed, symmetrical or asymmetrical, pointed or indented, smooth or rough. . . . Why, one wonders, this infinite variety instead of only one form for all?

53

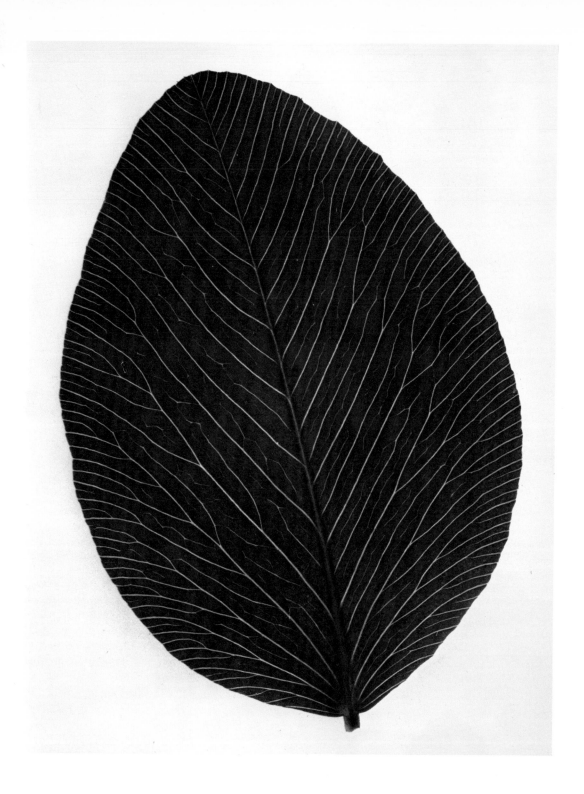

One basic leaf design (there are others) consists of a midrib with branching side ribs, which in turn divide into still smaller veins, the whole forming a connective system that covers the entire leaf. Its purpose is twofold; on one hand, the ribs and veins act as structural supports which, like the ribs of an umbrella, stretch and stiffen the membrane of the leaf to assure its proper exposure to light. On the other hand, they form an integrated system of pipelines throughout the leaf for the distribution of water and minerals taken up by the roots, and the transport of the food produced within the leaf by photosynthesis to other parts of the plant.

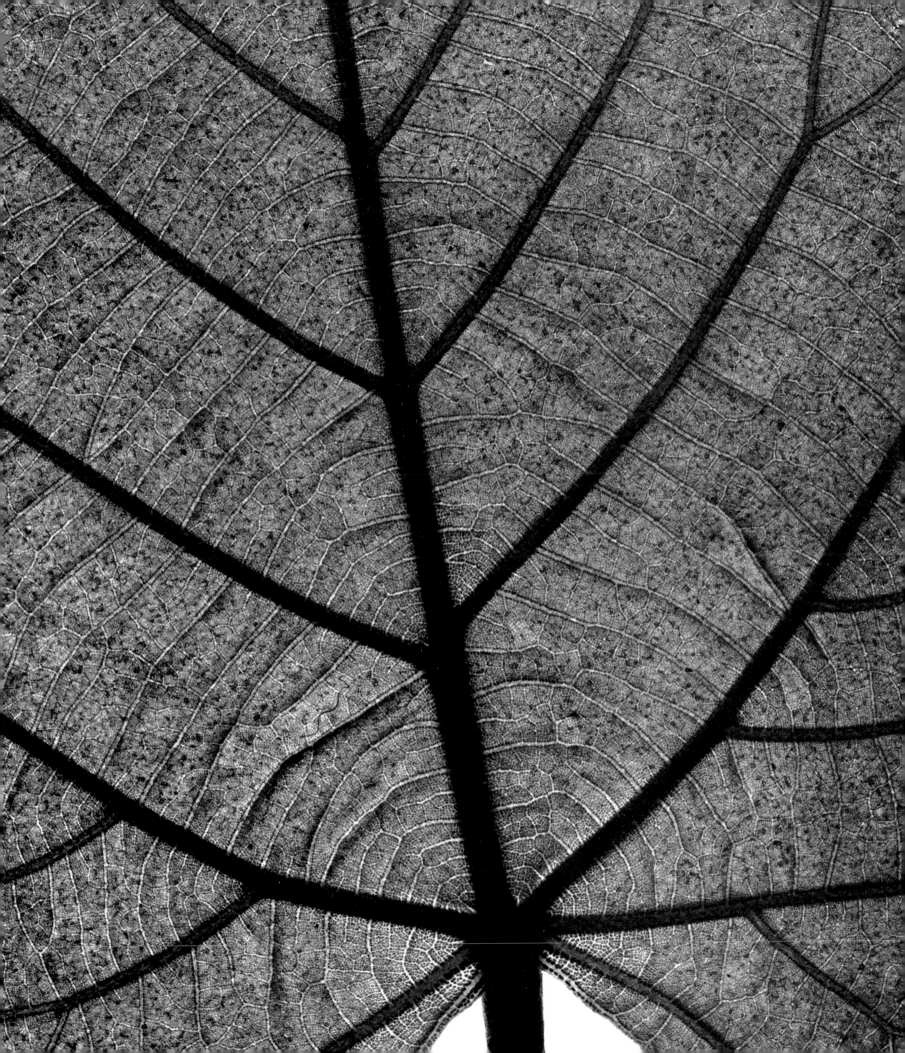

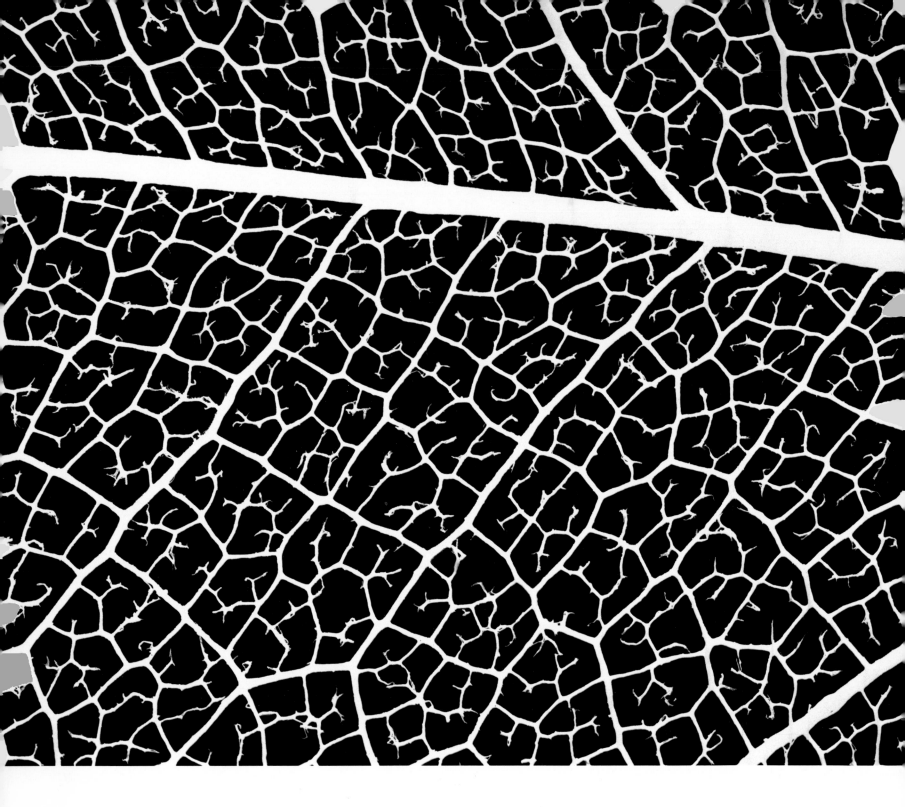

A closer look at leaves reveals the intricacy of their design. *Above:* A strongly enlarged view of a section of a leaf with everything but the veins removed by chemical treatment. It shows the regularity with which the system of veins covers the entire leaf in such a way that no point is farther removed from the distributing network than any other.

Right: The photograph of a decaying chestnut oak leaf reveals the over-all design of its veins.

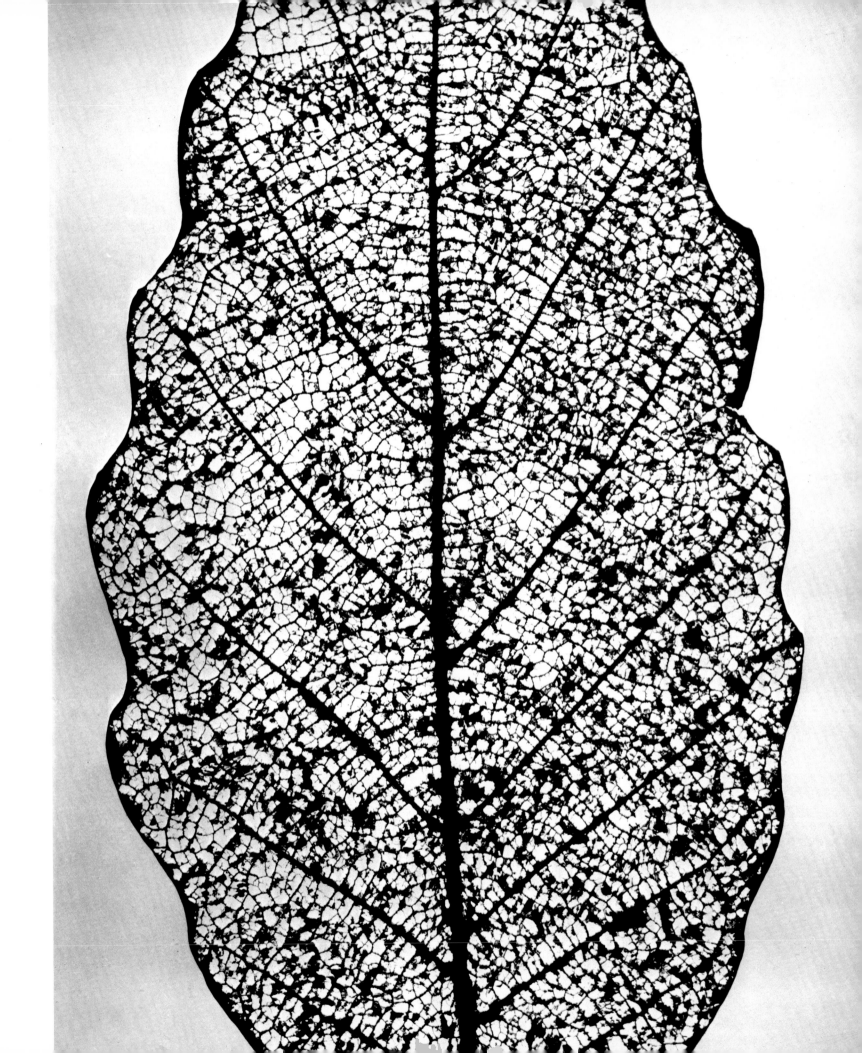

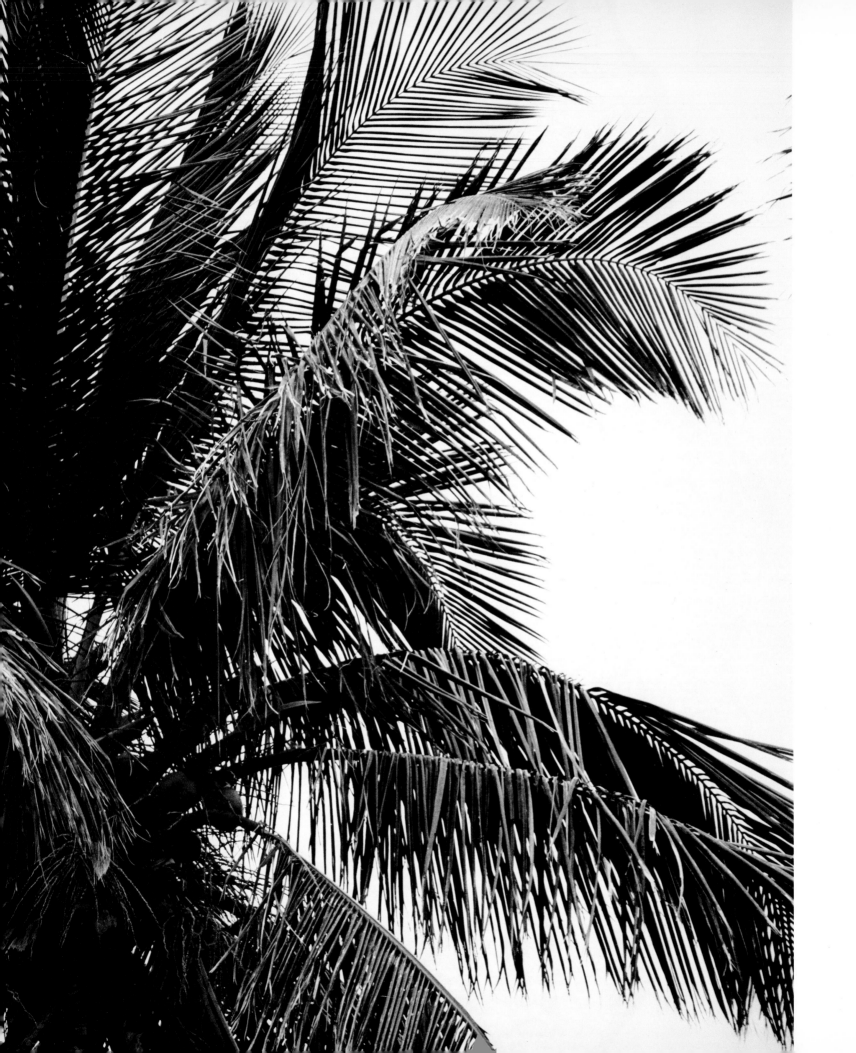

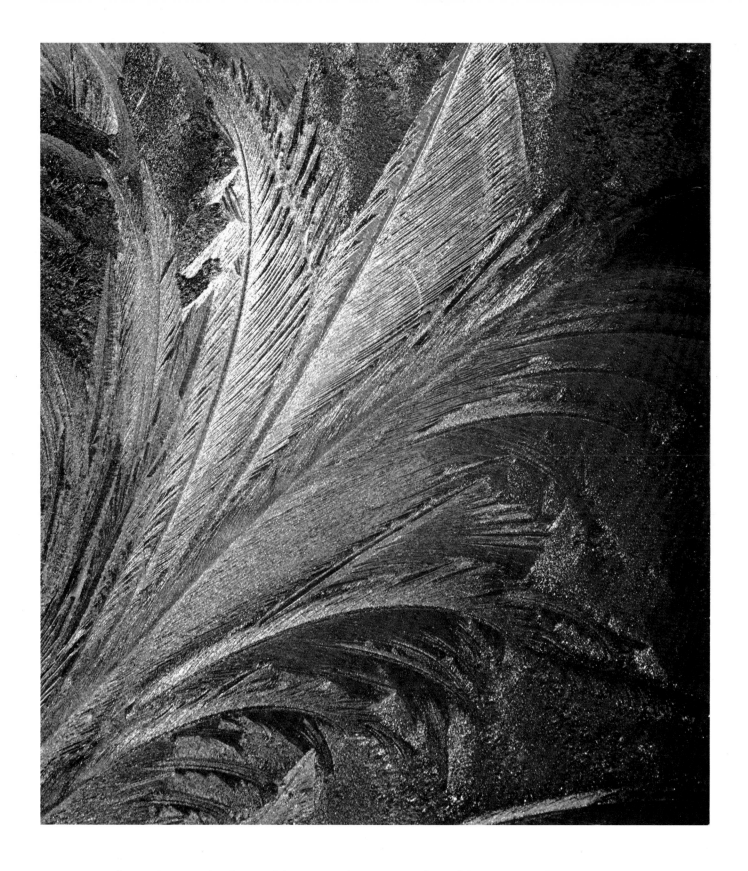

The similarity in the design of the crown of a coconut palm and frost on a window-pane is striking—and thought provoking. Science calls it coincidence, but is there anything coincidental in nature? Or does everything have an underlying cause? Considering our general state of ignorance, I am inclined to believe the latter. Perhaps someday we'll know. . . .

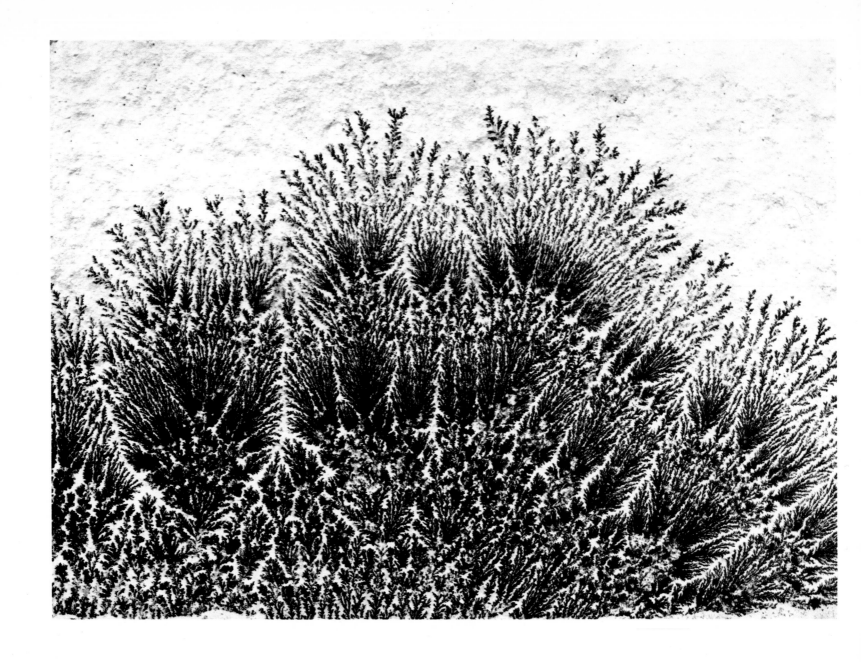

These delicate, plantlike structures are dendrites — depositions of manganese oxide which penetrated cracks in sandstone in solution. They have nothing to do with plants. Nevertheless, their resemblance to certain types of plants, which extends down to minute details of structure and growth pattern, makes one wonder whether there is a connection that science so far has overlooked — some basic principle that has to do with the way in which atoms combine to form molecules and molecules combine to form the grosser structure of things both inanimate and alive.

Actually, where is the boundary between the living and the dead? Dead crystals grow as if they were alive, and live viruses, when desiccated, crystallize like minerals, only to come back to life again when conditions are right. And in the last analysis, all the components that make up a living organism, including man, are nothing but inanimate matter — atoms, elements, chemical compounds — yet together they constitute life.

60

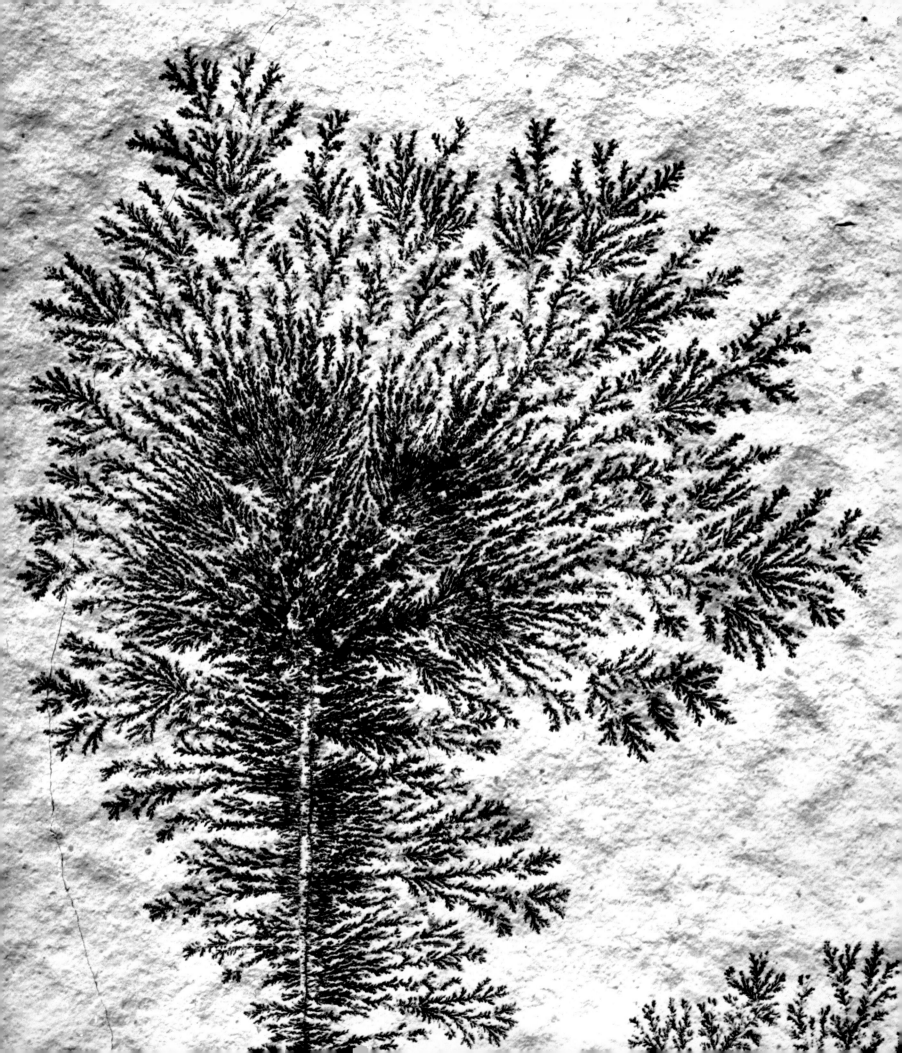

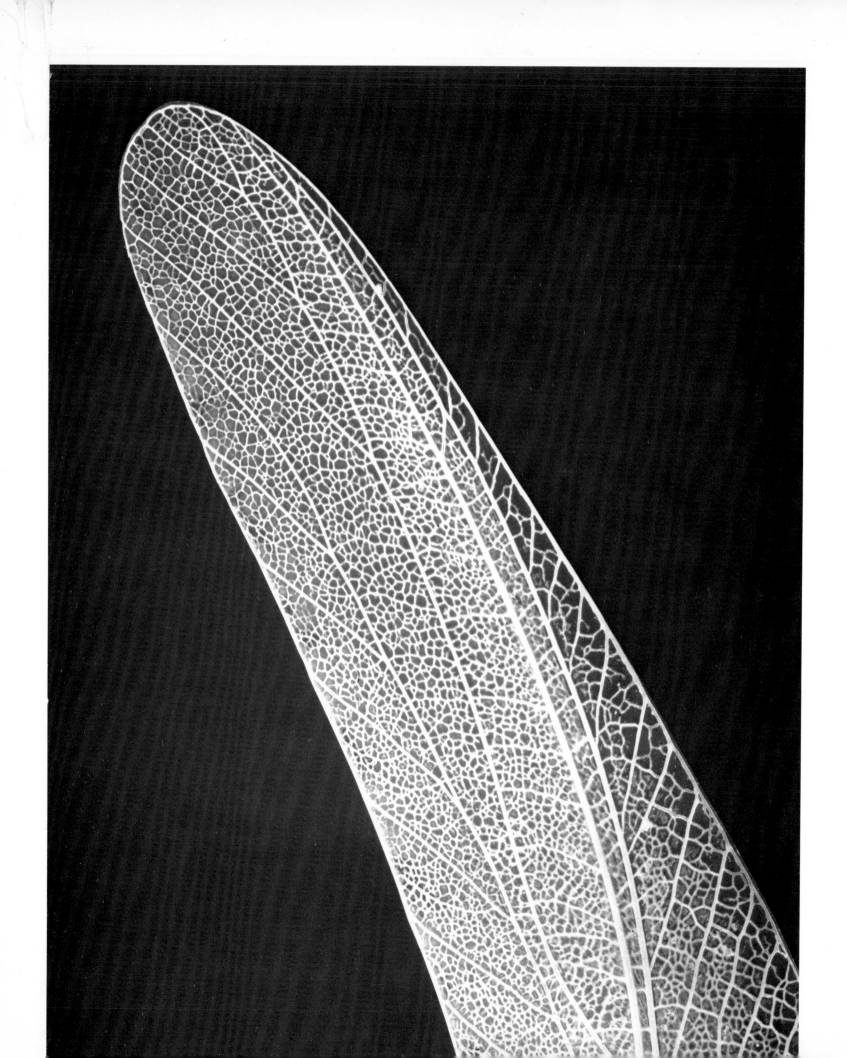

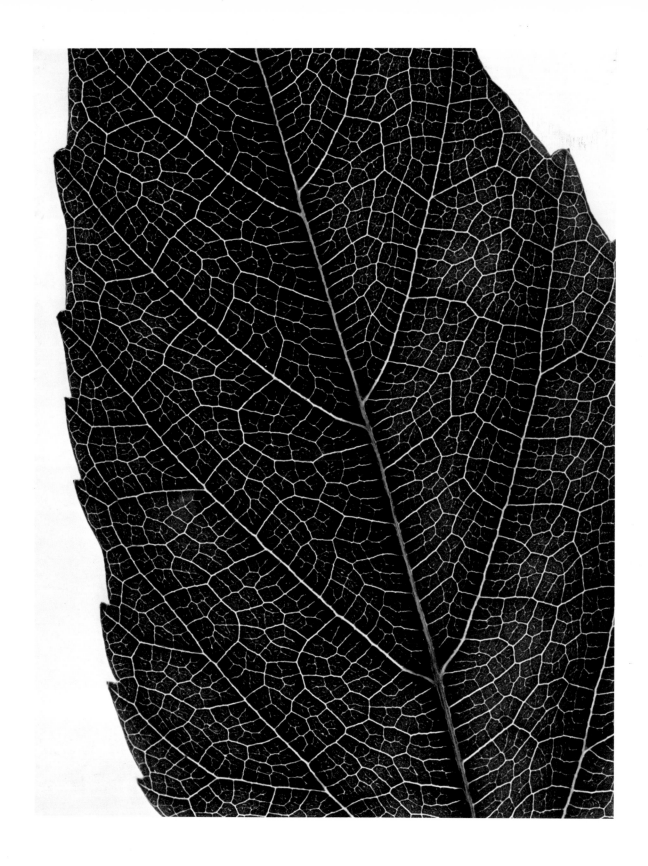

A comparison between the venation of a grasshopper wing and a cissus leaf reveals the striking similarity of their designs. In both cases the problem was identical — a membranous structure had to be stiffened — and identical problems demand identical solutions, regardless of the fact that, in one case, the subject is an animal, and in the other case, a plant.

63

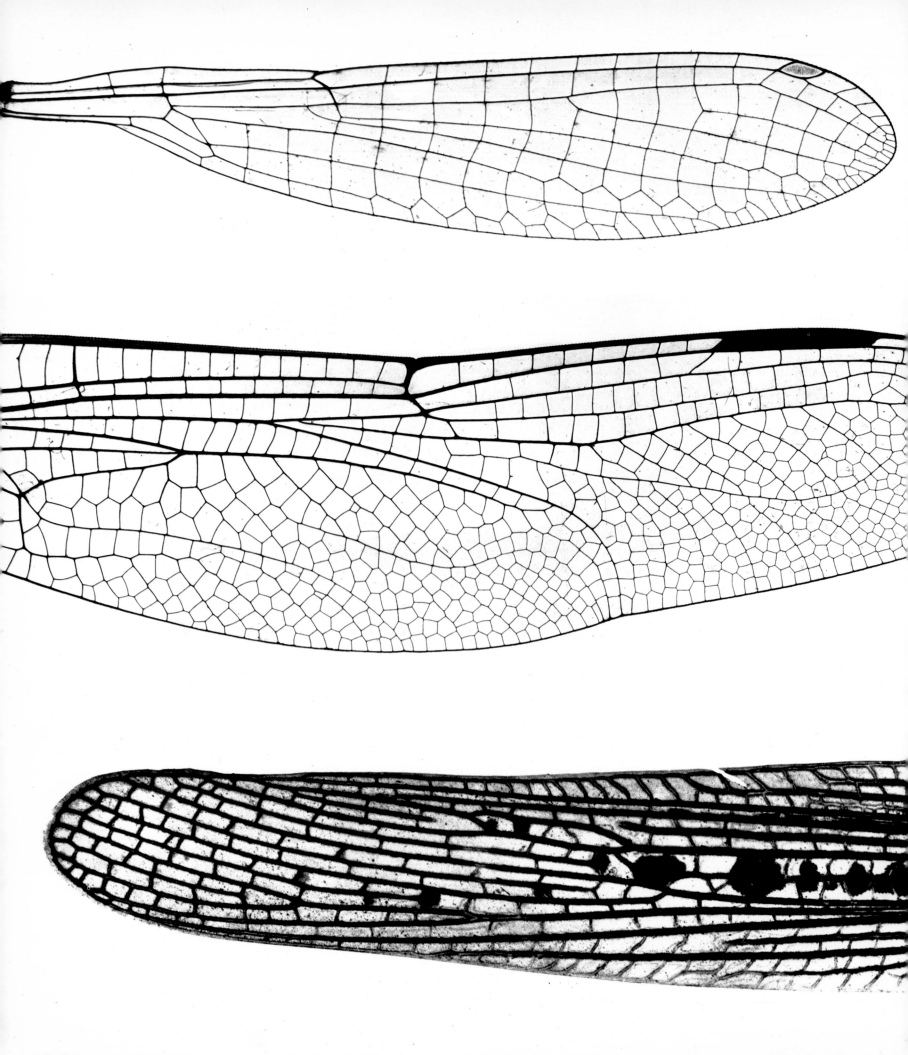

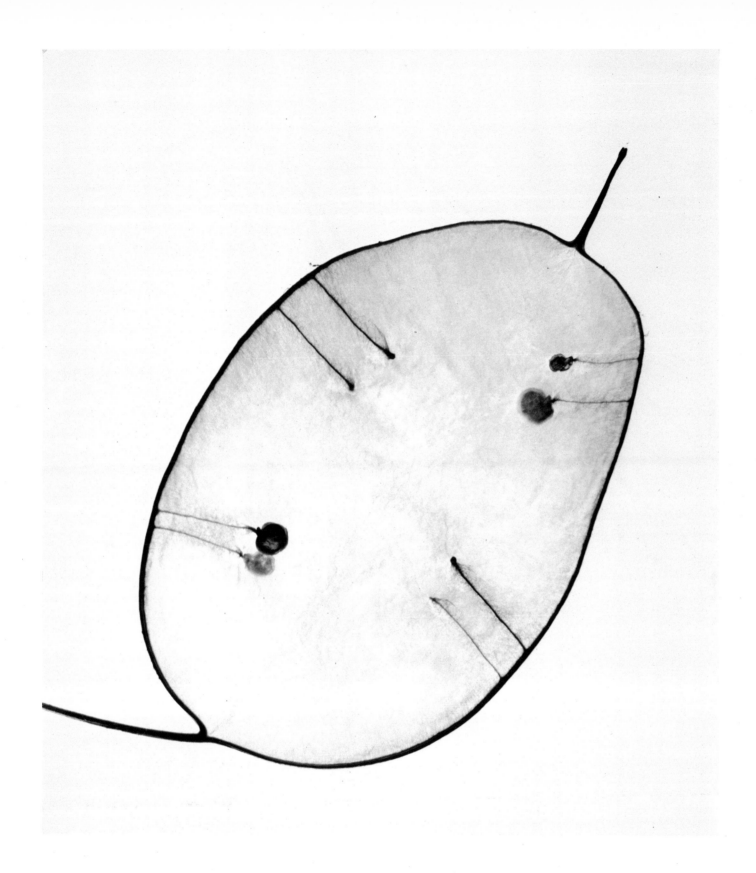

The problem: How to stiffen a membrane. *Left:* Wings from different insects. *Above:*
The dividing membrane of a silver-dollar seed capsule. The design of the insect
wings embodies the principle of stiffening by branching ribs; the seed membrane
employs a tension ring, analogous to the rim of a banjo or tambourine.

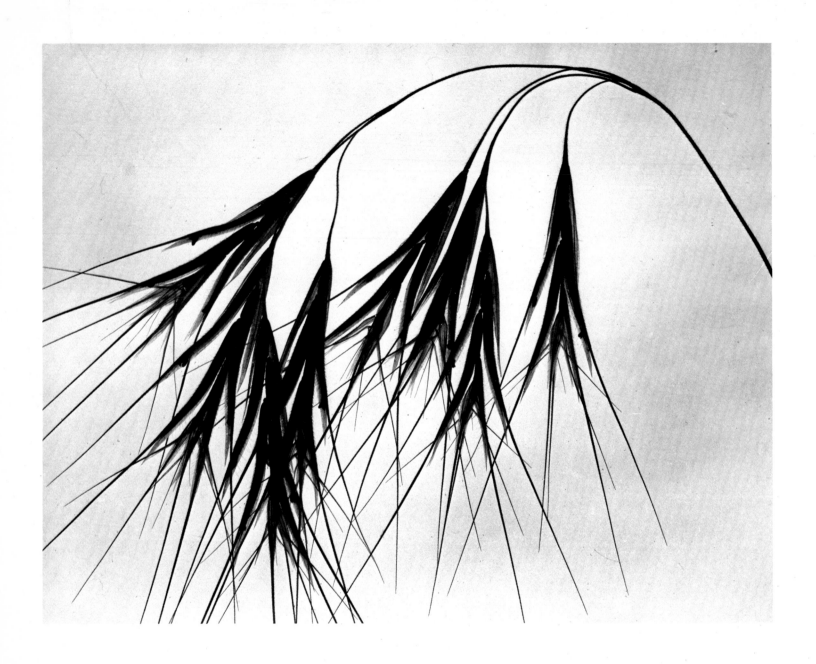

Seeding grasses from Connecticut, variations of the branch design, display their considerable graphic appeal. Surprising, isn't it, how decorative strictly functional forms can be. Perhaps there is a lesson for industrial designers who, at least in my opinion, only too often corrupt the functional creations of the engineer. Examples of this are legion in the automotive industry but are also common in the design of household appliances, television sets, tableware, furniture, and most other articles of daily life.

66

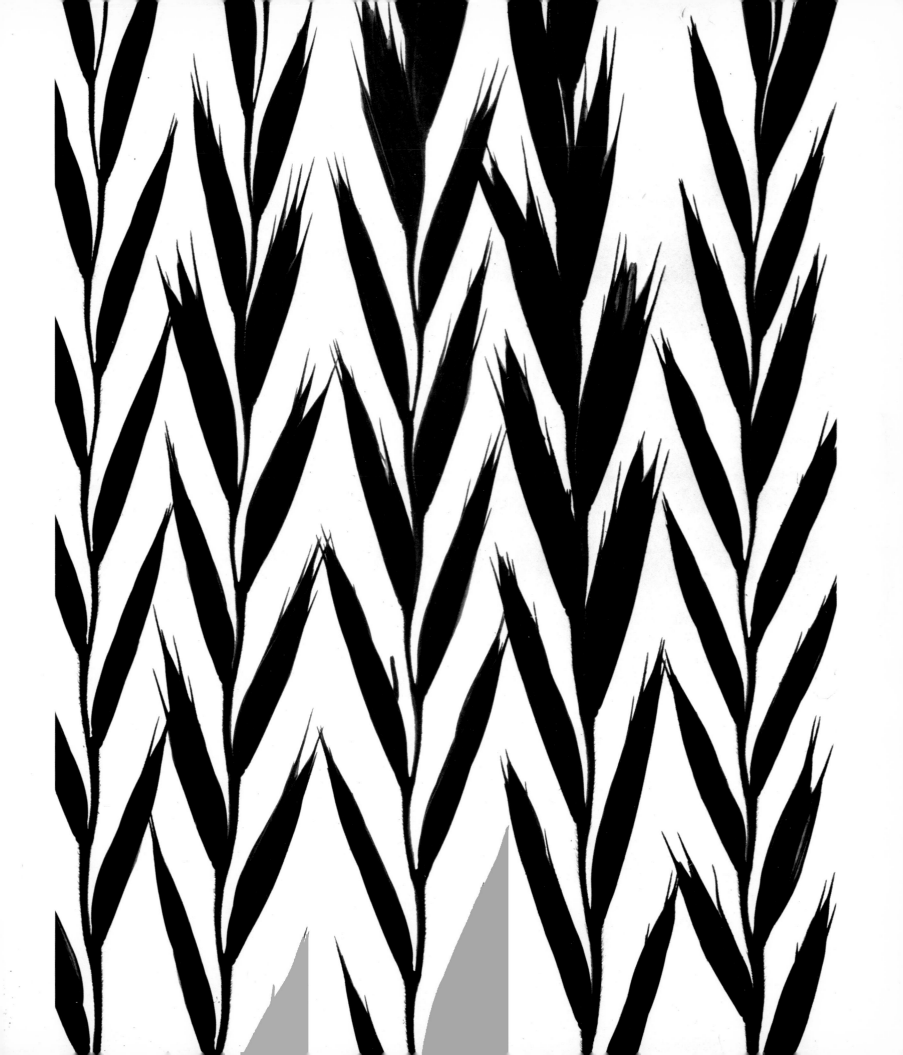

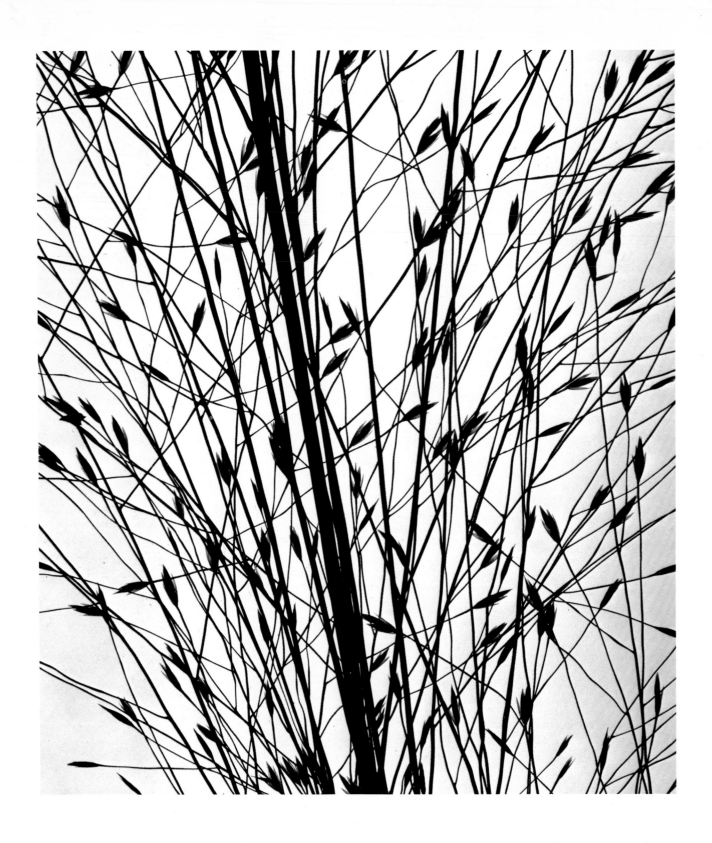

Another one of those "coincidental" design similarities in nature, this time between grasses and feathers. Feathers, incidentally, are one of nature's most marvelous creations: they are incredibly light yet unproportionally strong and durable. Because of their air-filled, cellular, interlocking design, they are also the best thermal insulators found anywhere.

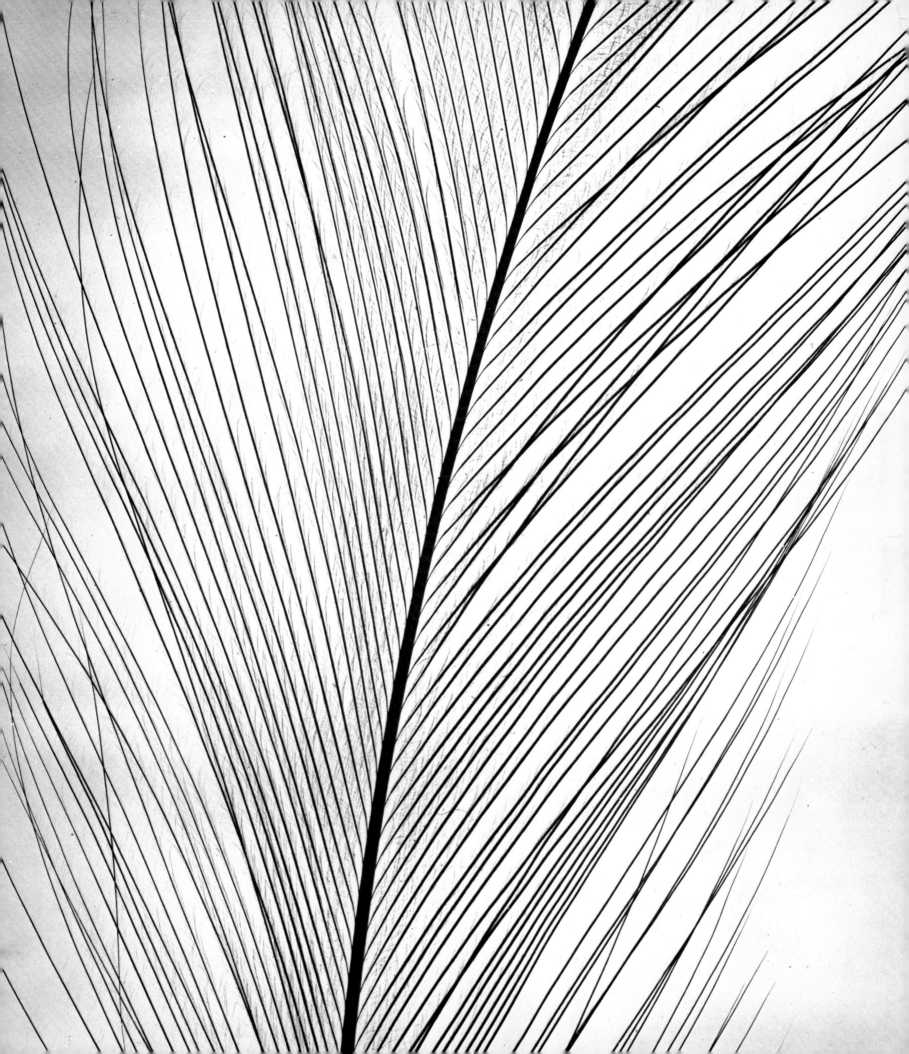

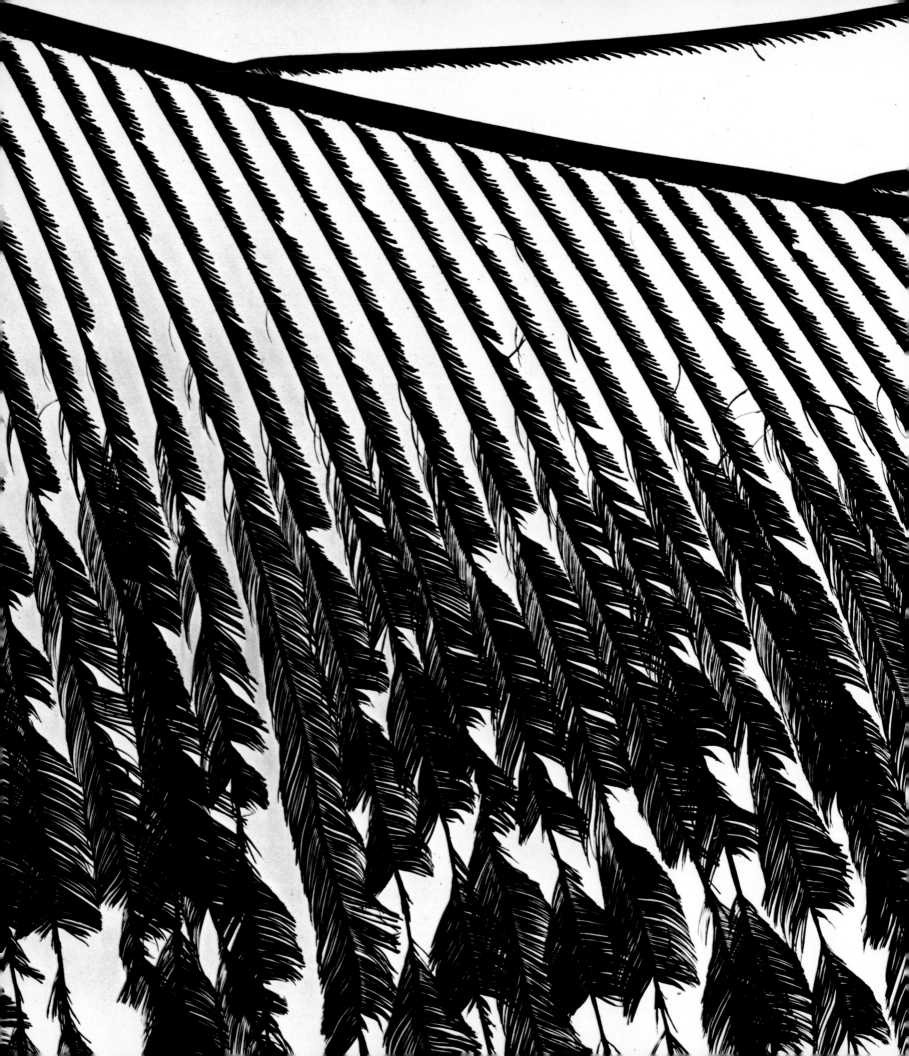

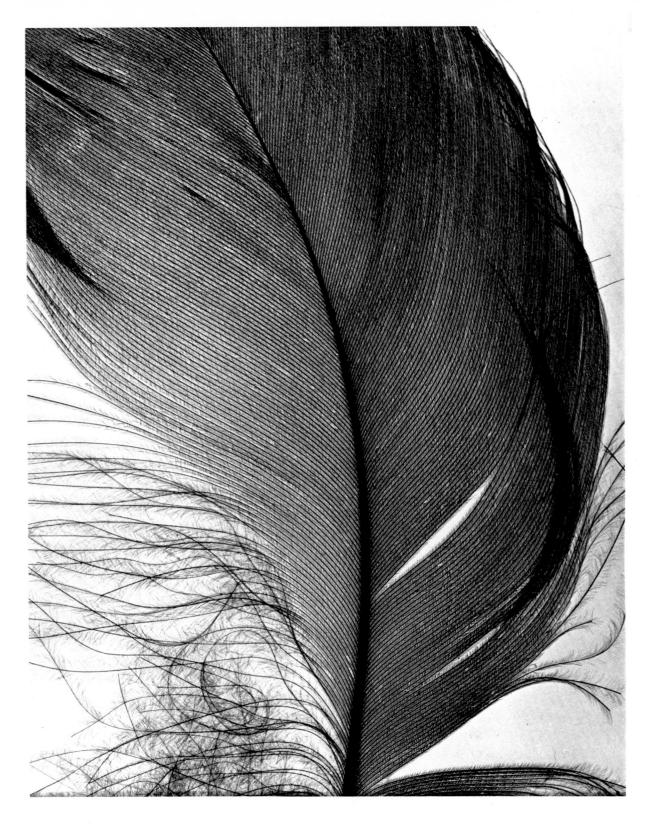

Like leaves, feathers represent a basic design that nature has modified to an almost infinite degree, each type adapted to serve most perfectly a specific purpose, which may vary from strictly functional to entirely ornamental. Three different examples, each beautiful in its own way, are illustrated on these and the previous pages.

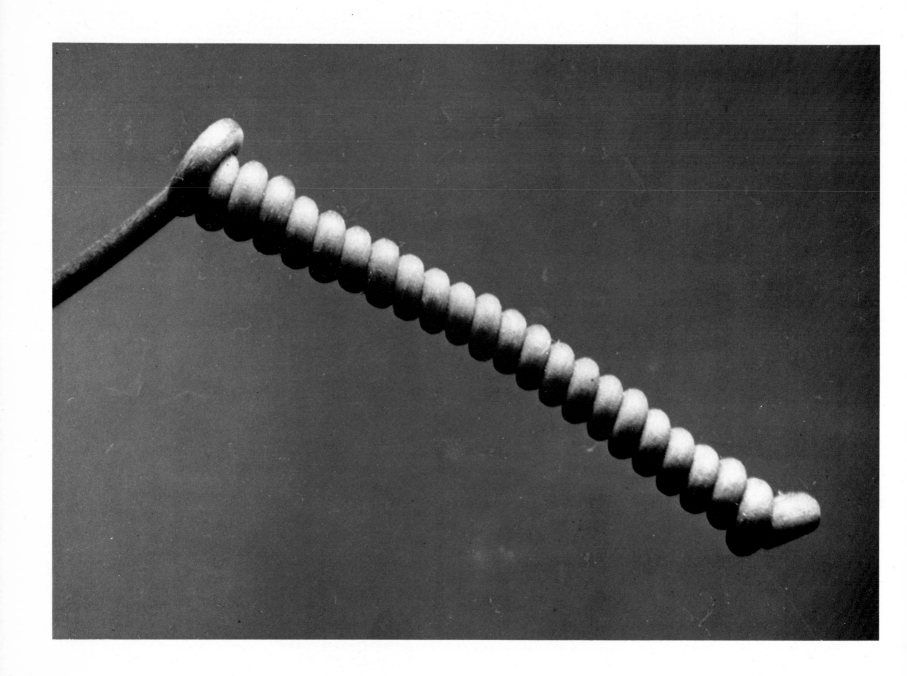

The helix is one of nature's basic designs. We find it in structures that range from Crick and Watson's famous "double helix" — DNA molecule — to the tentacles of plants and the shells of mollusks, from the way the seeds are arranged in sunflowers, to vortices in water and air, or the swirling star clouds of spiral galaxies.

Shown on these pages are a tentacle from a passion flower, the tightly coiled form of which evokes the latent power of a steel spring, and the twisted double-strand of egg cases of a whelk, a large marine snail.

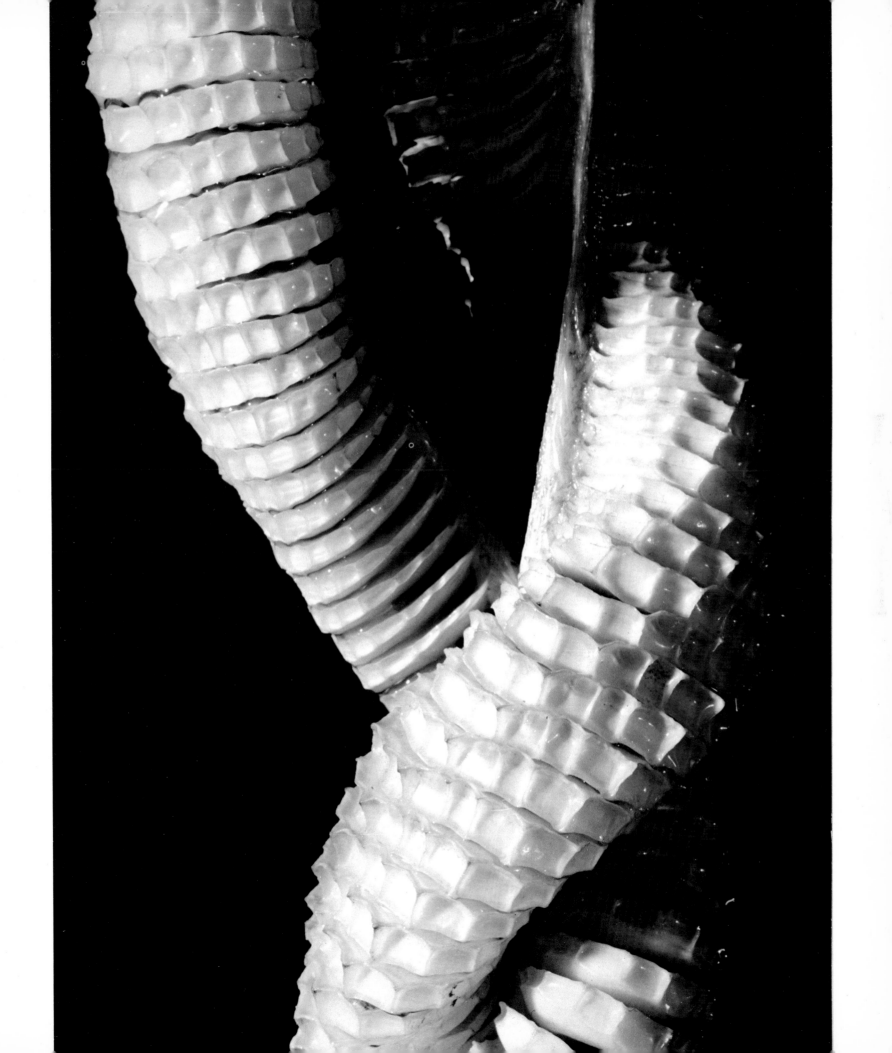

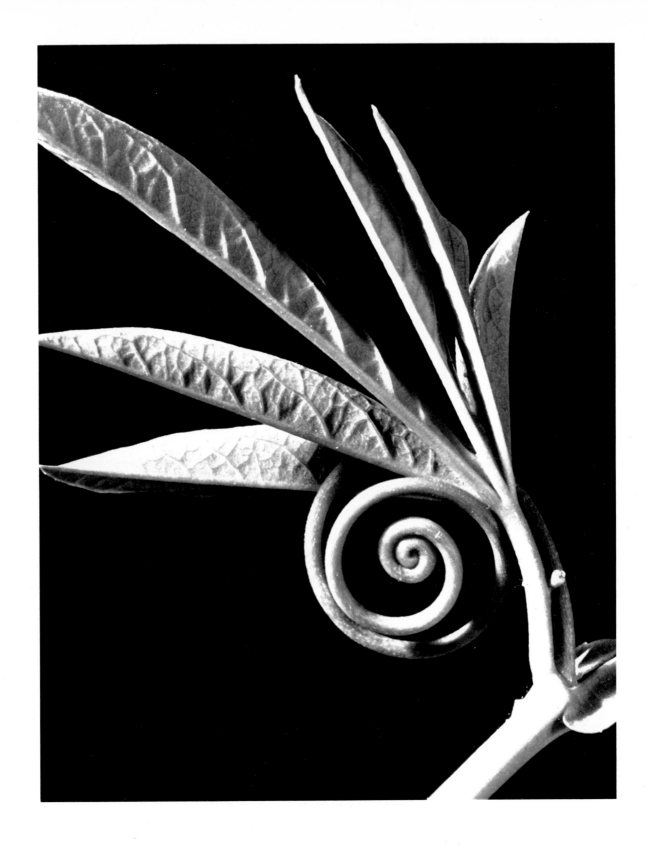

Left: Tentacles of a wild Connecticut grapevine form an abstract design. *Above:* The coiled tentacle of a passion flower ready to reach out and anchor the vine securely to the nearest solid hold. Its spiral form is identical with that of the coiled proboscis of butterflies and moths—another "coincidence" in nature.

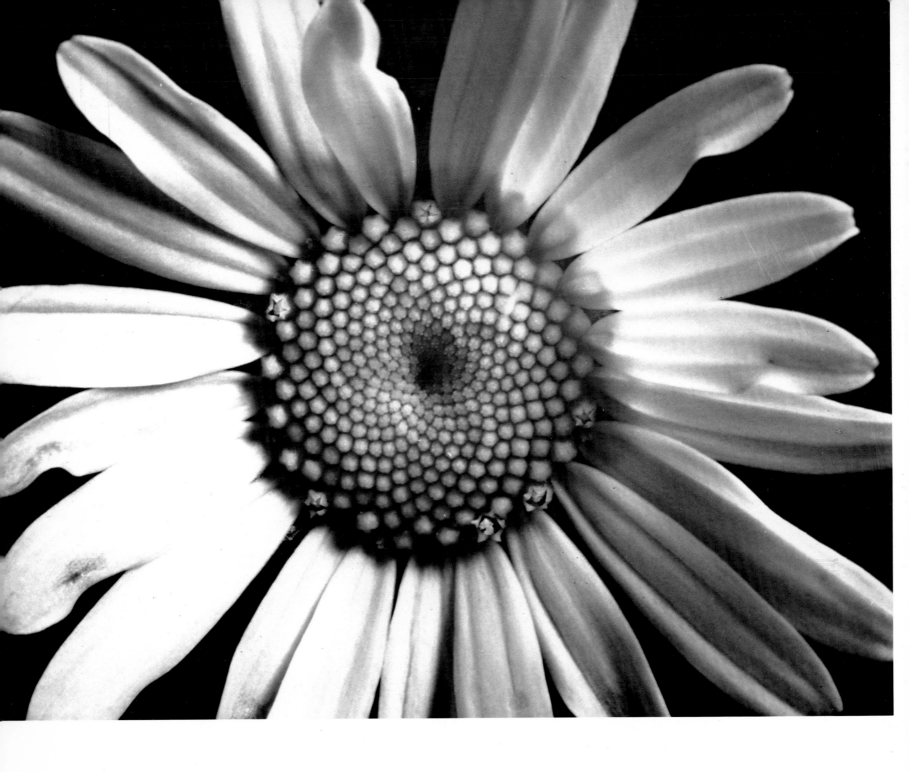

The florets in the core of daisy blossoms *(above)* and the seeds of sunflowers *(right)* are arranged in the form of two sets of spirals curving clockwise and counterclockwise, respectively, like opposite-directed pinwheels. Mathematically precise, each set always contains a specific number of spirals that is typical for the respective species. The same design of opposing spirals occurs also in pine cones where the scales form 5 and 8 spirals, respectively; in pineapples where the bumps are arranged in the form of 8 and 13 spirals, in sunflowers (55 and 89 spirals), and in the growth pattern of many leaves.

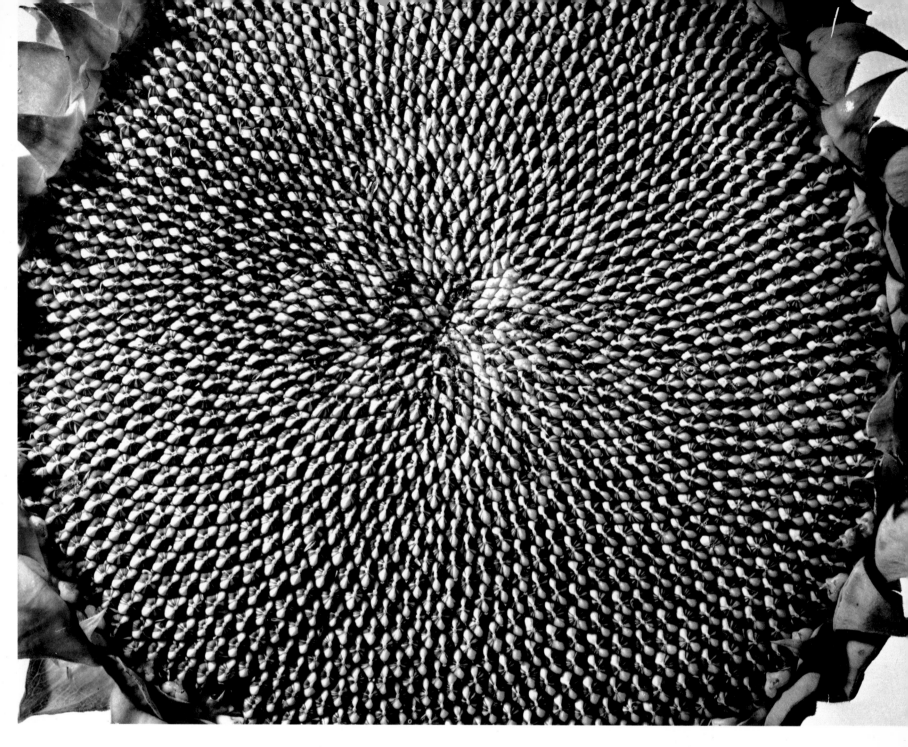

What makes this helical design particularly thought provoking is the fact that the number of spirals in each set invariably coincides with two adjacent numbers from a mathematical sequence known as the Fibonacci series. This series is produced by starting with 1, then adding the last two numbers to arrive at the next: 1, 1, 2, 3, 5, 8, 13, 21, 34, 55, 89, and so on. Now, the number of spirals is 5 and 8 in pine cones, 8 and 13 in pineapples, 21 and 34 in most daisies, and 55 and 89 in most sunflowers (count them!)—the same ratios as those of two adjacent Fibonacci numbers. Another "coincidence" perhaps?

Sunflower with 55 counterclockwise and 89 clockwise spirals

The shell of a gastropod (sundial shell) and the sectioned shell of a cephalopod (chambered nautilus) provide further examples of spiral designs in nature. Again, the curves are mathematically precise, this time representing equiangular or logarithmic spirals: if radii were drawn from the center of the shell, they would intersect the spiral at always identical angles. The question is: should we consider the fact that "lowly blobs of slime" construct their shells in accordance with sophisticated matematical formulas as still another "coincidence"—or does it point to the existence of certain universal principles in nature?

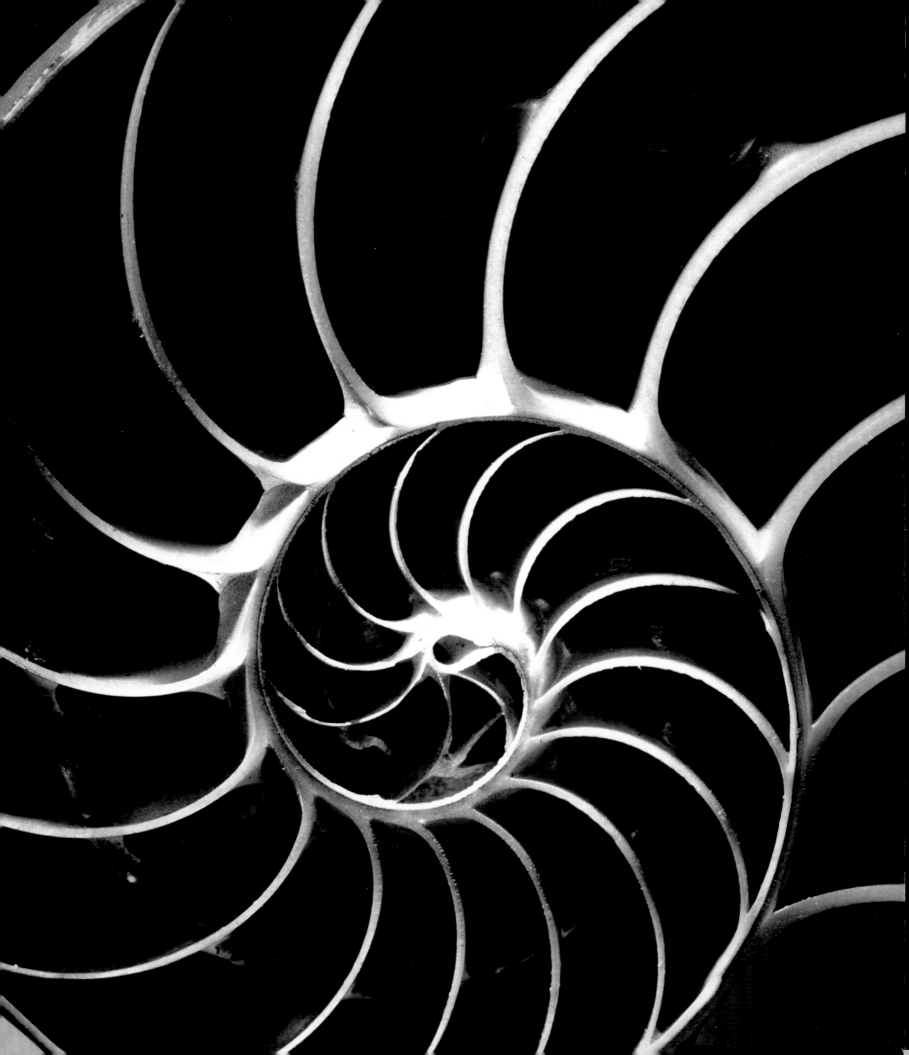

III Color

To the untrained eye, nature's colors frequently appear monotonous, vulgar, or dull: the endless green of fields and woods, the tans and grays of arid lands, the picture-postcard blue of the sky, with visual relief and excitement provided only occasionally by a colorful sunset. But those who know where to look can find a veritable riot of color: flowers, feathers, insects, minerals, autumn leaves. . . . These objects can be artistically attractive in two respects: color and design.

The following seven pages show photomicrographs of small sections of butterfly wings. In my opinion, the impact of these colors and designs is so overwhelming that nothing I can say could add to it. Except perhaps this: Give them the same attention you would devote to important works of art. Consider them as abstractions in their own right. Compare and relate them to man-made works—printed fabrics, tapestries, abstract painting, the feather mantles of the Incas, African tribal art. Ask yourself the maddening question: Why? Then go back and take another look and remind yourself that these stunning, sophisticated designs are the work of butterflies, the larval

stage of which is the caterpillar, the lowly worm most people squash on sight.

The six subsequently shown photomicrographs are the work of Jack Kath, Master of Photography, of Westfield, New Jersey. They represent thin sections of mineral specimens photographed in transmitted, polarized light. The hereby produced colors, independent of the body colors of the respective minerals, are the result of the polarization process and change with every turn of the polarizer, a fact which, of course, does not make them any less real or enjoyable. To a still higher degree than the butterfly wing patterns, these photographs invite comparison with abstract painting—with the balance tipped in favor of the minerals.

On the last spread of this section I show in juxtaposition the close-up of a dandelion and a sculpture by Harry Bertoia. Whether or not the resemblance between the two is intentional is immaterial. What intrigues me is that the spirit of the sculpture is identical with that of the flower—man and plant, each in its own very different way, obeying the same superior law.

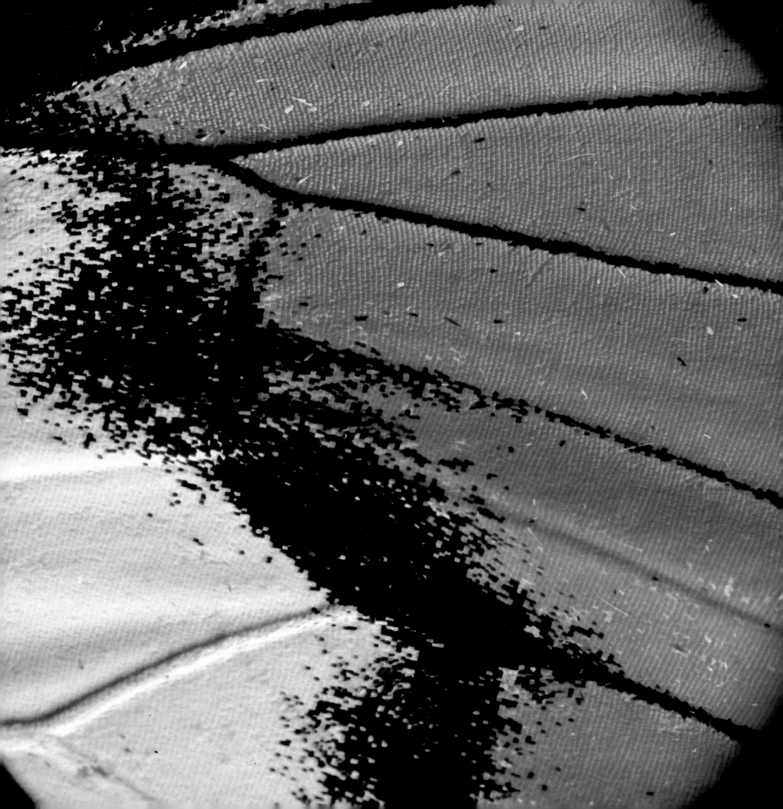

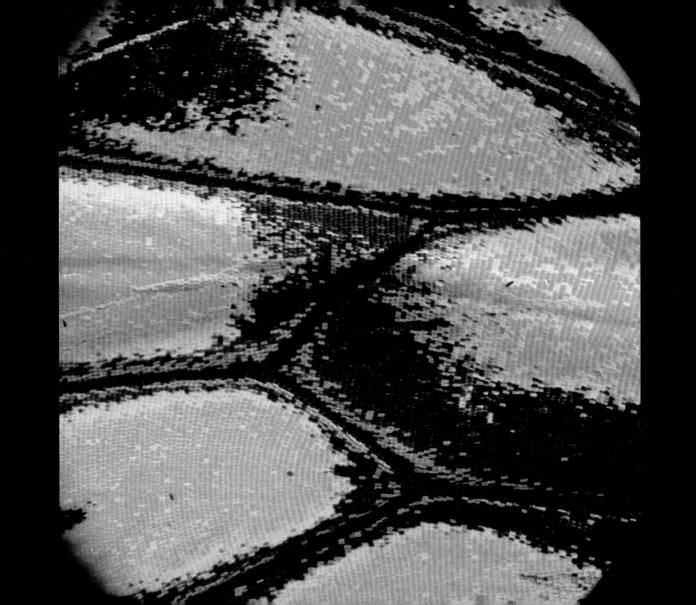

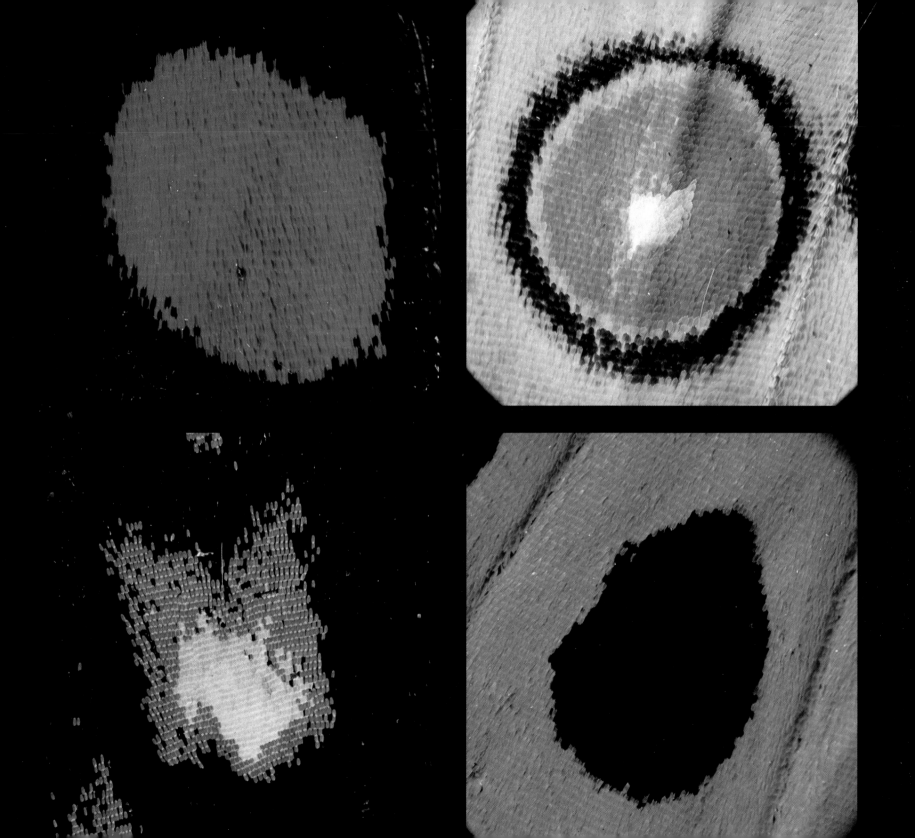

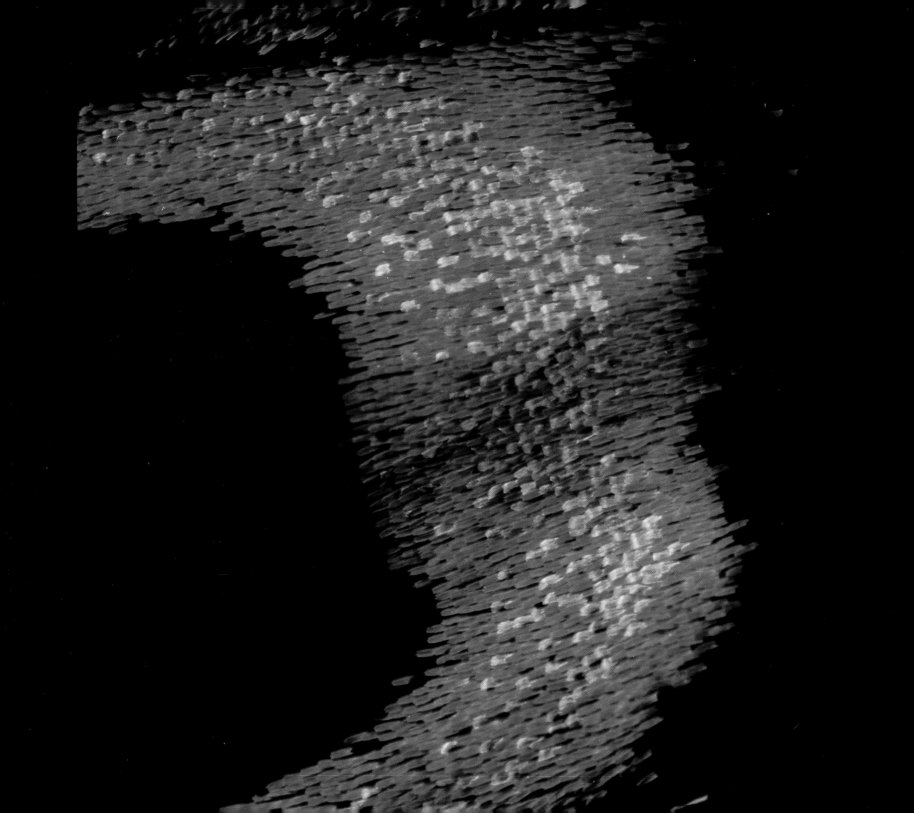

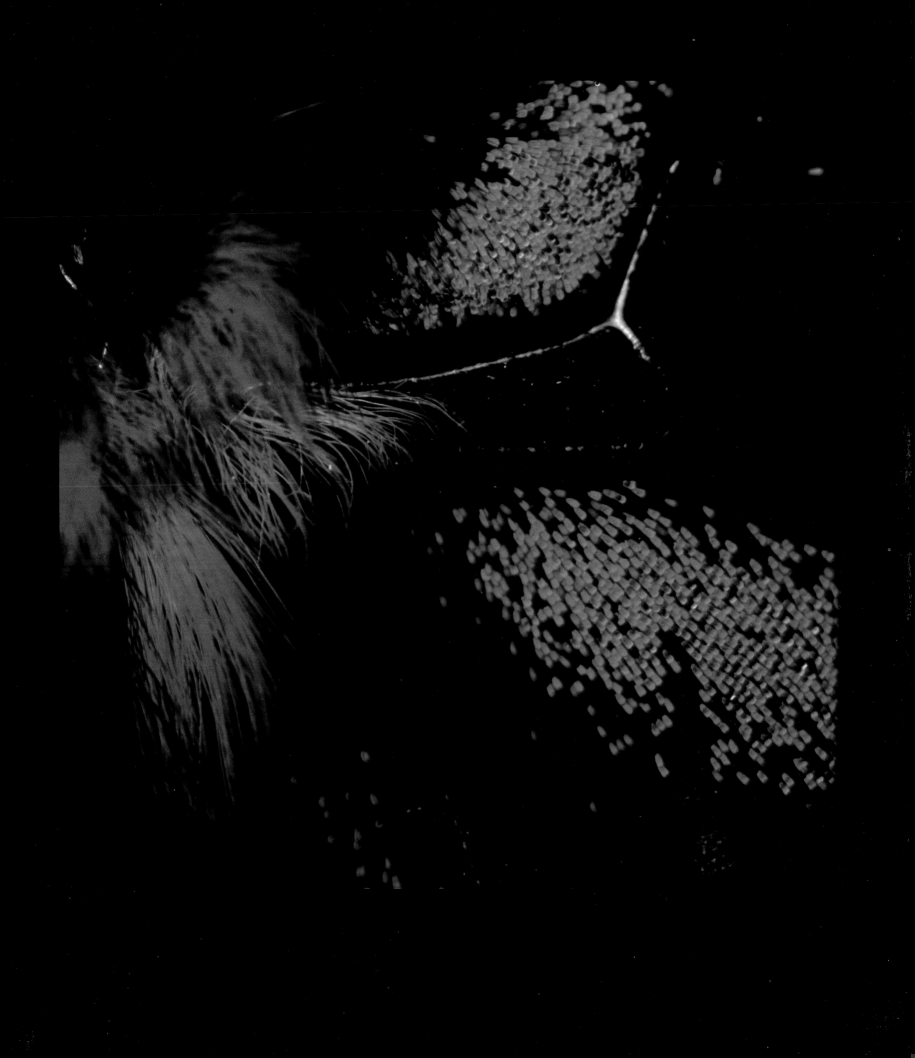

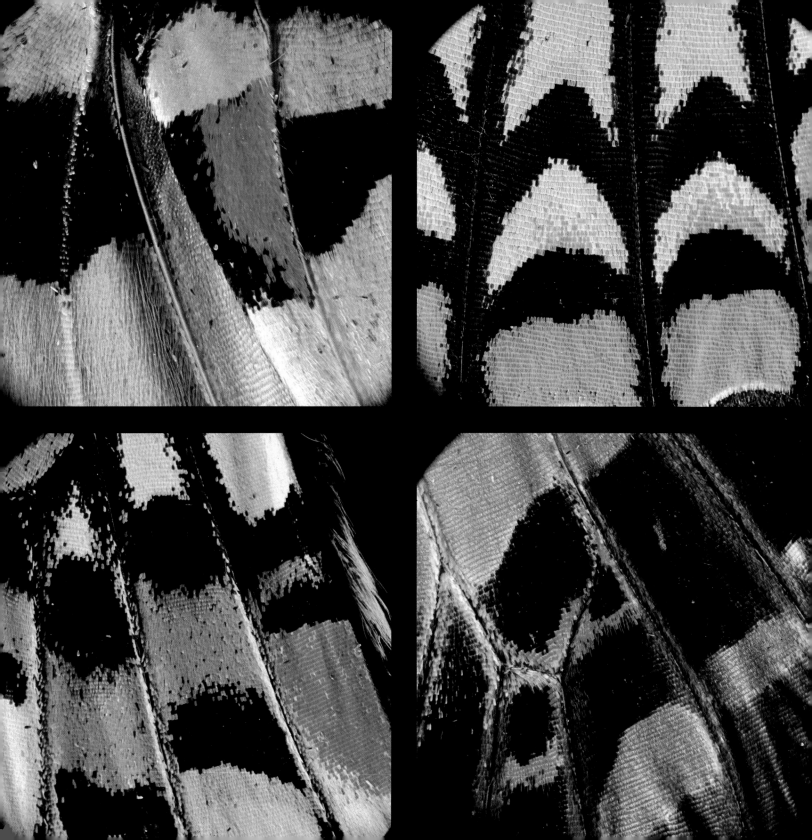

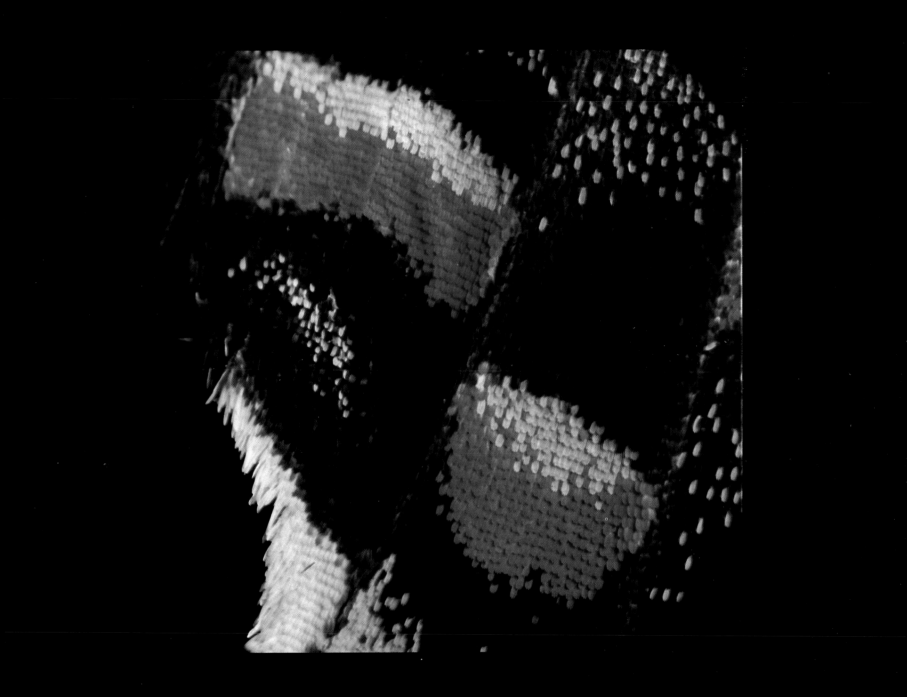

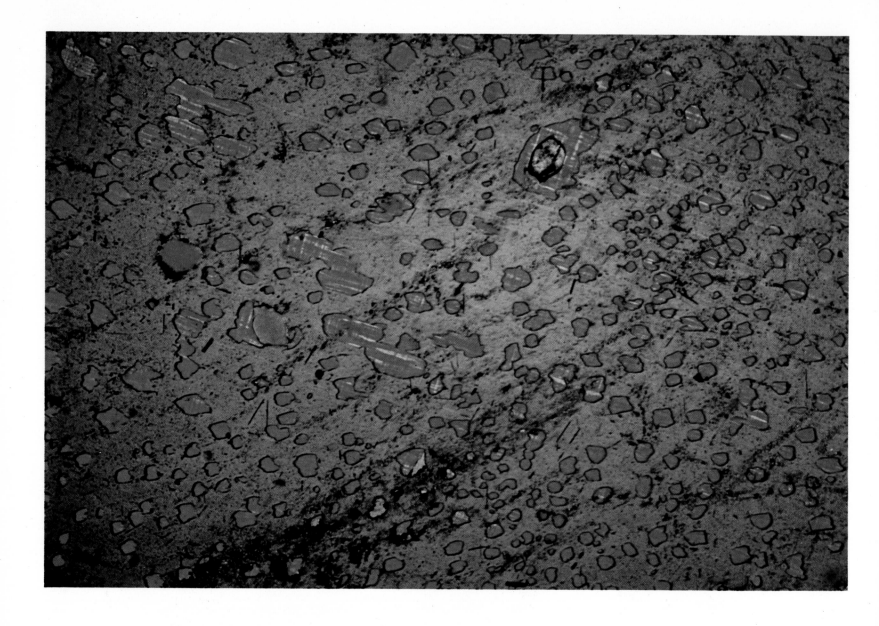

The photomicrographs shown on this and the following two spreads are the work of Jack Kath. I never tire of studying these fascinating designs in which I see landscapes, a patchwork quilt of unearthly beauty, a roaring waterfall, a face, an archipelago in aerial view, plus innumerable other things. Actually, *what* I see is unimportant; what matters is the fact *that* I see images at all, that I derive stimulation from these patterns of nature in which I can become absorbed to a degree that amounts almost to a high — a state of superawareness, a creative trance that frees the mind until the spirit melds with the Universe.

For the fact-minded reader, I add the names of the respective minerals: the photograph above shows antiperthite from the Garzón Massif in Colombia, the one on the opposite page two pyroxene amphibolites from the same location.

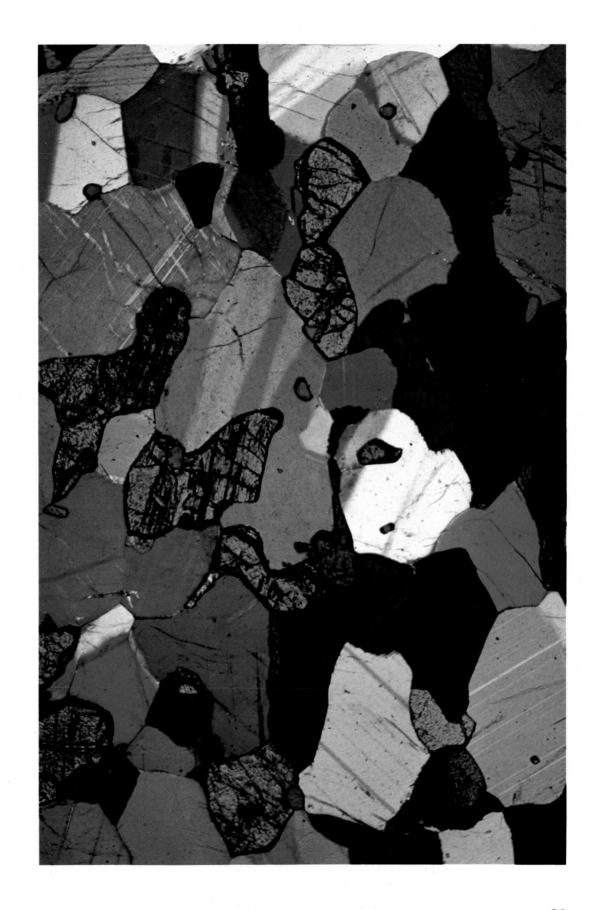

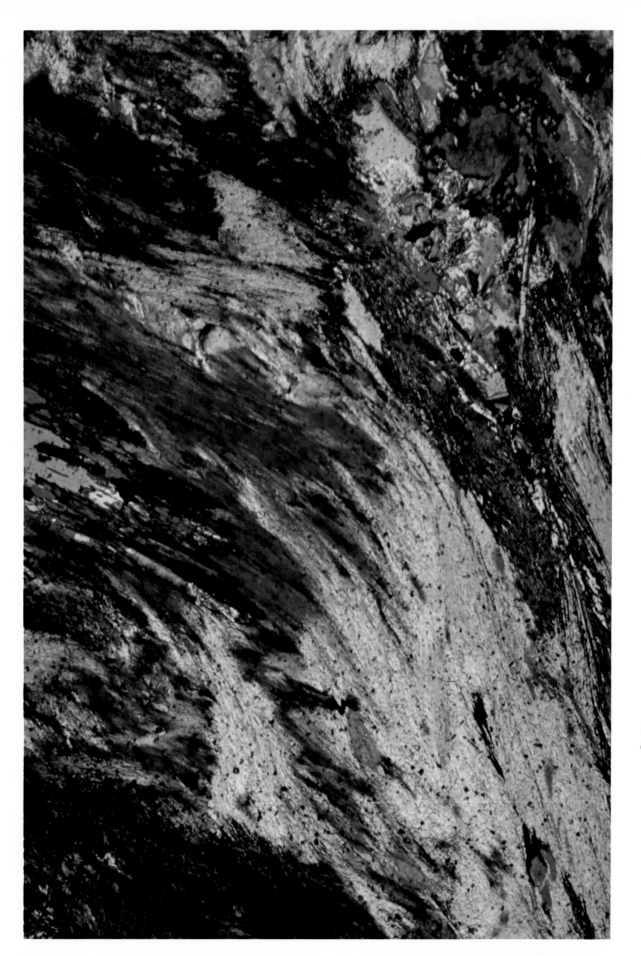

Fibrolite gneiss, Central Cordillera, Colombia.

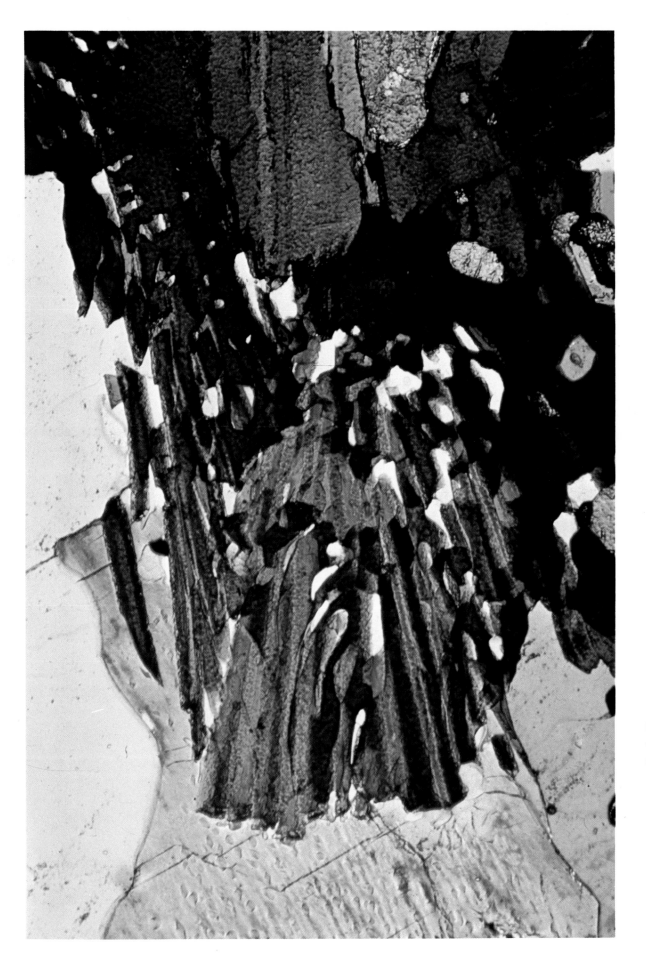

Poikilitic biotite in perthite-quartz matrix, Garzón Massif, Colombia.

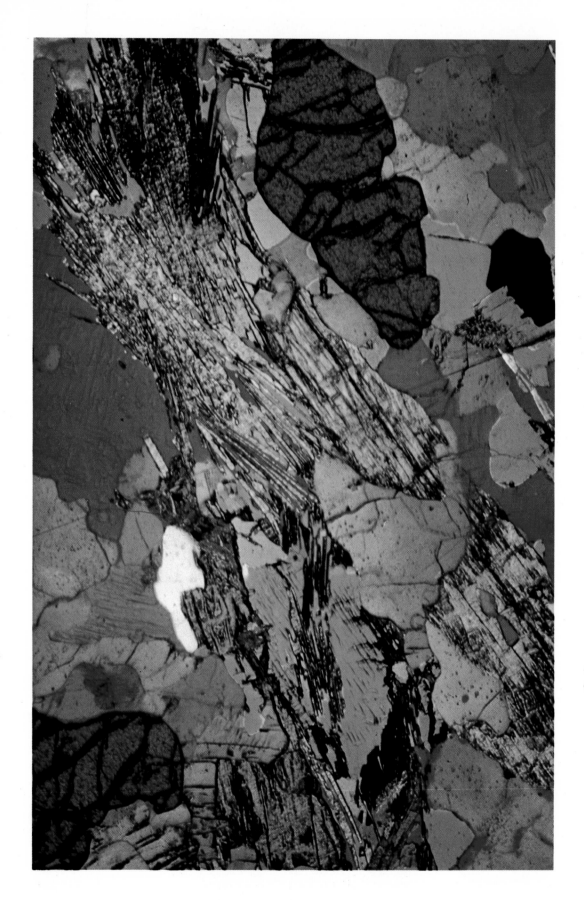

Garnetiferous granulite,
Garzón Massif, Colombia.

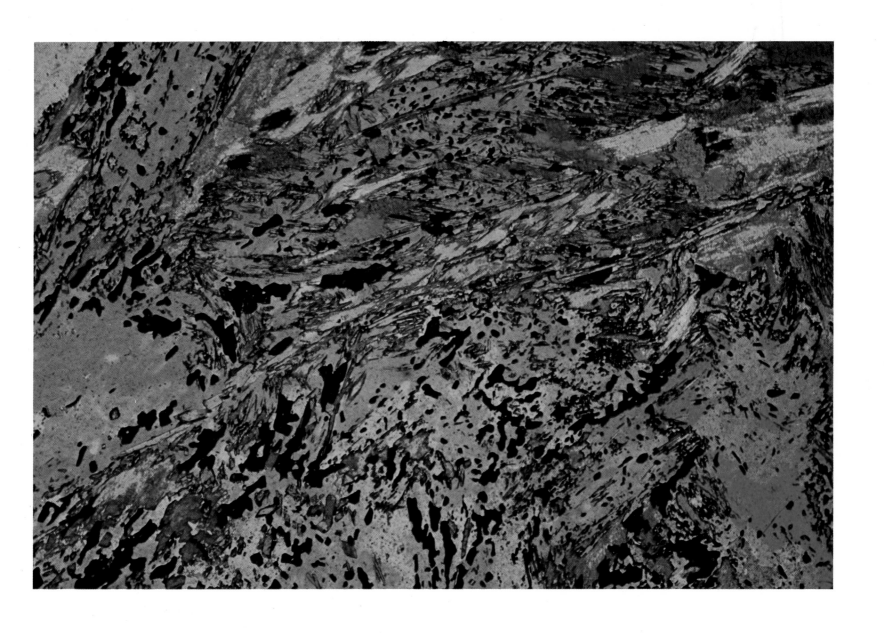

Fibrolite-cordierite-spinel
gneiss, Central Cordillera,
Colombia.

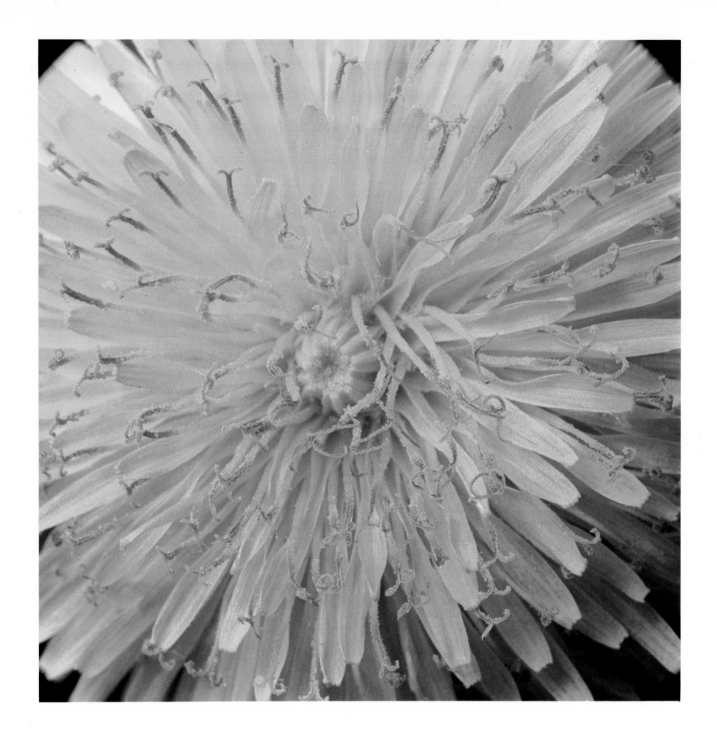

Of all the colors of the spectrum, my favorite is yellow — the color of the sun, suggesting light and warmth and life; the color of the first flowers in spring — forsythia, dandelions, daffodils; the color of gold, symbolizing freedom from want. And if yellow occurs in the form of a sunburst, as in the dandelion, the result is a veritable symbol of joy. I see the same joy reflected in Harry Bertoia's wire sculpture shown on the opposite page, a sunburst of gold, shafts of light tipped with pearls. And I ask myself: does the similarity between these two structures exist only in my mind?

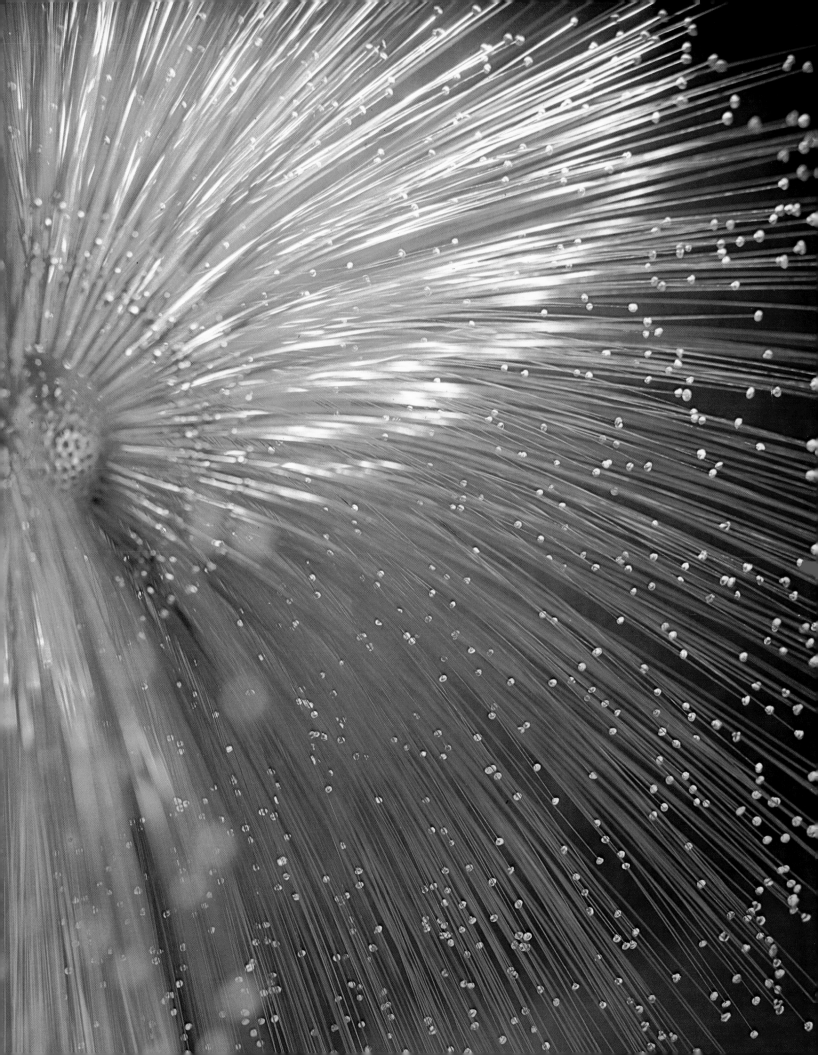

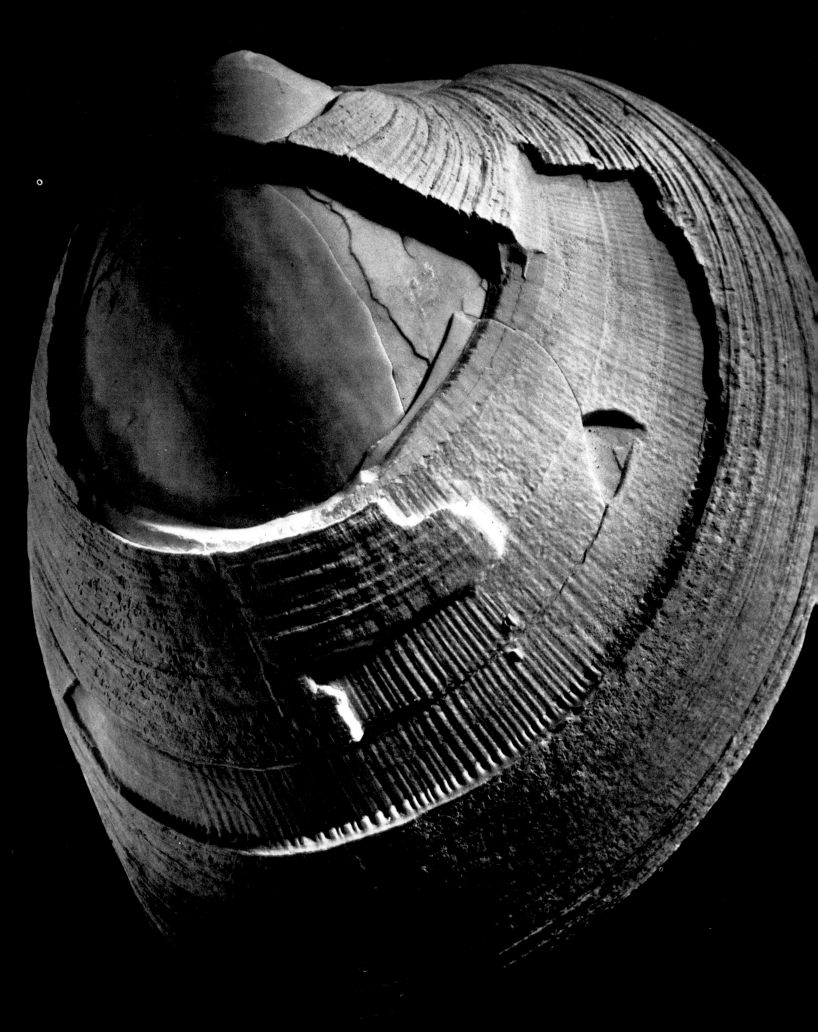

IV Structure

Nothing in nature is structureless. If something seems homogeneous or amorphous, it is only because its structure is too fine to be visible to the unaided eye. Even substances as "unstructured" as glass or water are internally organized, consisting of molecules, which consist of atoms, which in turn consist of subatomic particles. Whether or not there is a lower end to structure we do not know.

To me, a former architect and engineer, structure in all its forms has a special fascination. I see on one side organization, structure, function, and life; on the other, destruction, dissociation, chaos, and death. And out of destruction, I see new structures rising —plants and animals drawing nourishment from the remains of other animals and plants, mountains evolving out of the debris of older mountains leveled by wind and water—a never-ending cycle of construction and destruction, growth and change.

Nature builds its structures by accretion: atoms join to form molecules, molecules combine to form macromolecules, which in turn unite to form cell components and cells and tissues and organs and finally living things. Or atoms join to form molecules that clump together or are cemented together or fuse or crystallize to form the minerals that form the rocks that form the mountains and valleys and plains that form the landscapes that form the Earth.

For more than thirty years, within the limits of my modest means, I have studied the macrostructures of nature and found in them a never-ending source of joy and inspiration. Look, for example, at the broken clam shell on the opposite page. I picked it up one winter day on a beach near New York when the longing for open space became overwhelming and I drove out to feel once more the freedom of the sea.

Superficially seen, few things are lower than a broken clam shell, less valuable, less beautiful. Yet to me, this little derelict is a marvel, precisely because it is broken—broken in a way that reveals its internal structure: smooth, crystallized layers, followed by ribbed layers, followed by longitudinal layers, combine to form a structure that, for its purpose, is flawlessly designed and executed. How many man-made structures exist about which this can be said?

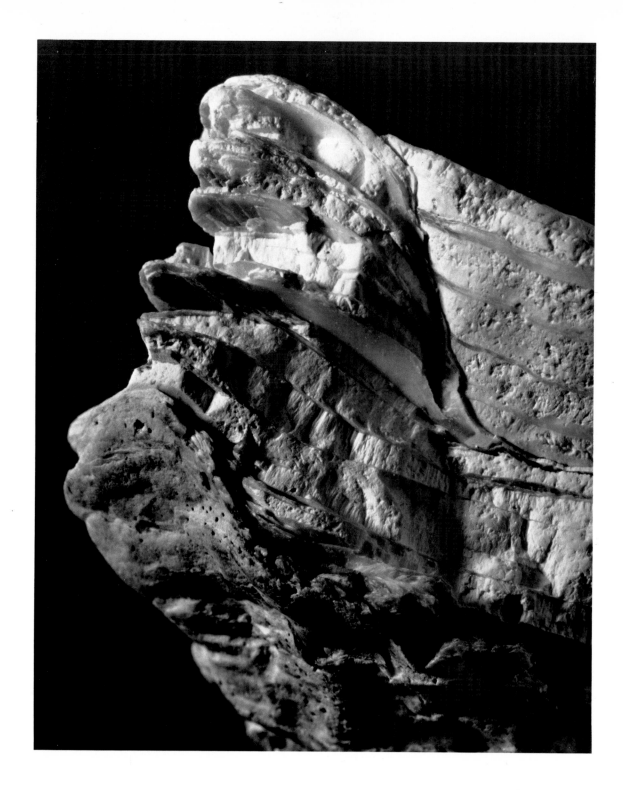

One of the universal principles in nature is growth through accretion structured in the form of layers. It applies equally to plants and animals and mountains. Man used the same principle to raise the Pyramids, the Parthenon, Gothic cathedrals, and the brick tenements of his slums. How nature uses layers to construct an oyster shell is shown by the fragment above, which comes from Westport, Connecticut. On the opposite page a hunk of wood reveals the same layered structure derived from annual growth rings.

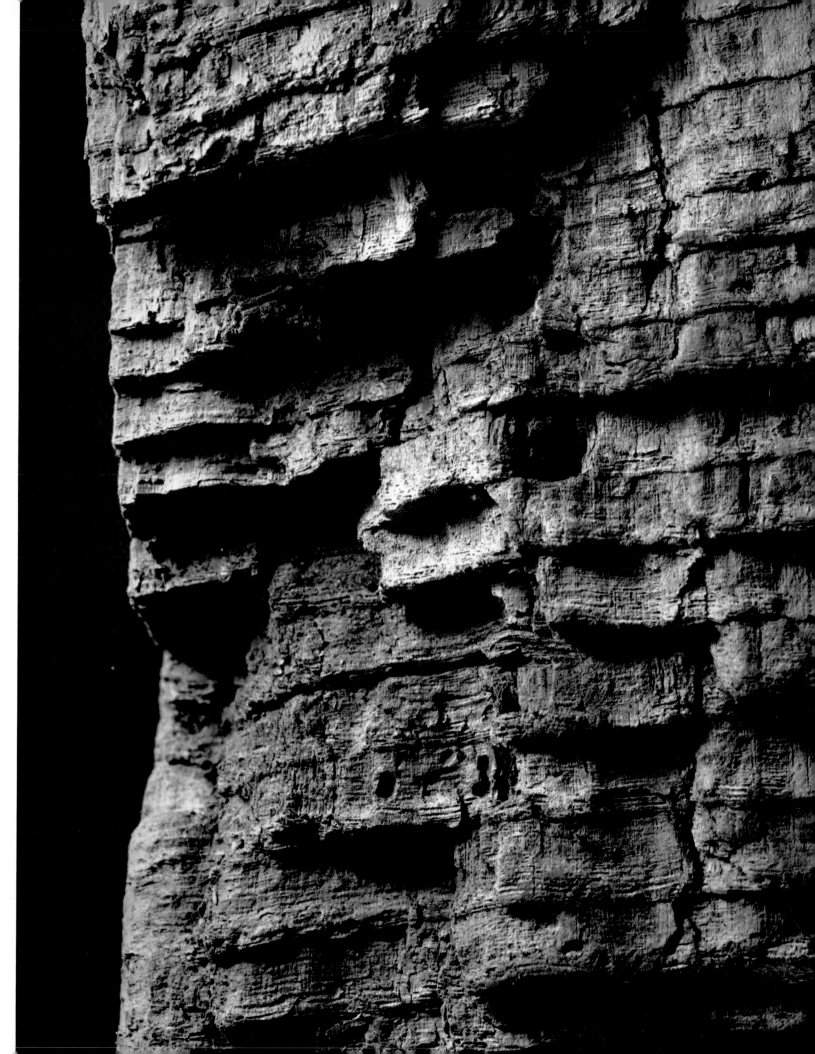

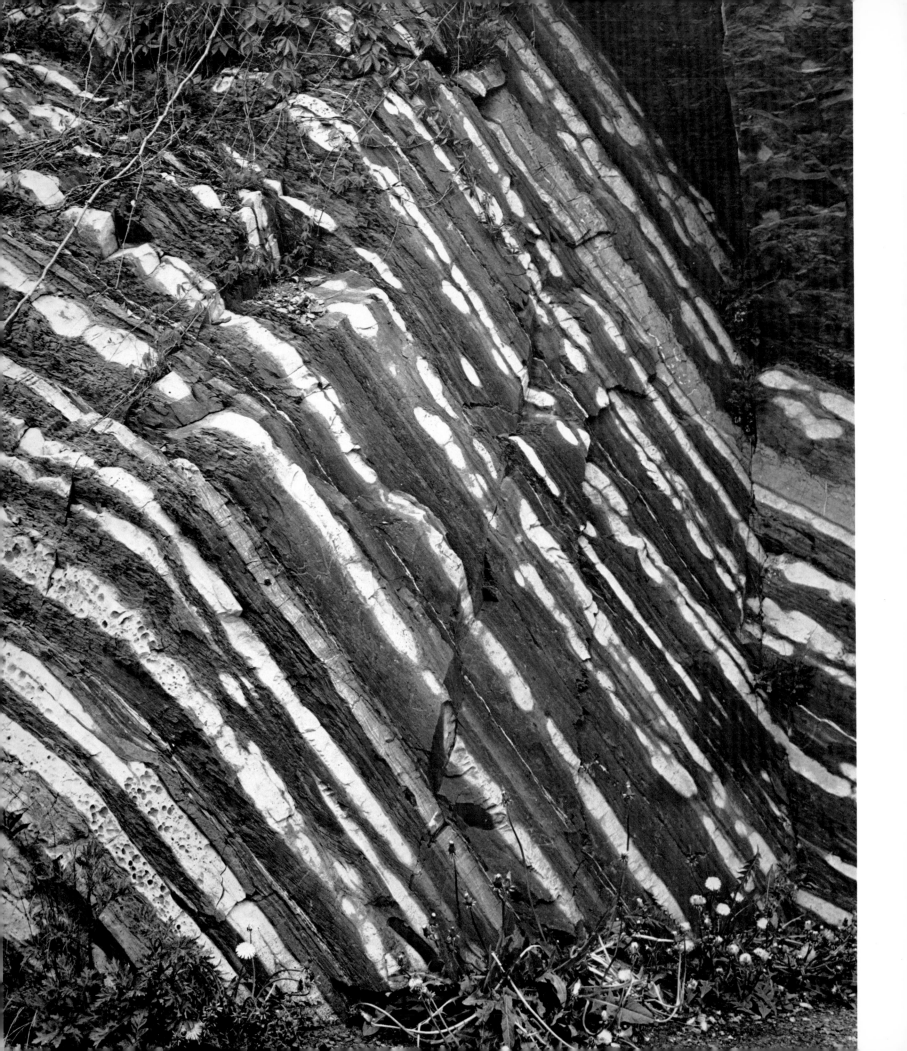

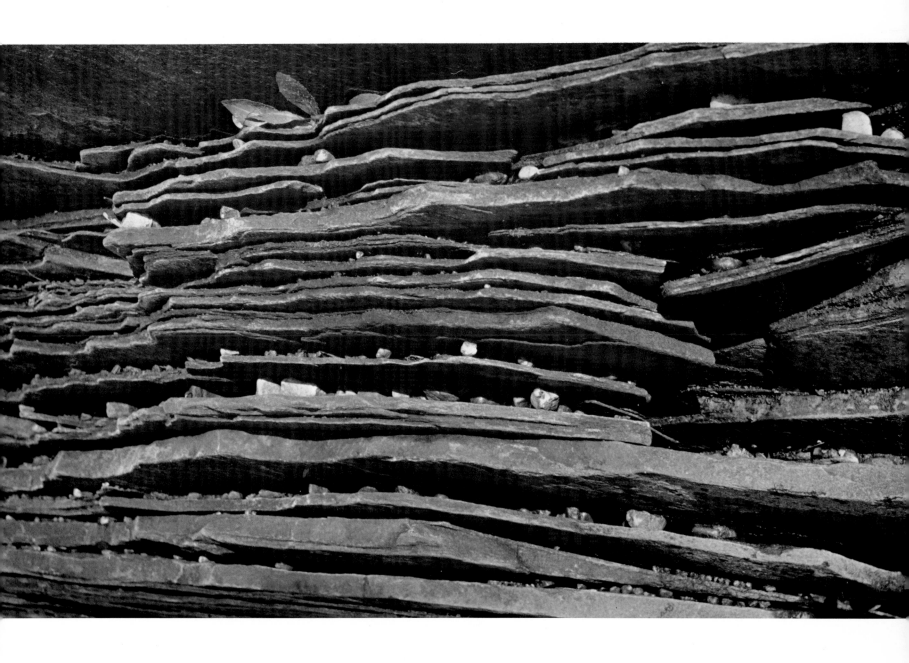

Left: Bedded limestone near Oslo, Norway. *Above:* Shale from the Housatonic River valley near New Milford, Connecticut. Both photographs show in the form of close-ups the layered internal structure of certain mountains.

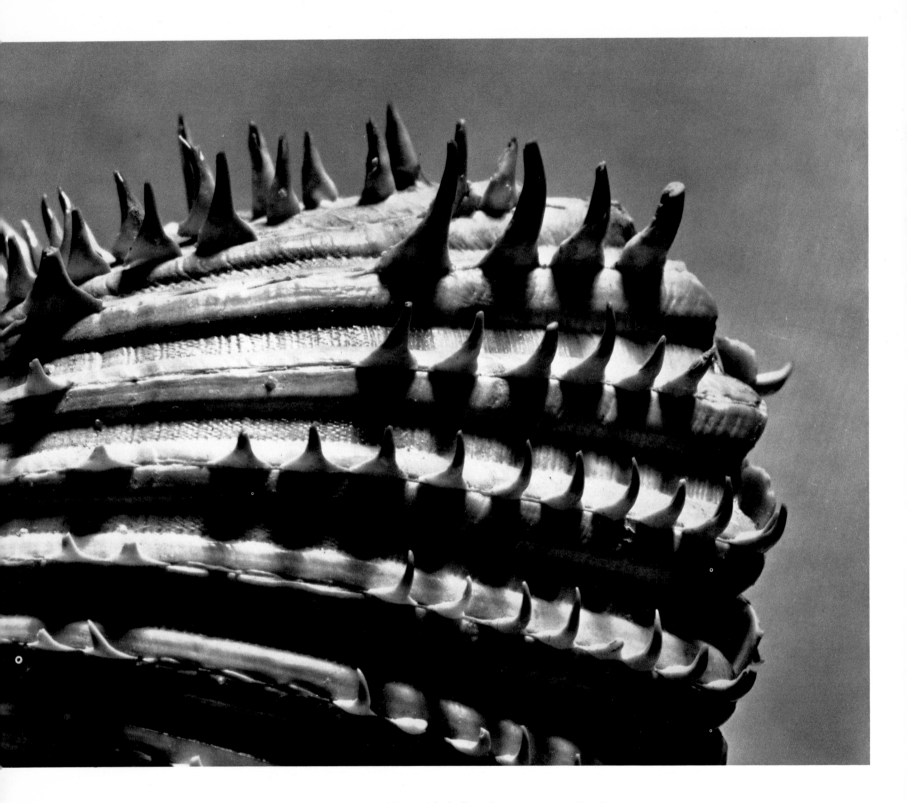

These pictures of a prickly cockleshell and some rose stalks demonstrate another universal principle of nature: defense by pointed structures. Man has put this concept to use in the form of barbed wire. Nature employs it in both animals and plants: cacti, raspberries, and roses . . . porcupines, hedgehogs, spiny anteaters, insects, lobsters, crabs, sea urchins, and shells. . . .

102

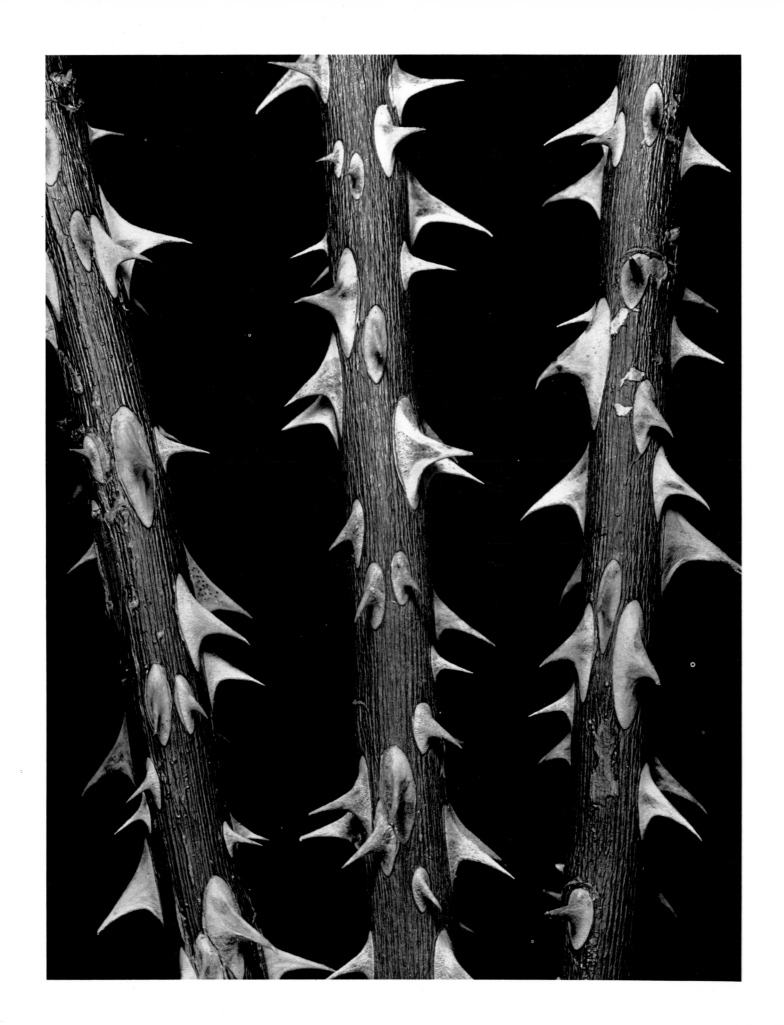

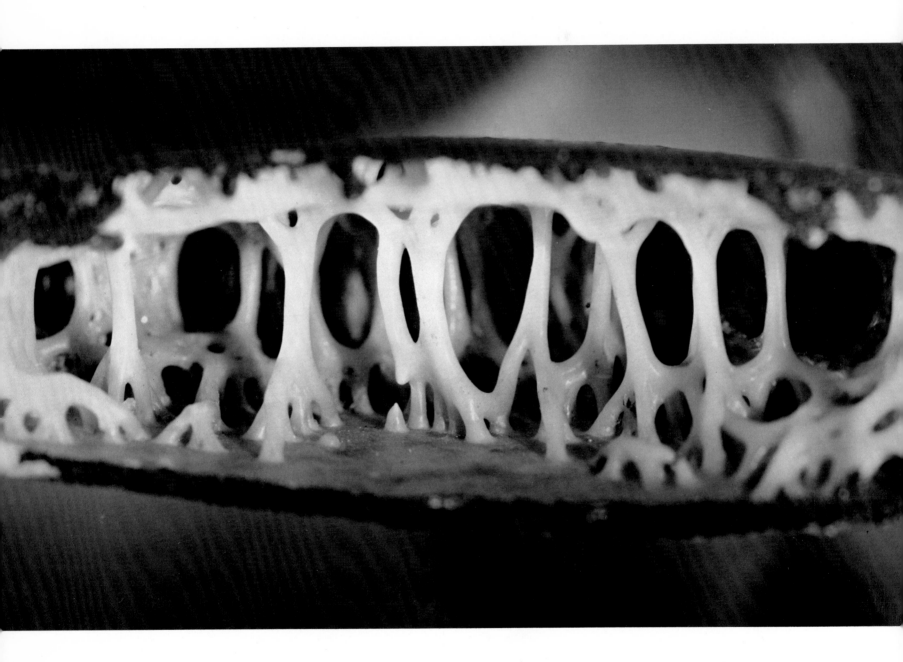

To achieve a maximum of strength with a minimum of weight and expenditure of material is another universal principle of nature, here attested to by two sectioned structures: *above,* interior view of the shell of a horseshoe crab, a crustacean; *right,* the inside of the femur of an eagle, a bird. Although these two beings are totally un-related, the concept by which strength and lightness are achieved—a thin shell reinforced by struts and braces—is the same.

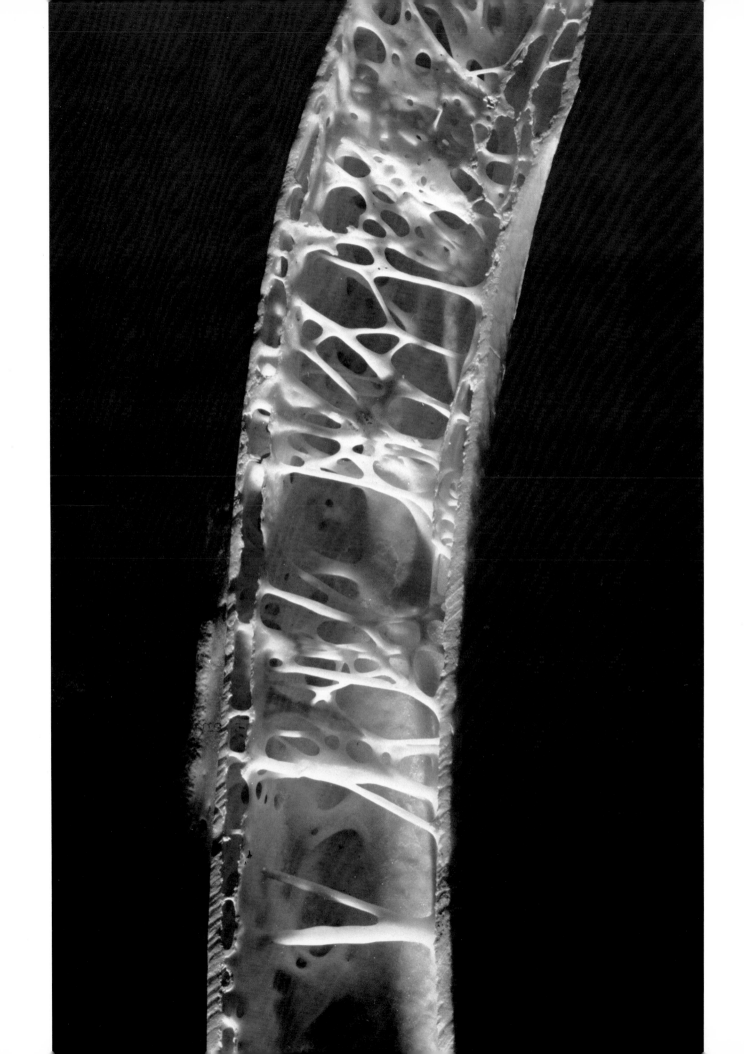

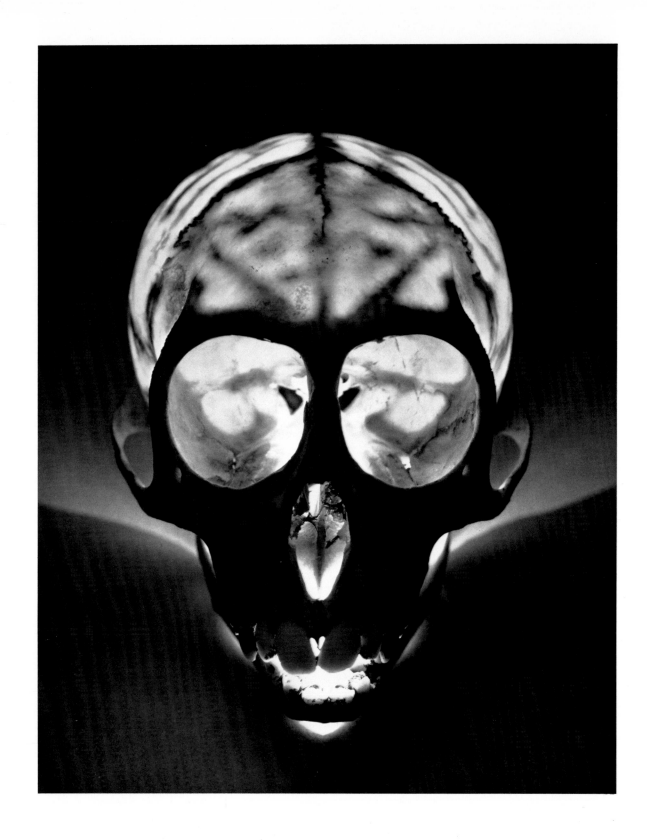

The skull of a monkey. Translumination, like X-ray photography, reveals how arched ridges reinforce the bony shell in strategic places, while bracing "beams"—zones where new bone is deposited as the shell expands in growth—strengthen the skull along the basically weaker lines of juncture of its plates.

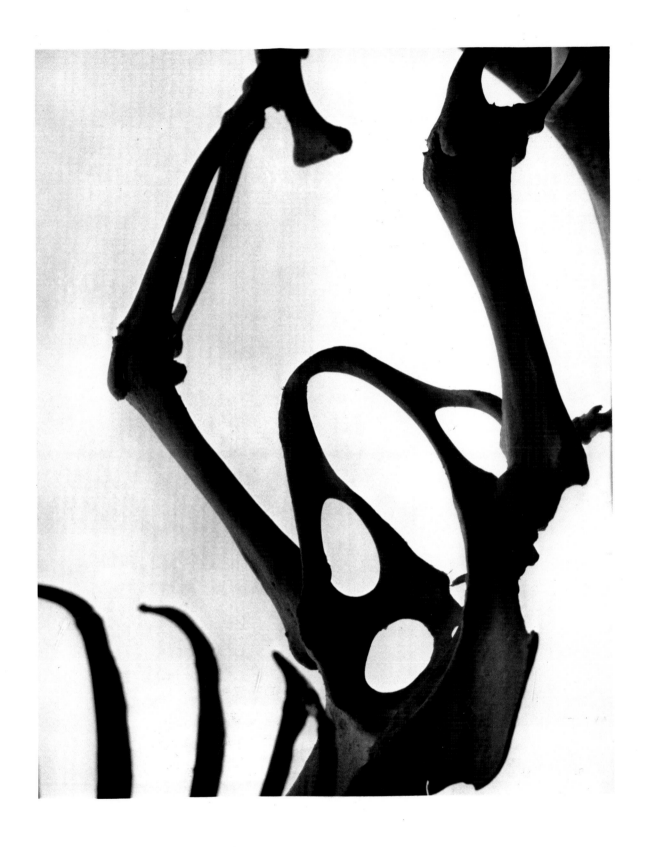

The pelvis of a three-toed sloth. Designed as if in accordance with the most modern engineering theories, it utilizes the principle of the ring, the strongest yet lightest of all structural forms. Double arches provide strength through form; lightness is assured through elimination of unnecessary material — the holes in the lateral plates.

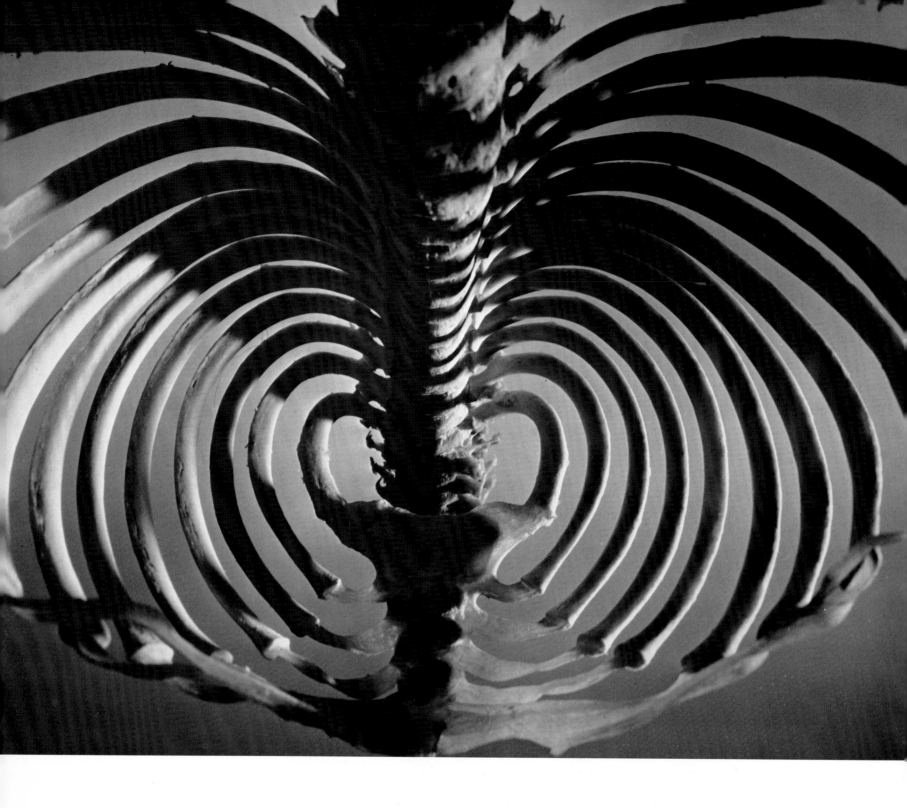

Above: The rib cage of a gorilla. *Right:* The pelvic complex of a bird. The study of skeletal structures is infinitely rewarding from both the engineer's and the artist's point of view because bones and their assemblies are not only functional to the highest degree but also beautiful. The rib cage encases heart and lungs—the body's most vital organs—in bony armor, articulated and yielding, yet tough and strong. The pelvic complex, a thin, shell-like structure reinforced by the fused bones of the spine and braced by struts like the keel of a ship for absolute rigidity, combines minimum weight with maximum strength and resistance to deformation.

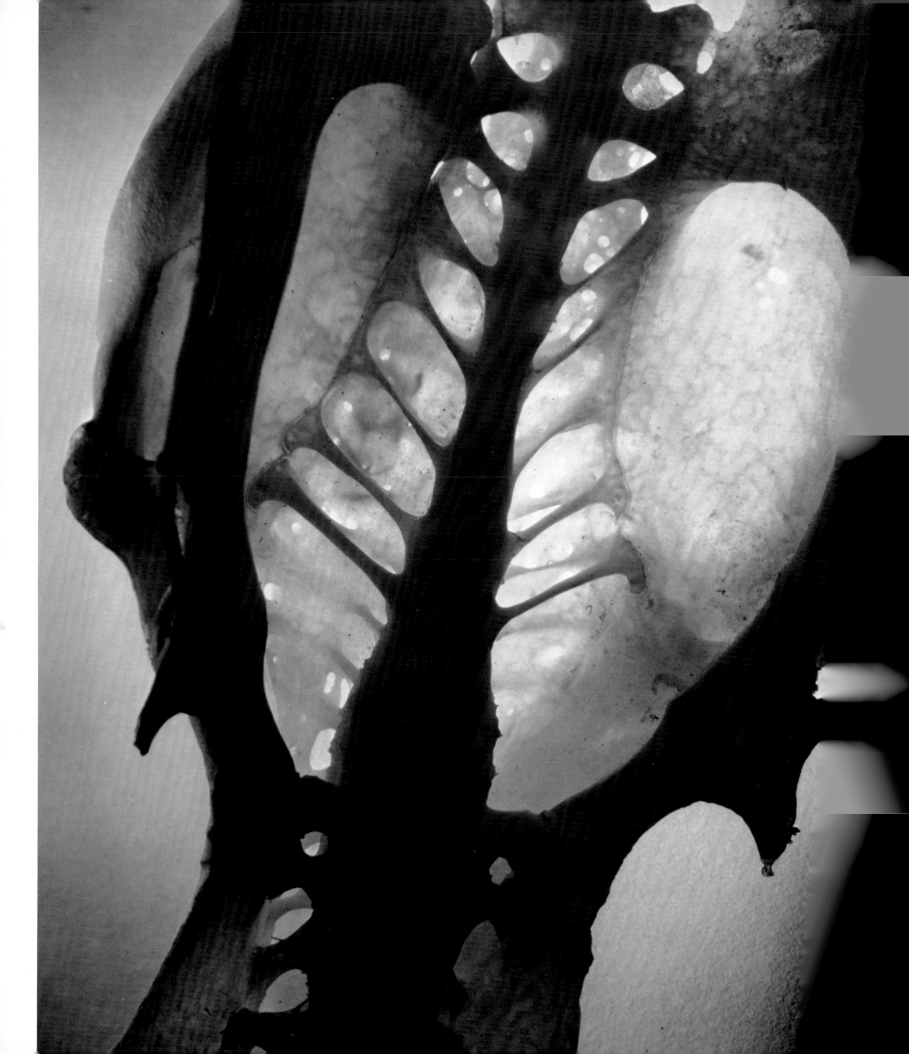

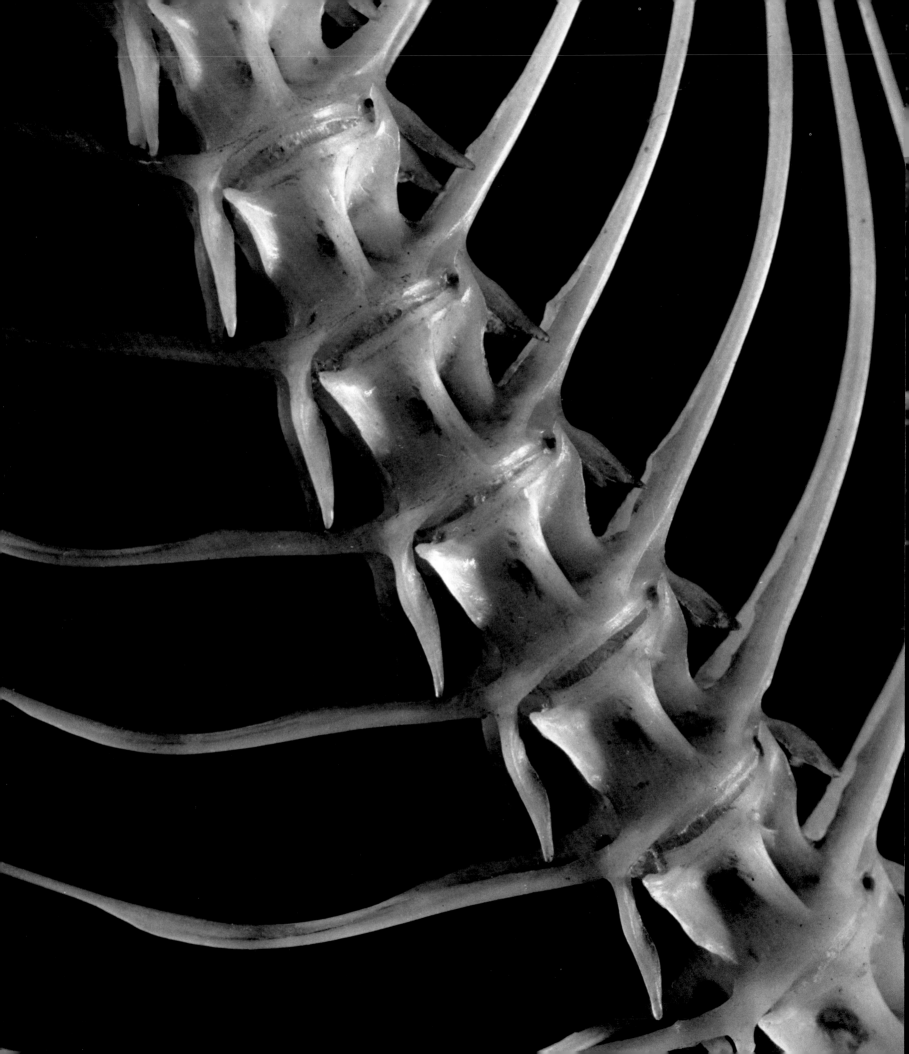

Left: A section of the spine of a fish. *Right:* Part of the spinal column of a skate. Both structures are marvels of functional engineering, combining strength with delicate articulation and inspirational beauty. The precision with which their components are formed and assembled rivals man's most advanced technological achievements. Their ability to maintain themselves throughout life borders on the miraculous.

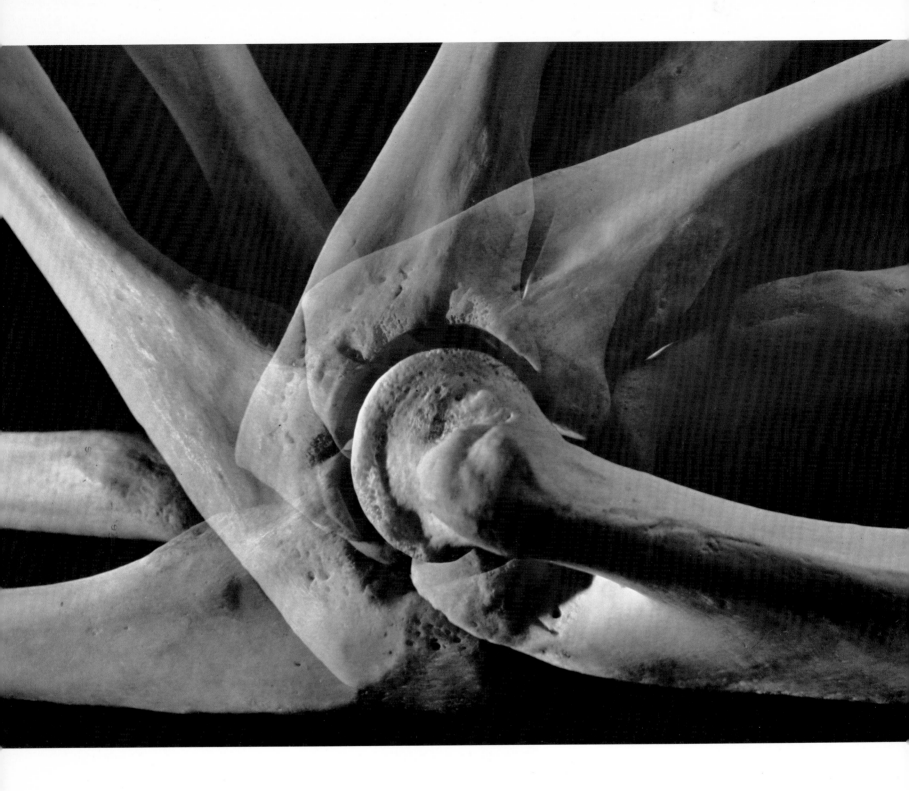

The hinge was not invented by man, nor was the ball-and-socket joint. Both were anticipated by nature, as proved by these photographs. *Above:* A human elbow joint shown in the form of a multiple exposure. *Right:* The ball-and-socket joint of the hip. In life, of course, a perfect fit is insured by means of cartilaginous inserts and a lubricating system designed to last throughout life, the entire structure backed up by the ability to service itself and, if necessary, perform minor repairs.

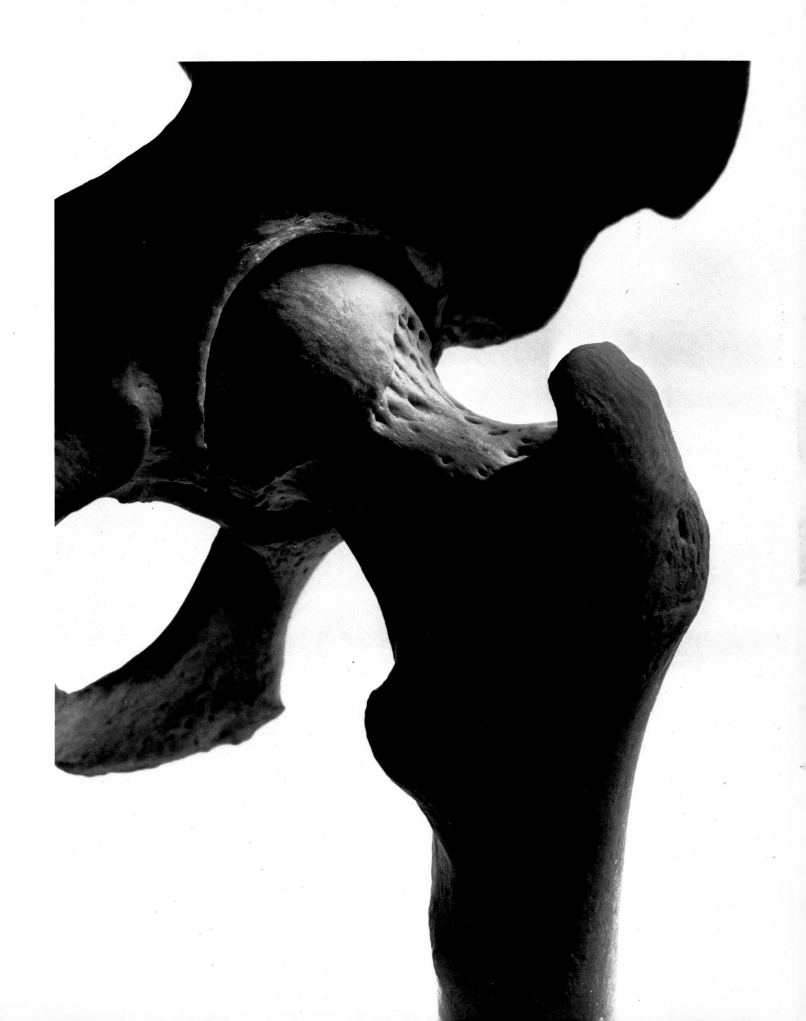

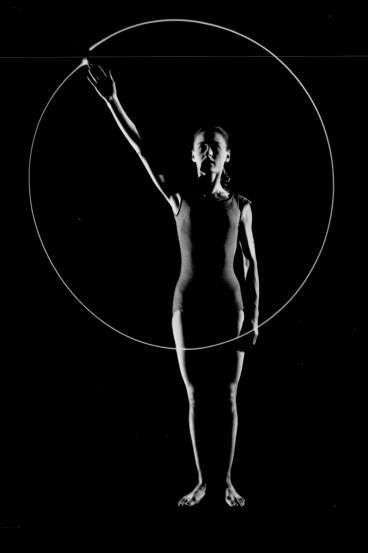

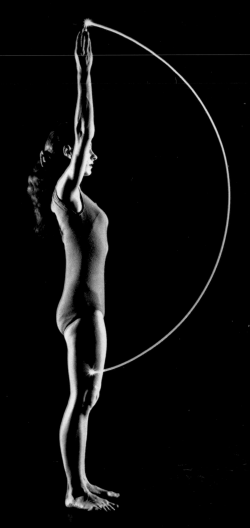

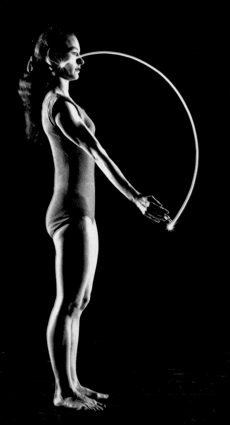

Design for motion. Skeletal articulation is based upon the principle of rotary motion. Most bones are joined in such a way that motion is essentially circular, the bone rotating about a stationary socket or hingelike joint. More complicated movements of limbs—hands, fingers, feet, and wings—are produced through a combination of several rotary motions by several joints.

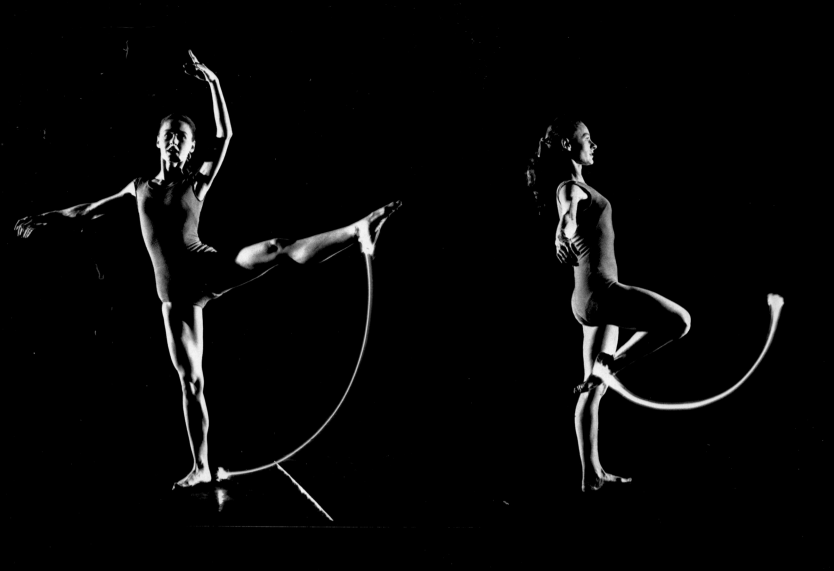

The photographs on this spread illustrate the principal motions of the human body with the aid of small, battery-fed flashlight lamps attached to the hand, foot, and shoulder of a dancer. The center of each motion is a major joint — the shoulder, the elbow, the knee, the hip. The movements were time-exposed in the dark, with the figure flashed at the end of the motion.

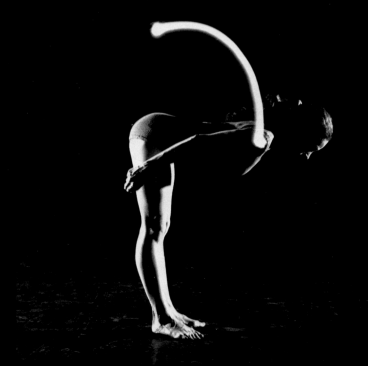

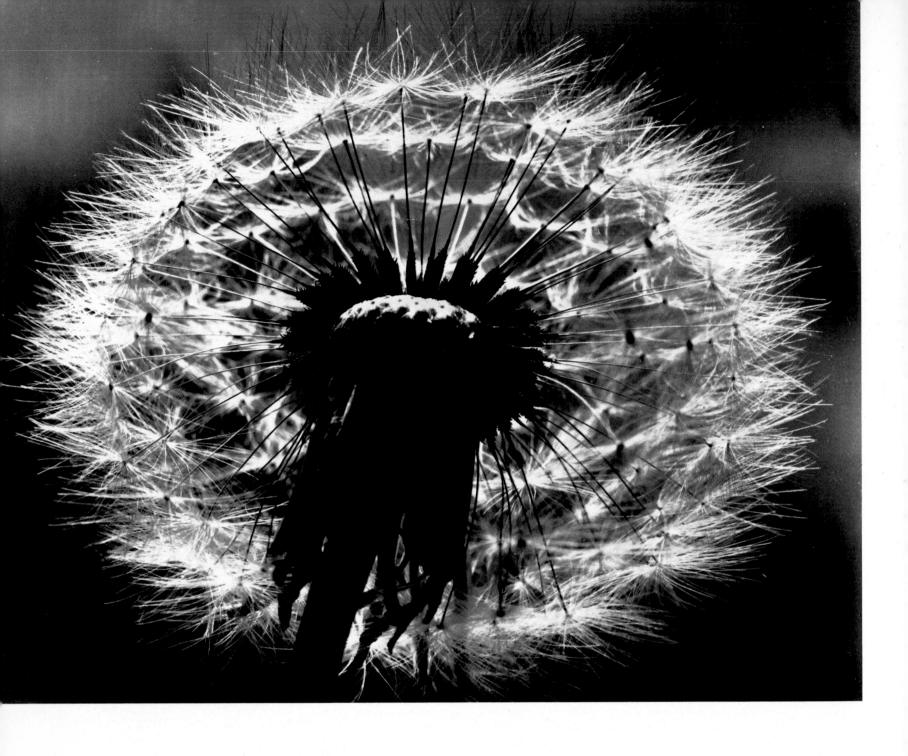

Design for plant mobility through seed dispersal. *Above*, dandelion seeds. *Right*, sycamore seeds. Seeds are among nature's most diversified, ingenious, and thought-provoking creations. Some hook to the coats of animals and fall away as the animals rove. Others are dispersed by birds who feed upon their fruit but eliminate the indigestible seeds. Still others fall to closer ground, shot to distances of several yards when the drying seed pods split with a snap. Some travel with ocean currents and tides, remaining buoyant for months, retaining power to germinate and grow on distant island soils. But the greatest number travel with the wind, gliding on gossamer parachutes, like the dandelion seeds; spinning in spiral flight and descent, on miniature propeller forms, like the maple seeds; or whirling in a rolling race with prairie winds to shake from the parent husk, like the seeds of the tumbleweed.

116

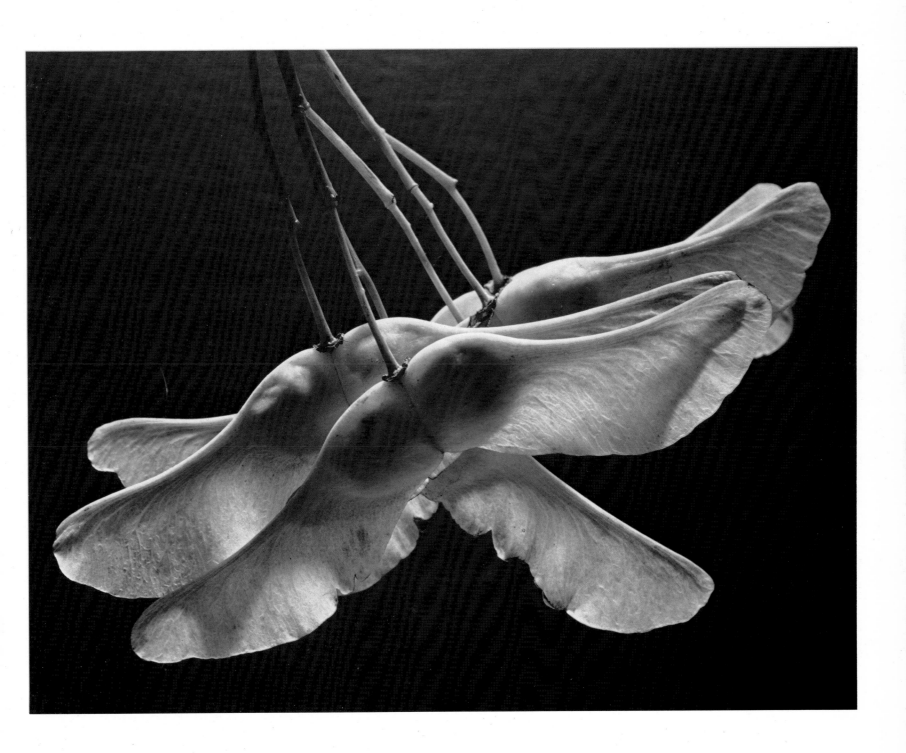

To assure maximum dispersal, seeds employ some of the most ingenious devices in nature. Illustrated here are two forms designed for aerial distribution. *Left:* Descending milkweed seeds strike the ground like falling bombs. *Above:* The propeller-driven seeds of maple.

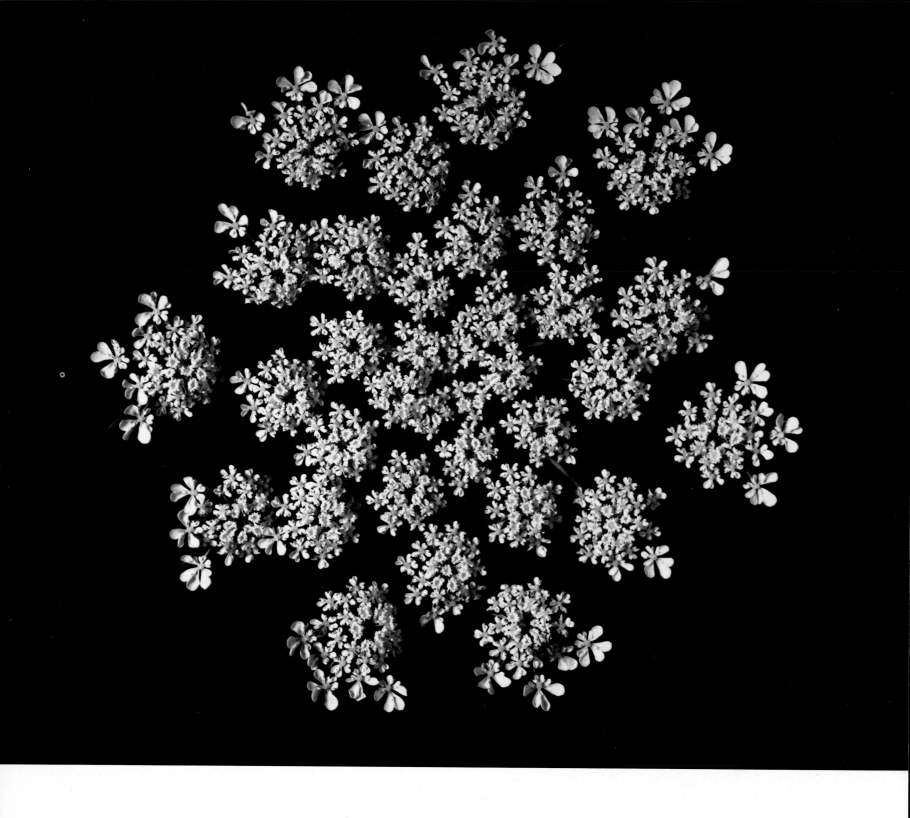

The aesthetic appeal of Queen Anne's lace is irresistible to me. *Above:* Arranged in roughly hexagonal form, clusters of tiny flowers mirror the star-spangled night sky. *Right:* Shielded in the protective embrace of the structures on which they grew,

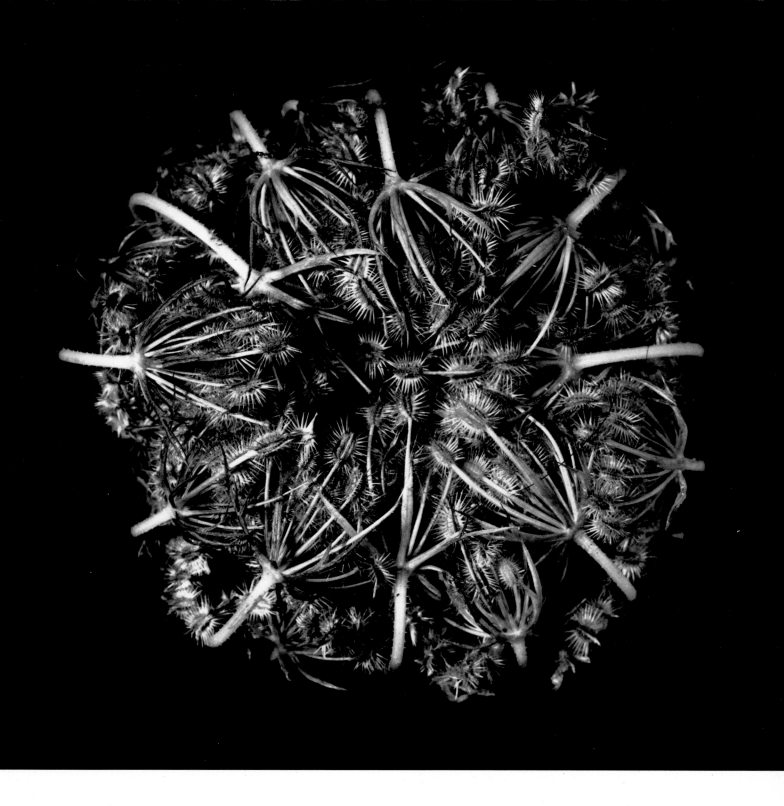

hundreds of seeds mature and wait for the moment of release. Equipped with hooked spines, they will attach themselves to the fur of passing animals, to be carried off and dropped in distant places where they can germinate and start the cycle of growth and flowering and seed production again.

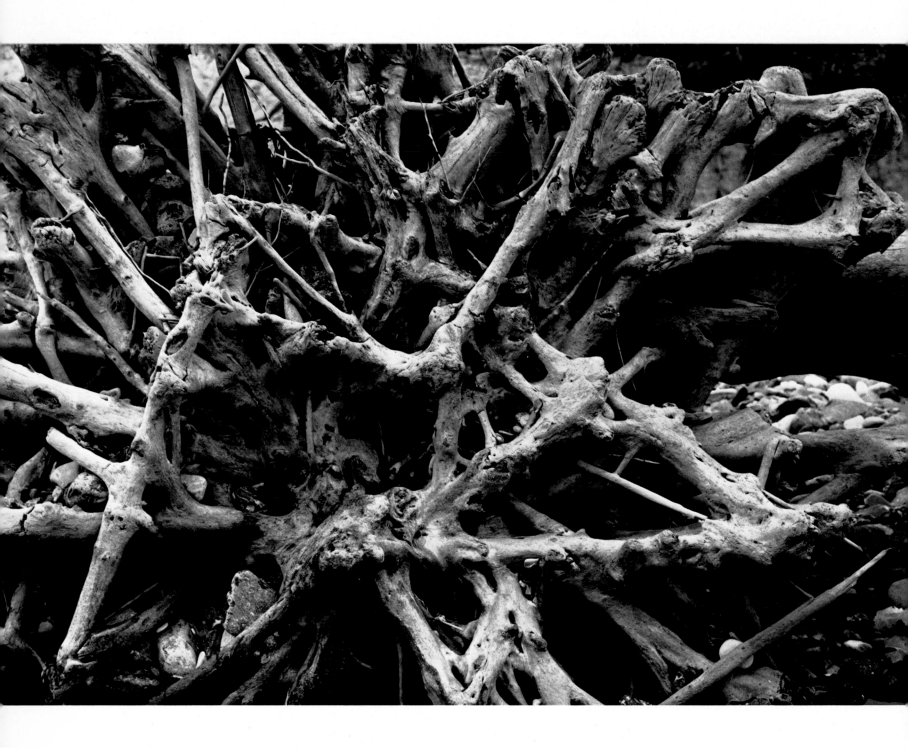

Above: Part of the root system of a fallen beech in Denmark. *Right:* Pollarded sycamore in France. Many modern sculptures seem to have been inspired by forms similar to these. Whereas the root might give rise to a constructivist creation, the tortured branches of the sycamore make me think of goblins holding bunches of flowers with upraised, widespread arms.

122

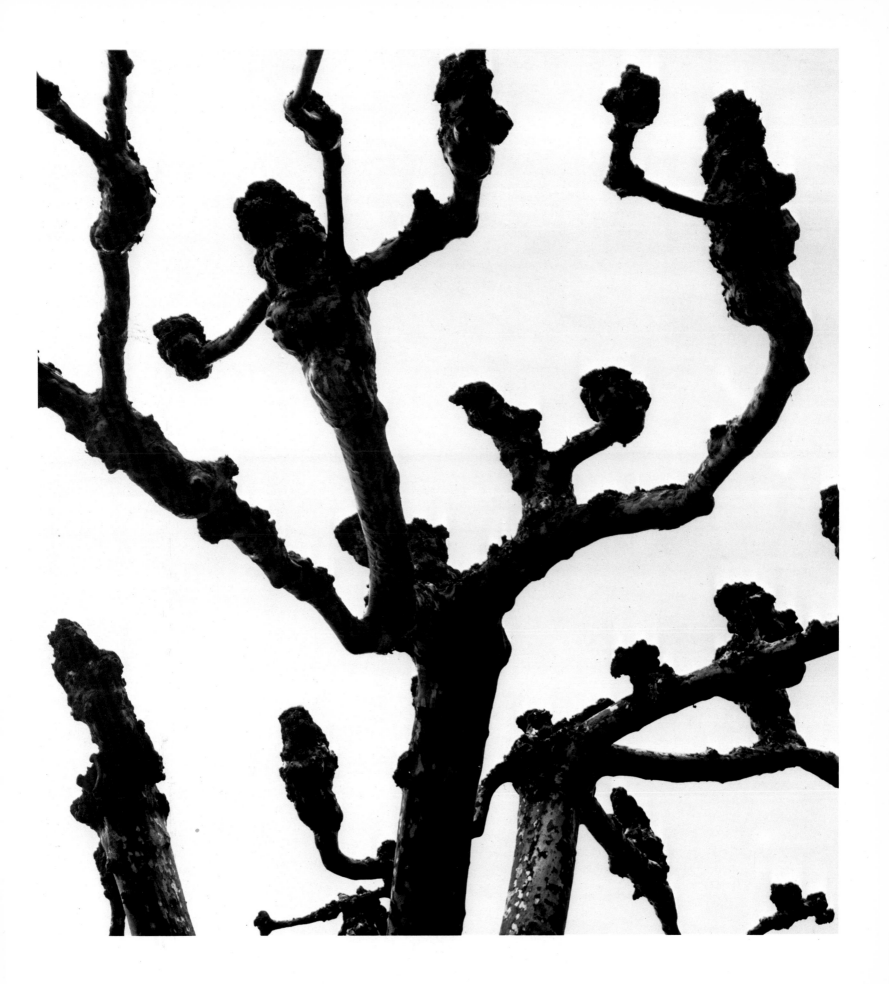

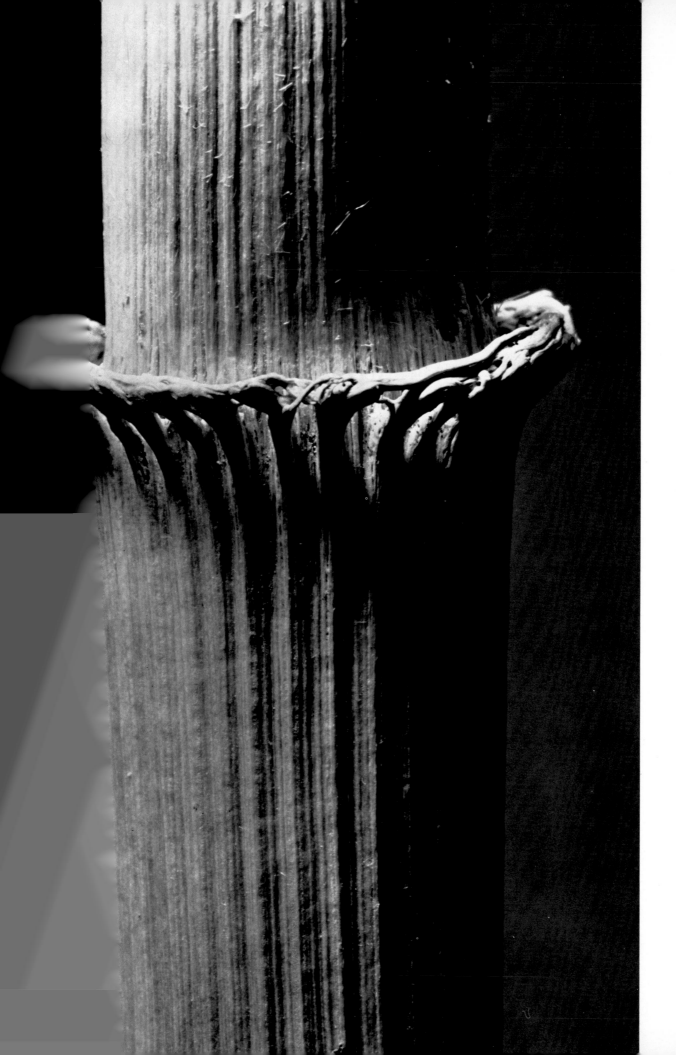

Left: Stalk of a reed. Aesthetically, it rivals classical columns in grace and beauty of design. *Right:* The supporting, woody skeleton of a cholla cactus, a tubular, girderlike structure that combines maximum rigidity and strength with minimum weight and expenditure of material. In mechanical efficiency it rivals any comparable structure made by man.

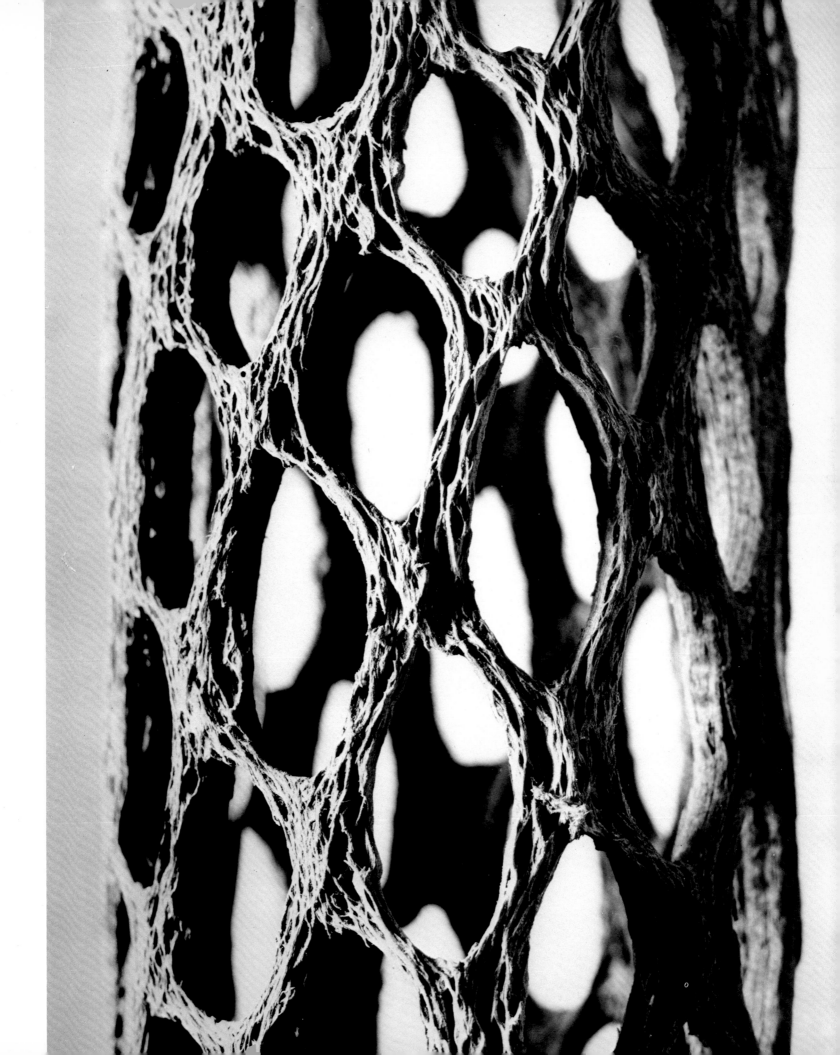

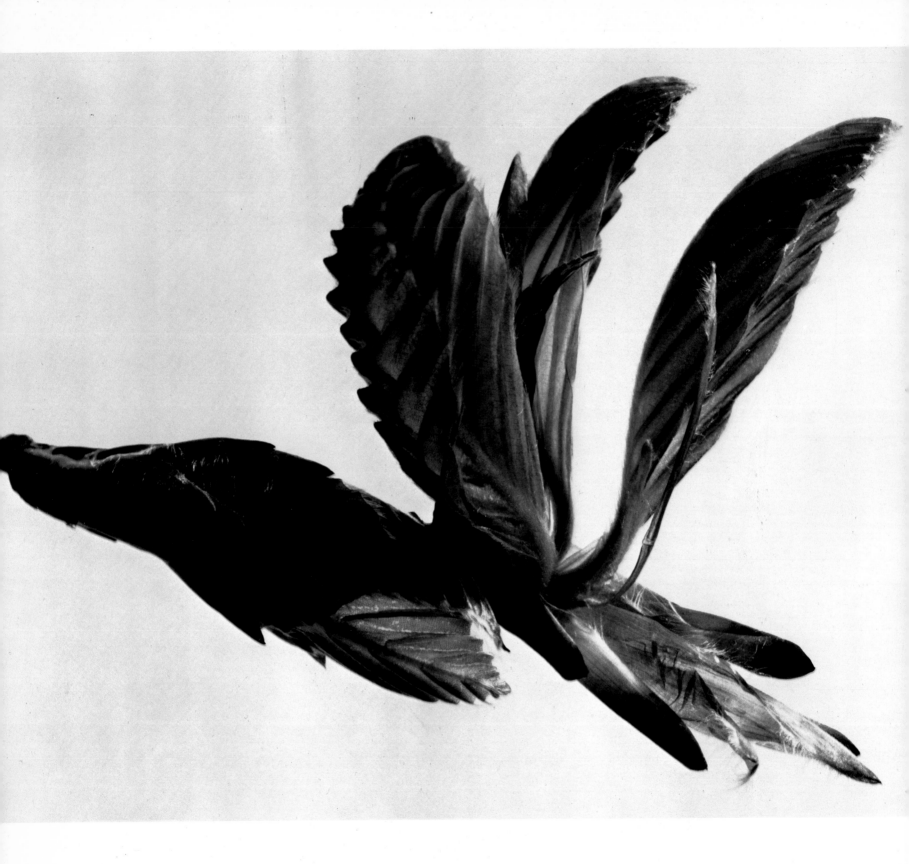

The joyous emergence of beech leaves in May. Two views of the same bud in consecutive stages of development. Its opening reminds me of the unfurling of sails preparatory to an adventurous voyage, of a bird spreading its wings, of a friendly face symbolizing hope and renewal and spring.

126

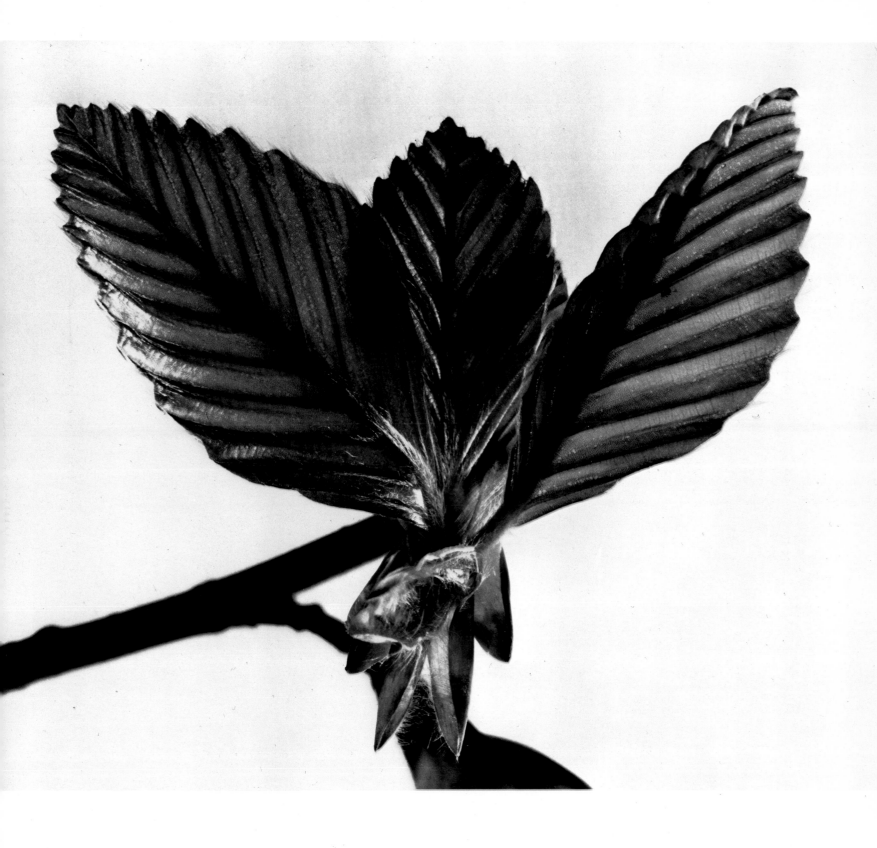

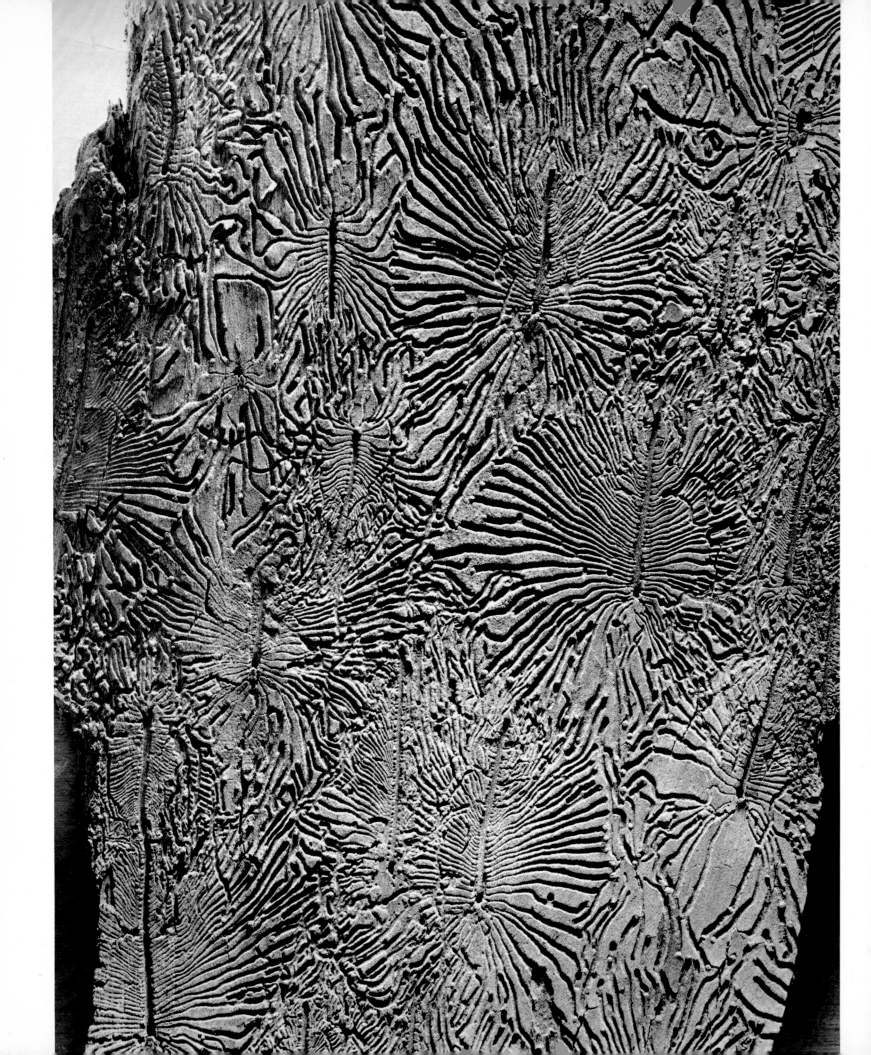

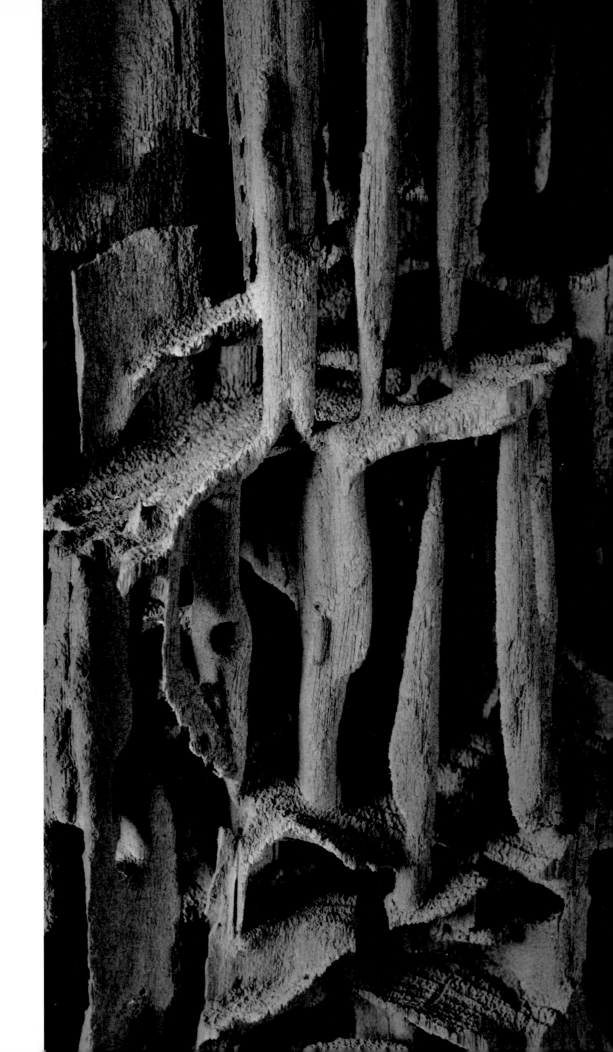

Left: The tunnels of bark-beetle grubs. *Right:* Galleries carved from the heartwood of an oak by carpenter ants. To me, these structures are both functional and beautiful. Functional—because the bark-beetle tunnels almost never intersect (which would be disastrous to the grubs), and the ant galleries are constructed in a way designed to weaken the wood to the least extent. Beautiful—because the tunnels form an organized pattern consisting of more or less symmetrical designs, and the ant galleries represent a three-dimensional construction which in abstract beauty rivals the work of Noguchi.

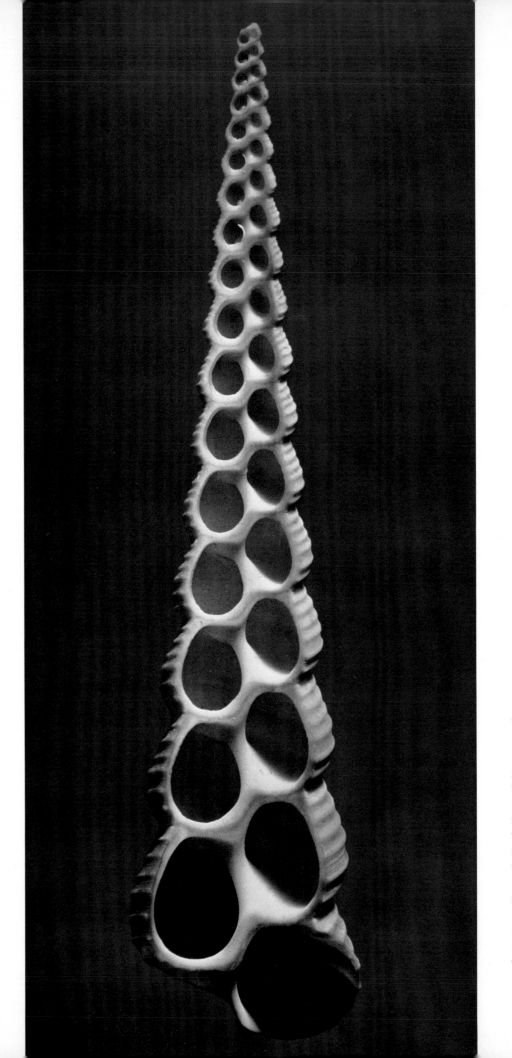

The structural beauty of shells. *Left: Turitella terebra* Linné. *Right: Turbinella angulatus* Lightfoot. That these hard and gleaming, mathematically precise structures are the work of mollusks—apparently insignificant blobs of animated slime—is hard to believe. To my mind, they are living proof that nothing in nature is "insignificant," that applying the term "insignificant" to objects of nature is a sign either of ignorance or stupidity, and that the more we study the "insignificant" aspects of nature, the more we are likely to learn, to gain in understanding, and to appreciate the wonders of our world.

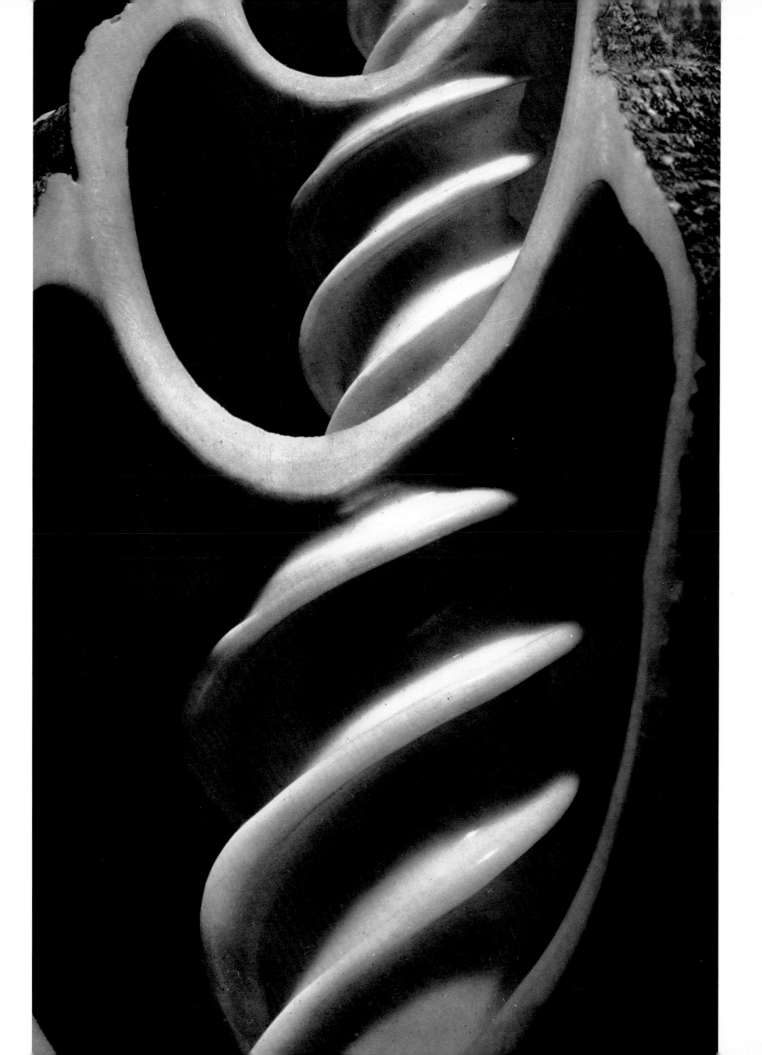

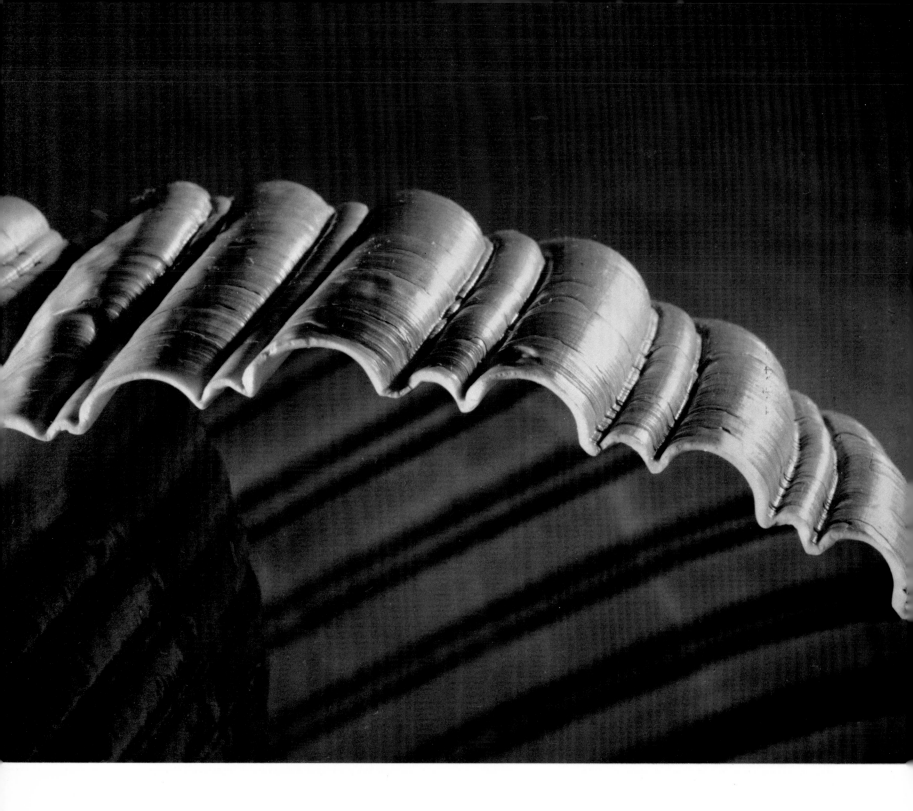

The functional beauty of shells. *Above: Tonna melanostoma* Jay. *Right: Argopecten irradians* Lamarck. We know today that the simplest way to increase the load-bearing capacity of a sheet is to corrugate it. Nature has used this principle for millions of years, as illustrated by these close-ups of shells, the thin and fragile walls of which have been strengthened significantly by corrugation. Although strictly functional as far as the shell is concerned, to the sophisticated mind these utilitarian forms are beautiful.

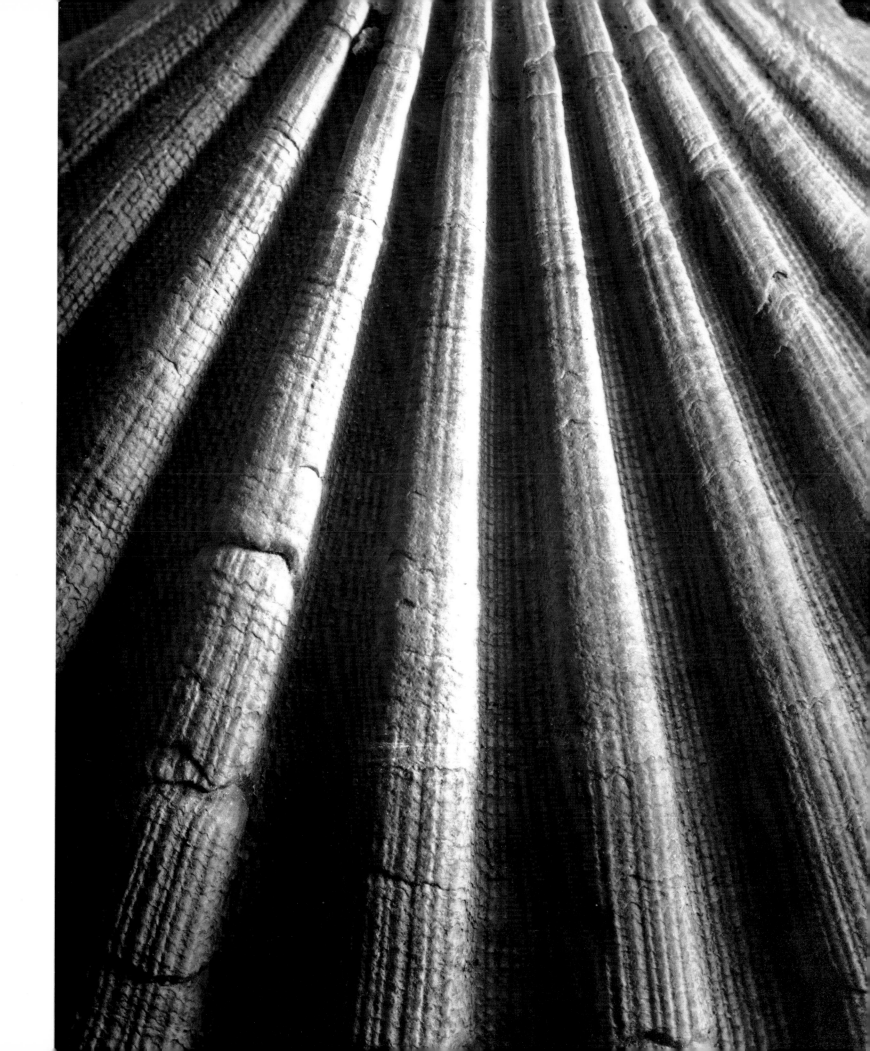

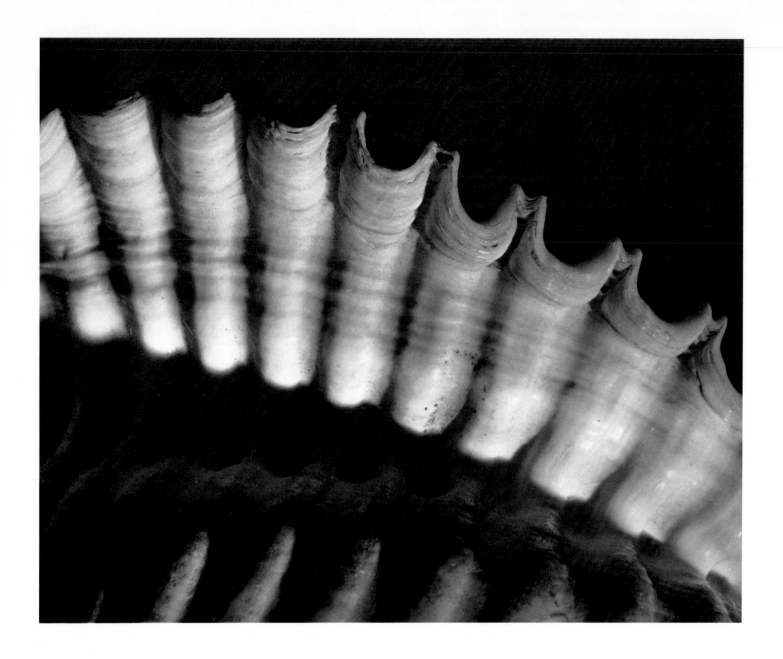

The aesthetic beauty of shells. *Above: Malea ringens* Swainson. *Right: Murex ramosus* Linné. Close-ups of the outer lip of shell apertures bring to mind dorsal fins of fish and spume blown off the top of cresting waves—forms and phenomena associated with the sea. Although such similarities are merely coincidental, associations like these, if carried further, make me aware of the interdependence of things and events in nature, the consequences that tampering with one aspect of nature must have on all the others, and the fact that man himself, dominant, powerful, and overbearing as he may be, plays only a temporary role in the great drama of evolution and, since he represents the apex of the pyramid of living things, not necessarily an indispensable one. Destroy the lowest level of the pyramid—the phytoplankton of the sea—and life in all the oceans dies; lop off the top of the pyramid—man—and life everywhere else will continue to flourish.

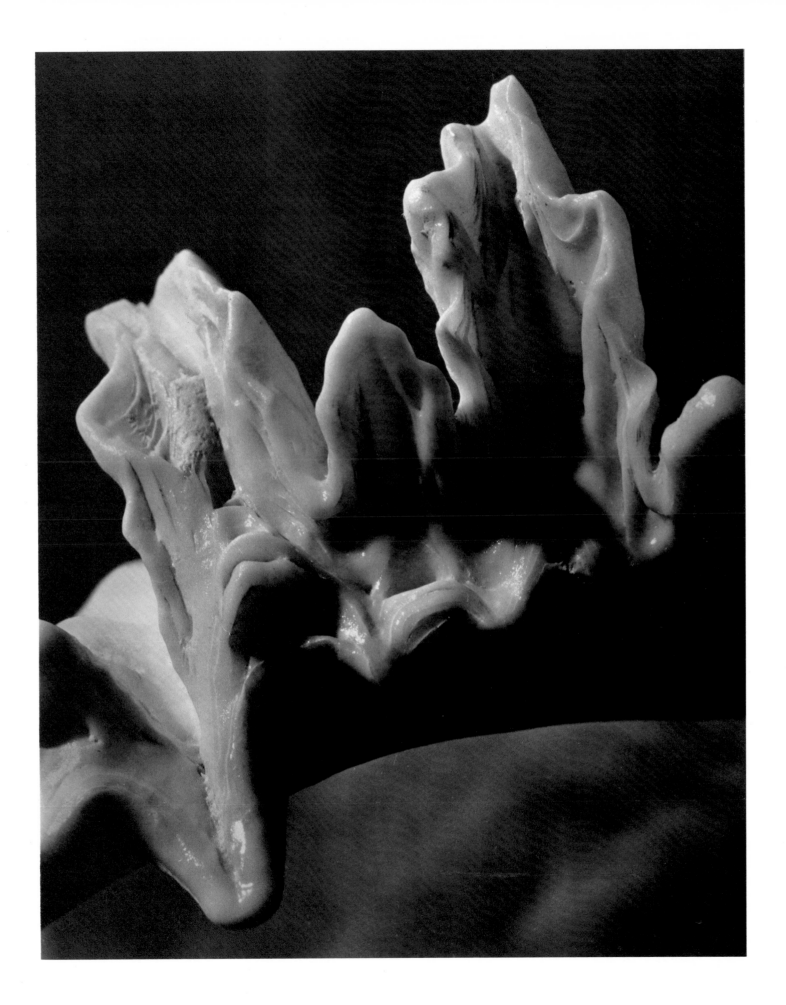

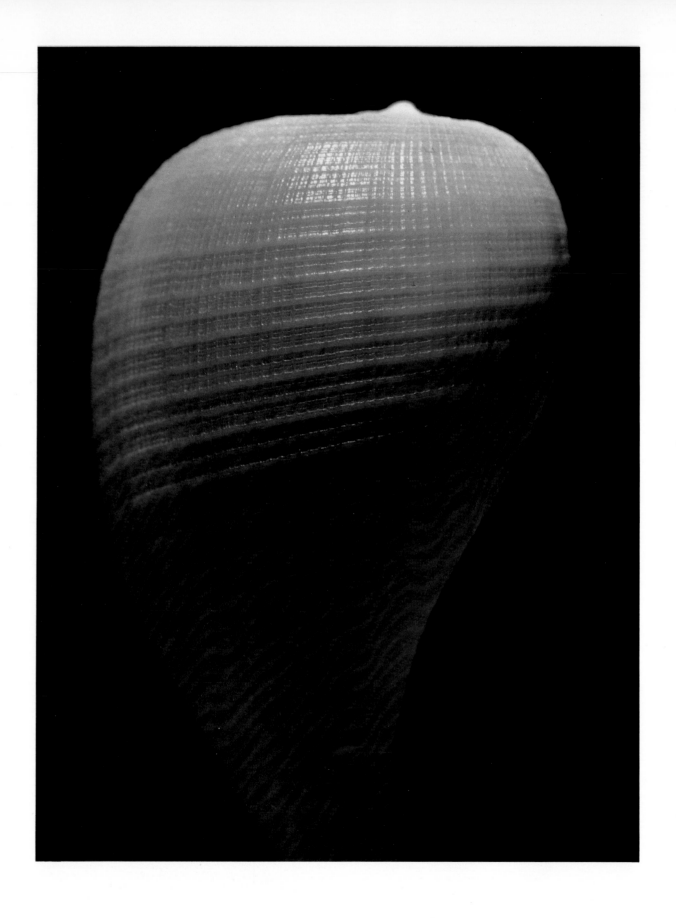

The sculptural beauty of shells. *Above: Thatcheria mirabilis* Sowerby. *Right: Ficus dussumieri* Valenciennes. Mollusks, humble creatures of the sea, built these magnificent structures, which in elegance of form, richness of detail, and precision of

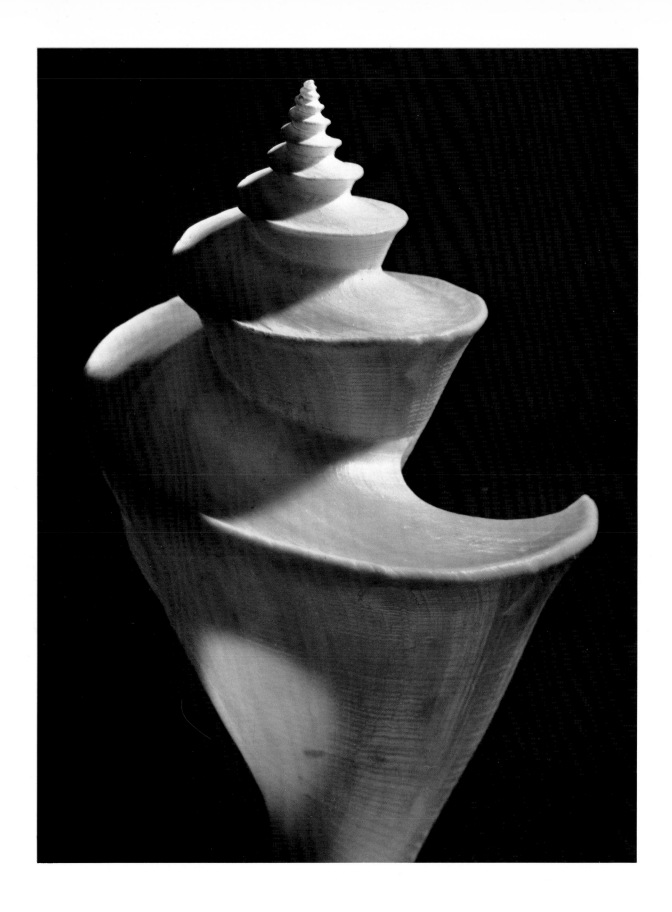

execution rival the highest sculptural achievements of man. Perhaps it is time to review our values, mend our arrogant ways, and look at our fellow creatures with more objective eyes.

V Texture

Texture, in the sense it is used here, is surface structure. In nature, surface structure is either functional, ornamental, shaped by external influences, or is the combined result of several factors, some of which may still be unknown. In any case, I find its manifestations fascinating from the point of view of both the engineer and the artist. In regard to versatility and inventiveness, the textures of objects of nature are virtually unlimited; in regard to beauty, they rival and frequently surpass anything comparable created by man.

But in addition to interesting me as functional structures and pleasing me as works of art, surface textures stir my curiosity. I constantly ask myself: Why? Why is this surface ribbed and that corrugated, this one coarse and that one smooth, this one gray and that one red? Innumerable times I have questioned scientists—experts in specific fields—only to be told, "We don't know."

This, of course, makes the texture of many objects of nature rather mysterious, and the mysterious has an attraction all its own. It stirs the imagination, it stimulates the mind, it speaks to the dreamer and poet who, to a greater or lesser degree, lives in all of us.

I find contemplating the textures of nature extremely rewarding. I can take a shell, a rock, a leaf, or a piece of bark and study it minutely, often with the aid of a magnifier, letting my thoughts roam freely. And after a while I begin to see images in this surface, configurations, objects that lead my thoughts deeper and deeper into new realms. I begin to see connections I had not realized before, I gain insight into puzzling phenomena, I feel related by atomic bonds to the structure I study, I become a part of the Universe. This is an almost mystical experience beyond the rote of daily life that can be described with words only inadequately.

Look at the photograph on the opposite page. It shows little more than a square inch of the surface of a common shell. But to me, it represents an entire landscape, perhaps from an unknown planet, rugged, arid, mountainous. I see pinnacles rising sharply (and think of Machu Picchu in Peru), I see crevasses and the entrances of caves. I see corrugated conic shelters clinging to the hillside, but they are vacant; the occupants have left. And I wonder what these occupants might look like, these citizens of Planet X—these barnacles, sessile little animals waving their delicate, feathery plumes. . . .

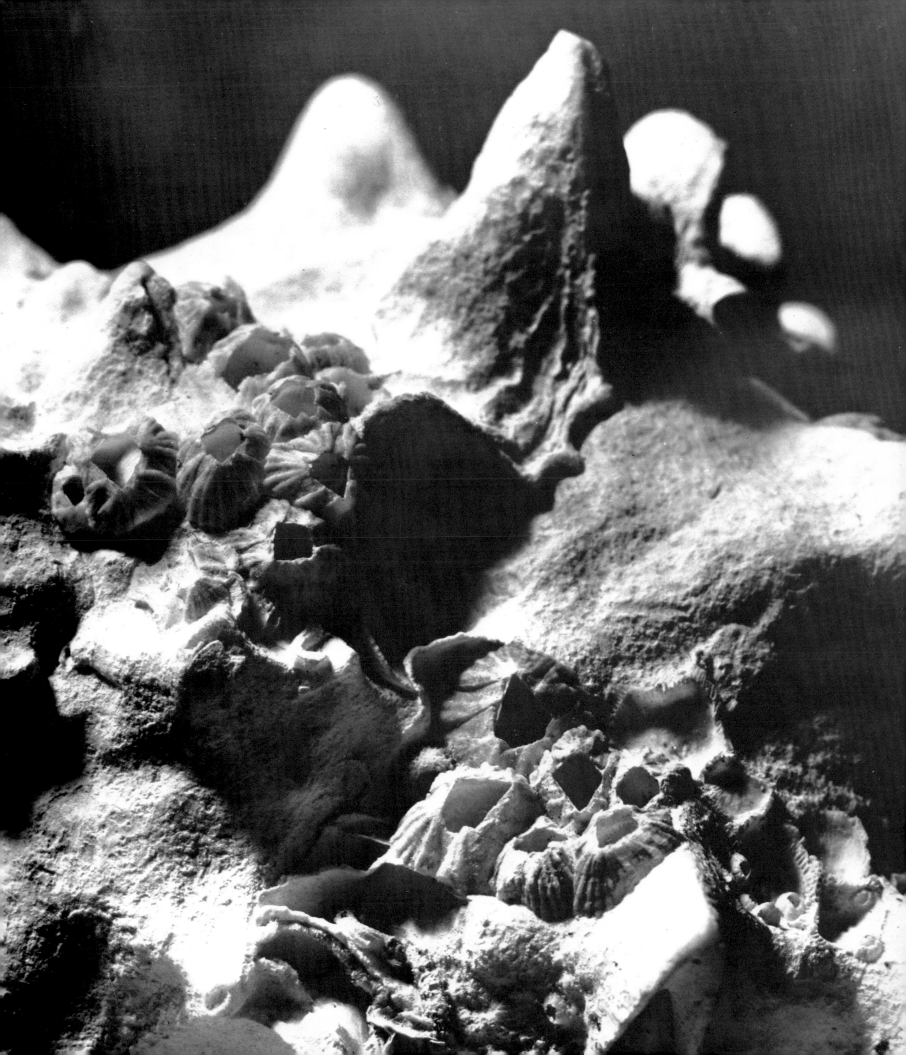

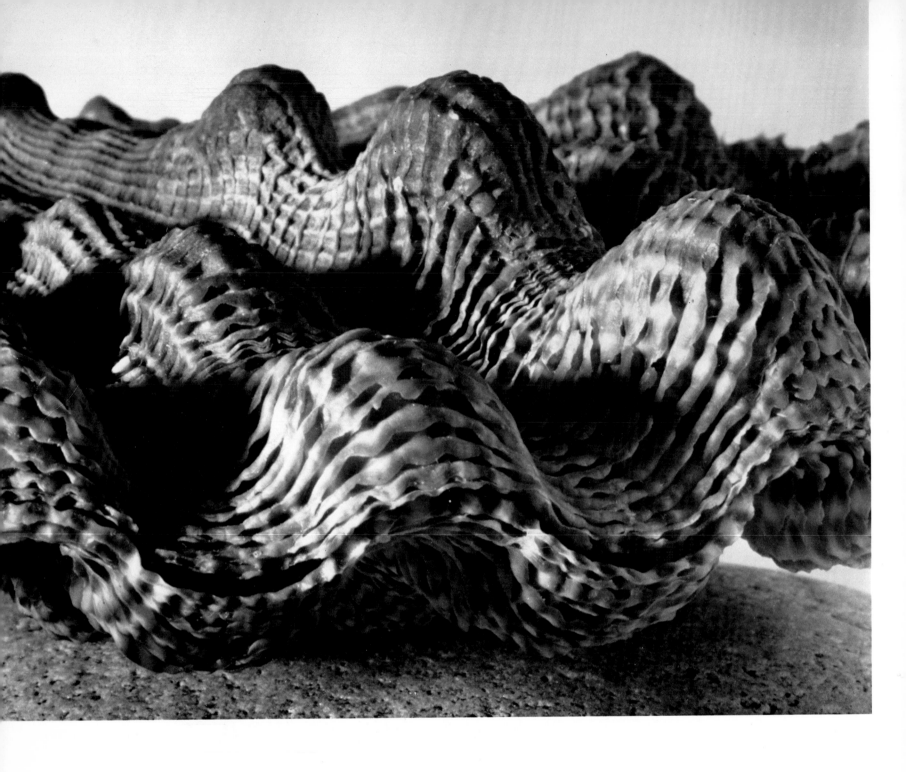

These and the following four pages show close-ups of shells. They give a first, faint indication of the overwhelming variety of their surface structures. The purpose of these textures is probably protective — to achieve maximum strength with a minimum expenditure of material. To me, it is fascinating to see that this can be accomplished in so many different ways, and again I ask myself: Why? Why not use one or two proved designs for all shells? What is it that compels one shell to adopt a laterally and longitudinally crimped texture (*above: Lyropecten nodosus* Linné) while another one (*right: Cardium costatum* Linné) relies on heavy ribs?

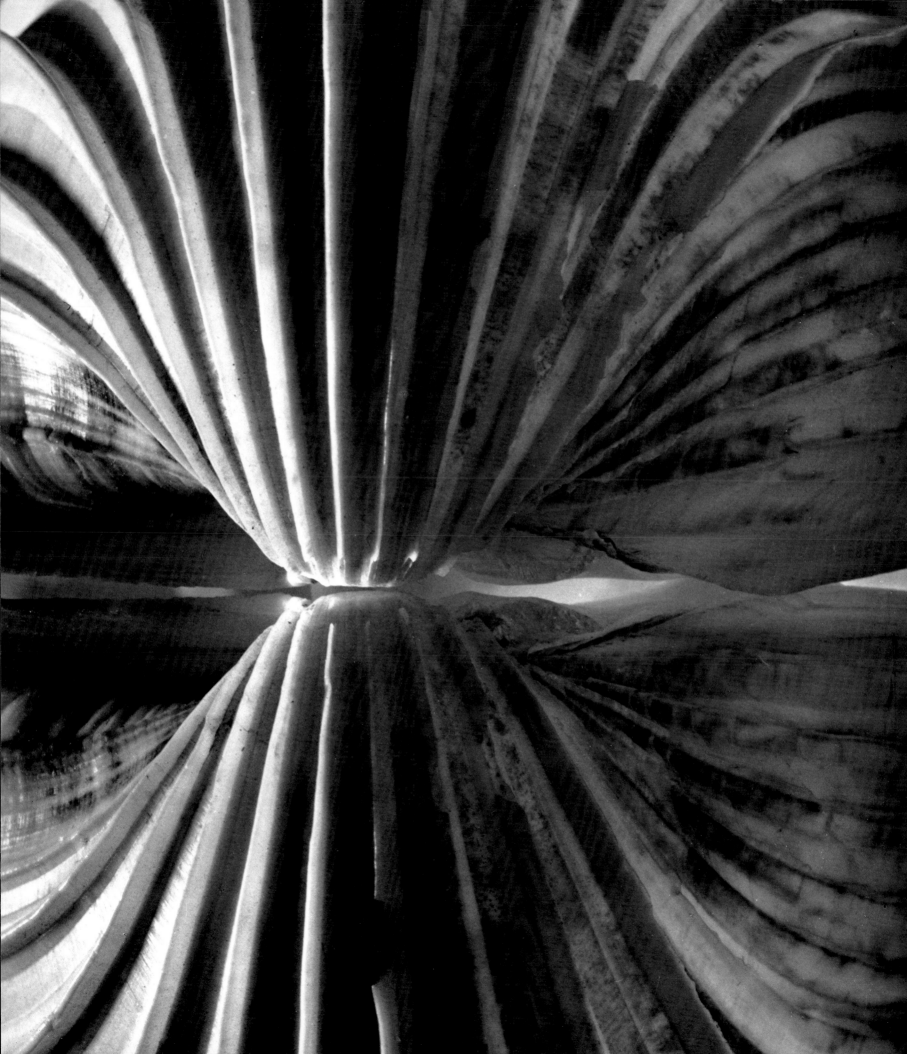

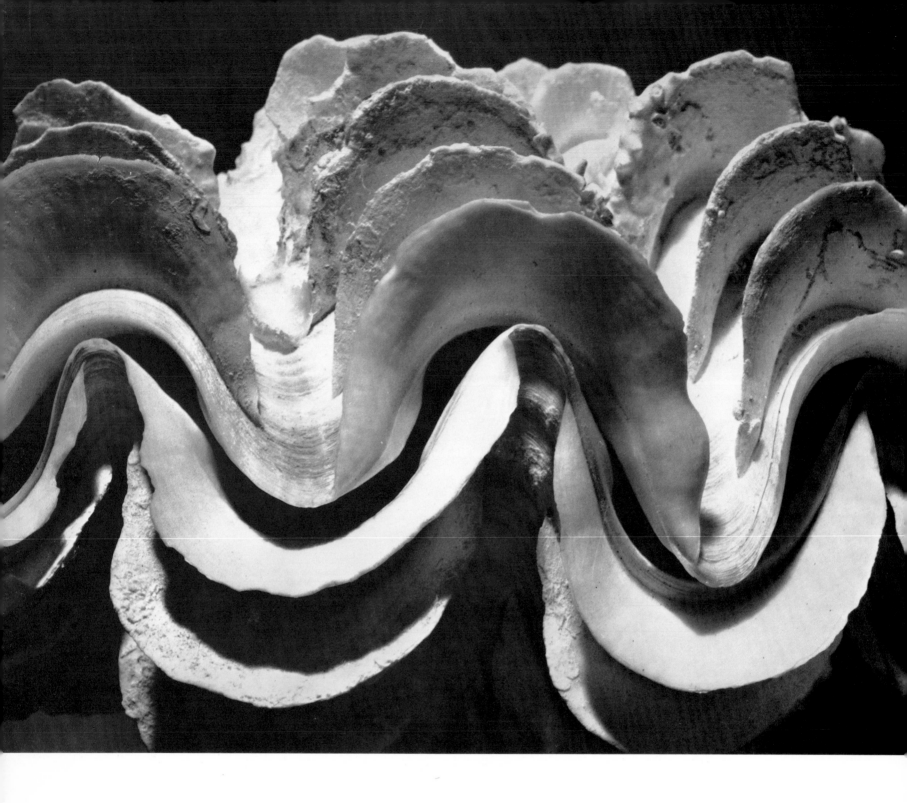

Whereas the texture of some shells is coarse, that of others is fine. Examples of each are shown on these two pages. *Above:* The coarsely fluted shell of a giant clam (*Tridacna maximus* Röding). *Right:* The beautifully textured surface of a fig shell (*Ficus filosus* Sowerby), shown in approximately ten times natural size. Whether texture is coarse or fine is probably determined by the habitat of the shell — finely textured, more delicate shells being able to survive only in quieter waters and on softer bottoms than coarsely textured, more rugged ones. But then, there are exceptions too, and again I ask myself: Why?

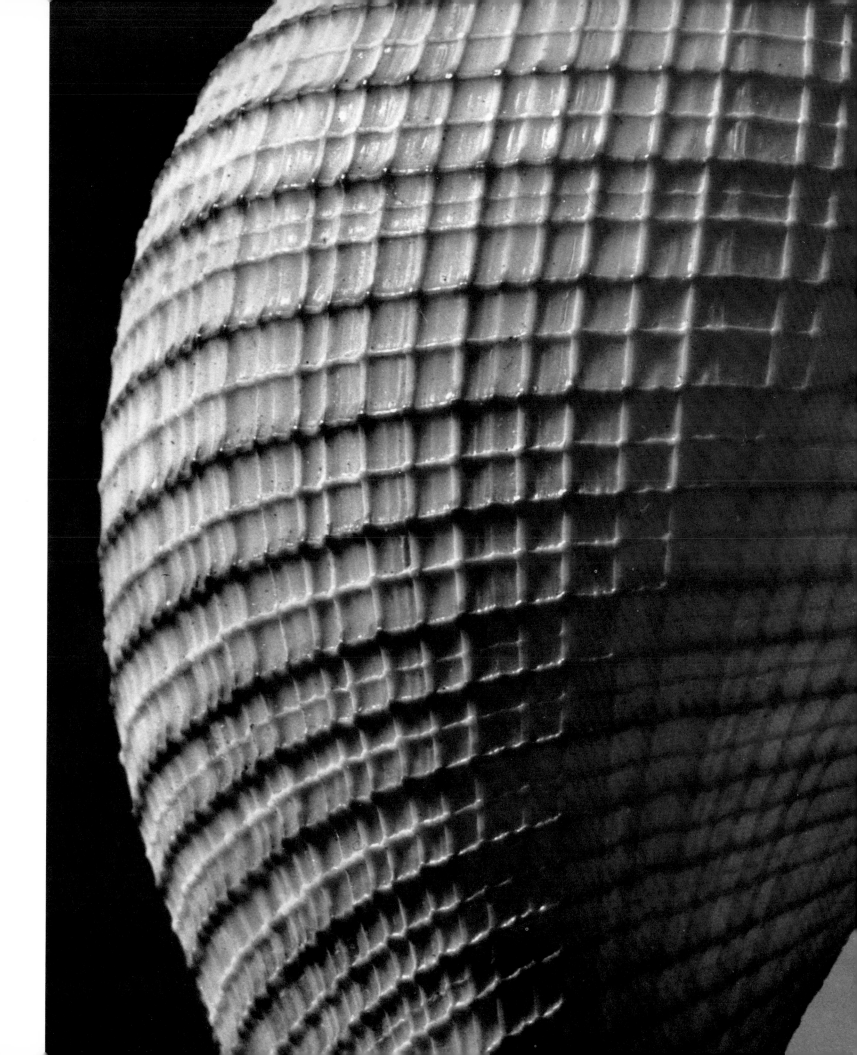

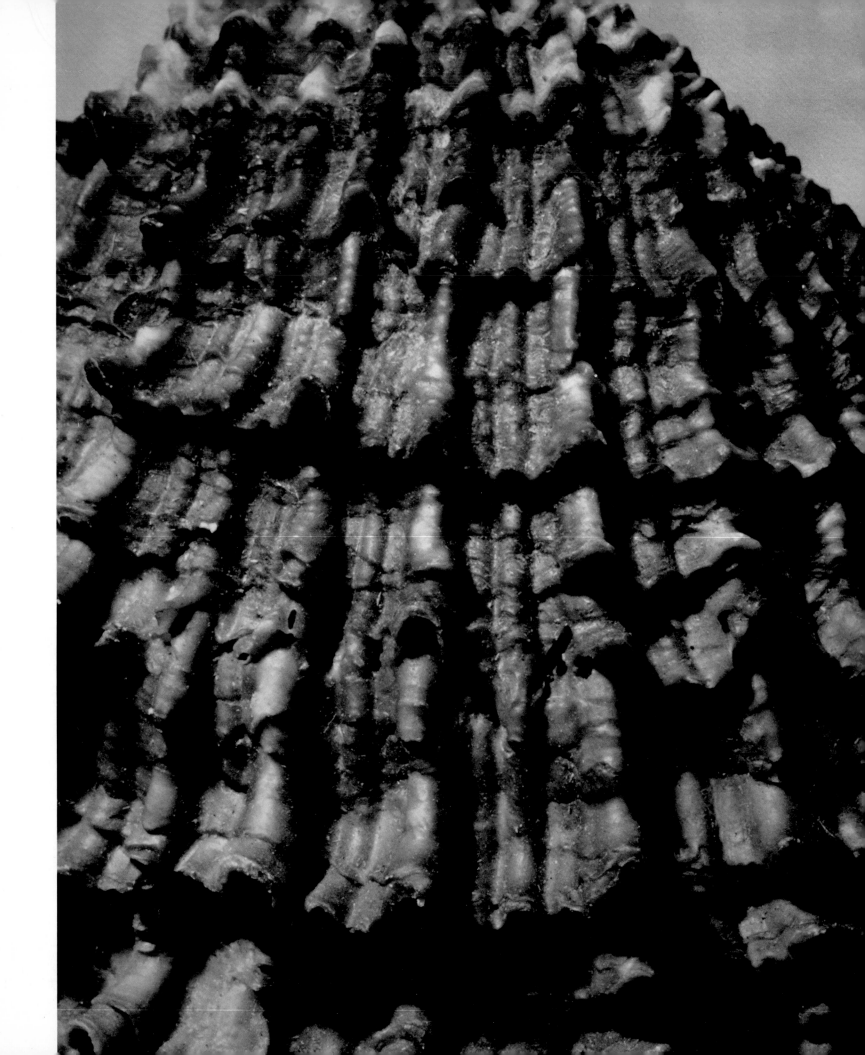

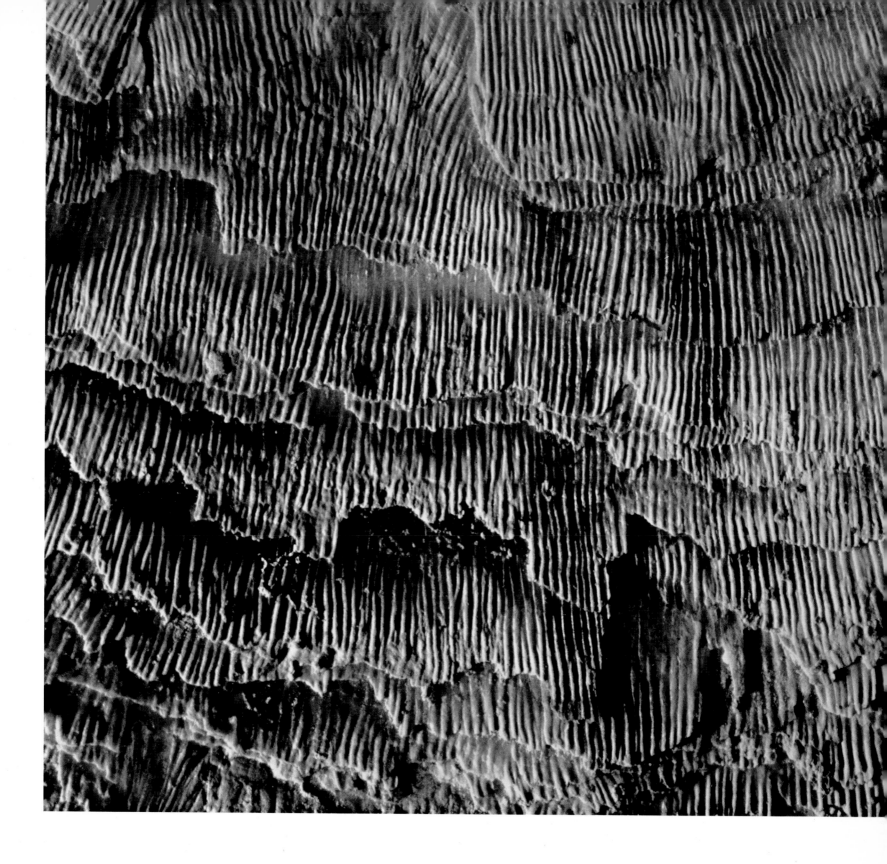

Close-ups of the shells of an open-mouthed purple (*Concholepas concholepas* Bruguière) and a saddle oyster (*Placuna sella* Linné). How different their structures are from those shown on the previous pages. The texture of the open-mouthed purple (*left*) brings to mind the tiled roofs of sun-baked Spanish towns, that of the saddle oyster (*above*) hand-split cedar shakes.

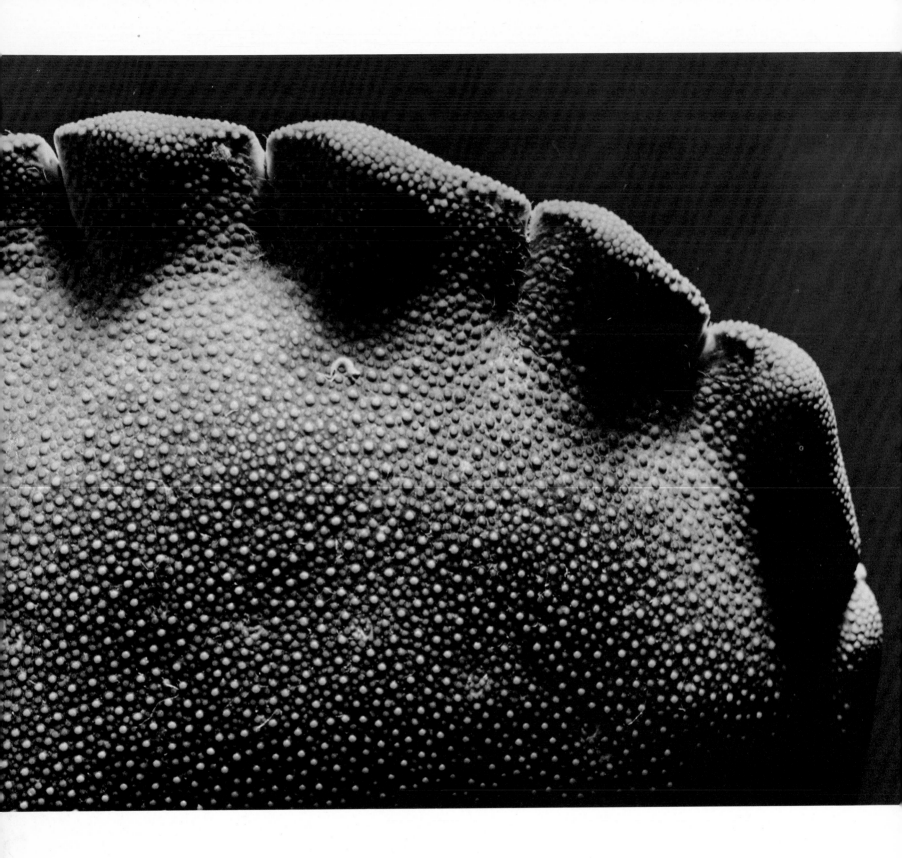

Above: The granular texture of the carapace of a crab. *Right:* The surface of a sea urchin, strongly magnified. Both testify to the infinite inventiveness of nature.

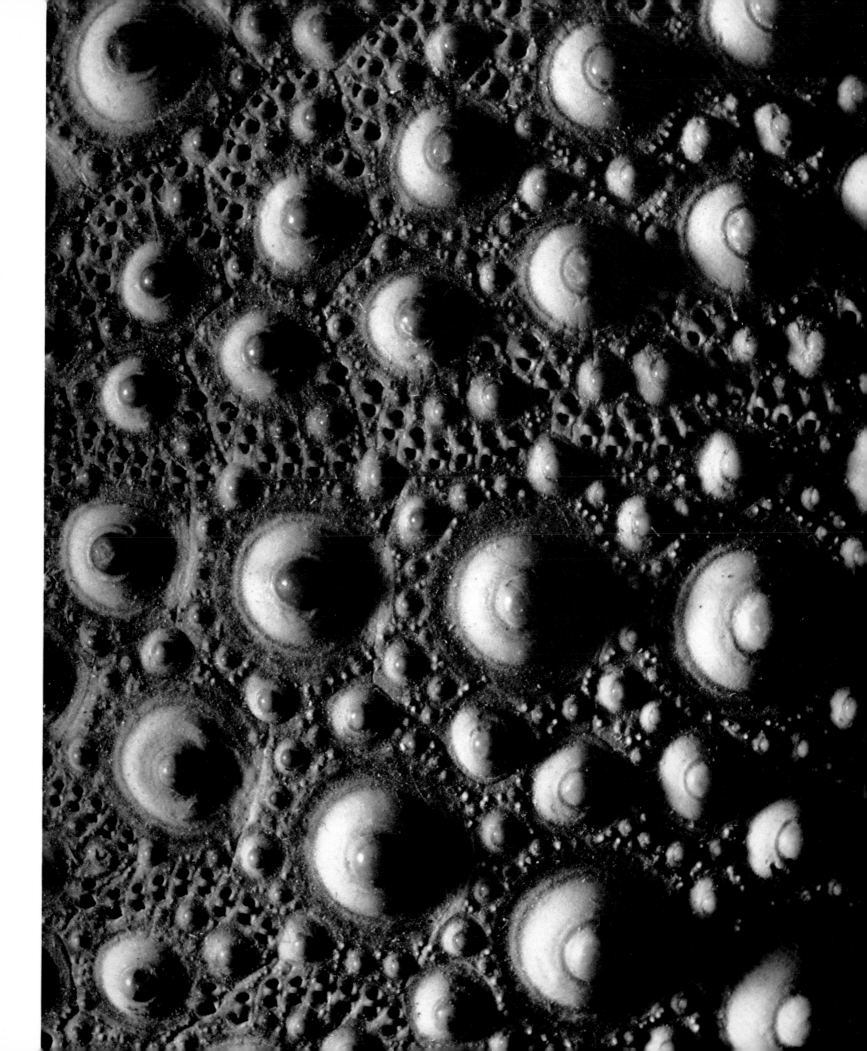

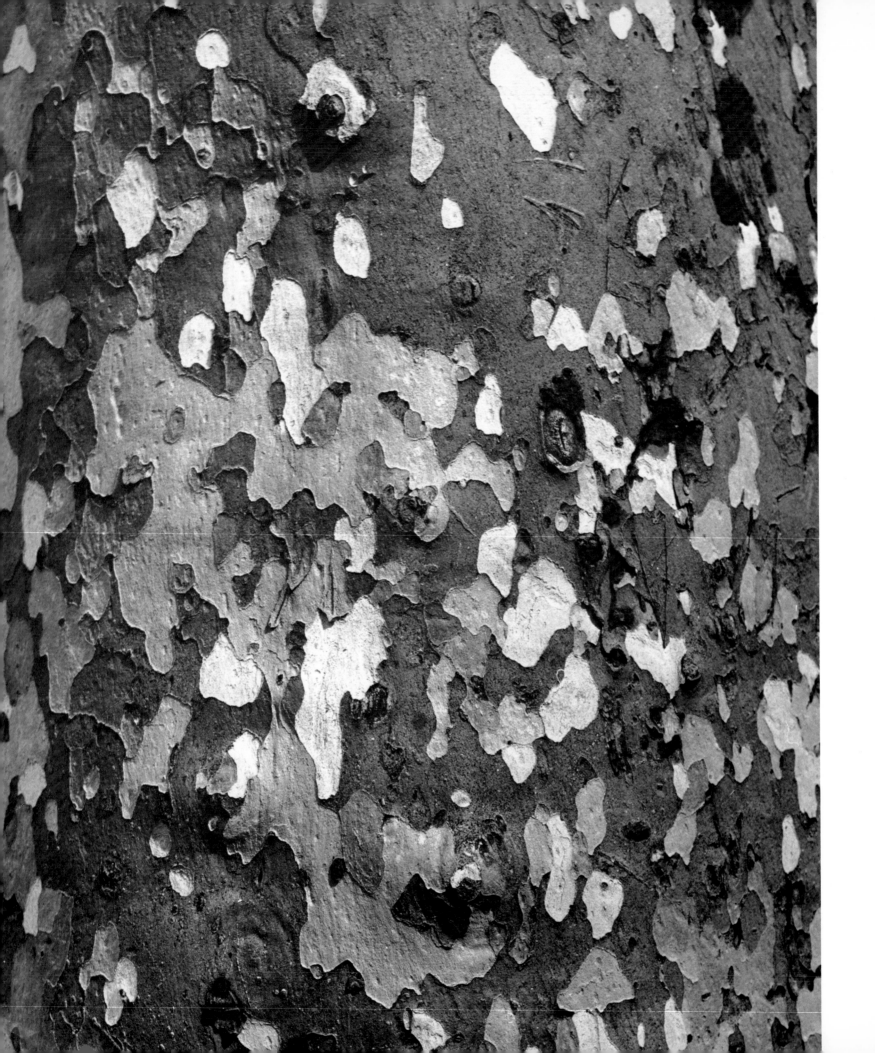

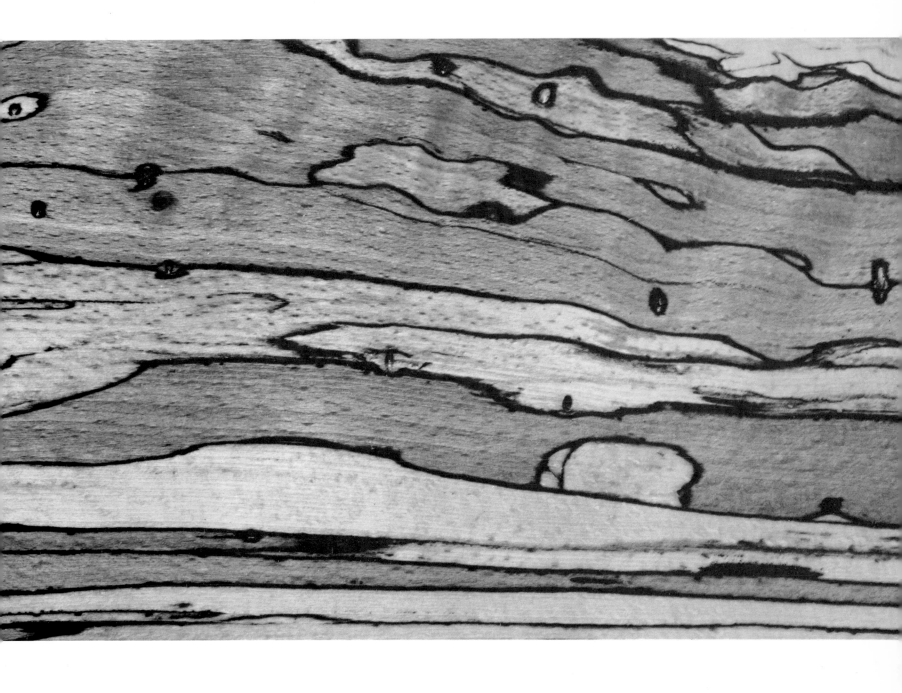

Studying the textures of objects of nature is an avocation of mine that has given me as much pleasure and stimulation as art lovers derive from contemplating modern abstract art. But unlike abstract art, which is based on such intangibles as emotions and feelings, the textures of nature are rational manifestations, functional, inevitable. As a result, it is possible to enjoy the textures of nature not only from the point of view of the artist sensitive to the beauty of their abstract designs, but also from the point of view of the scientist or engineer interested in structure and function, cause and effect.

The picture at the left shows the bark of a sycamore trunk, the one above, a cross section through a fungus-infected piece of wood.

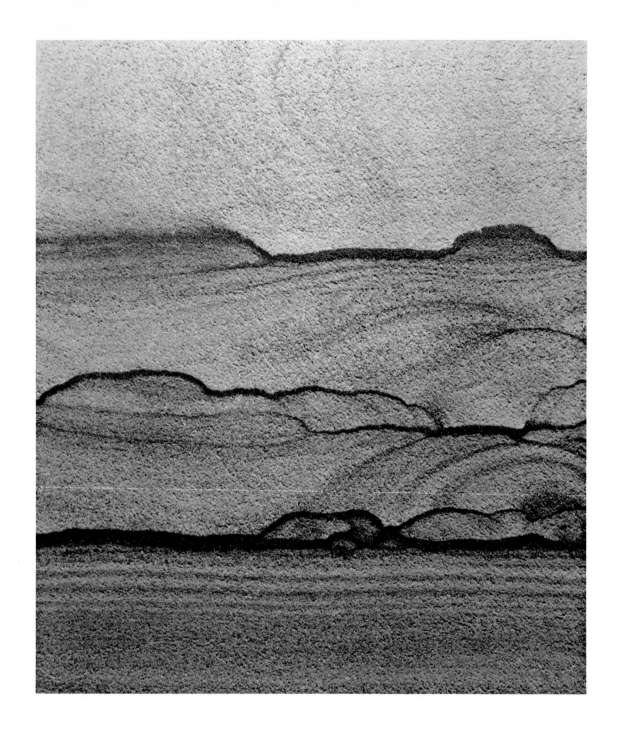

What at first may be mistaken for semi-abstract paintings of landscapes are actually works of nature — cross sections through certain types of layered sandstone in which impurities have created abstract designs. I see in them tilled fields, hills and mountains, cloud formations, the sky. I feel the wind sweeping across the Great Plains. I sense the lure of the West. No wonder sandstone plaques like these have become fashionable as ornaments and are sold in many stores.

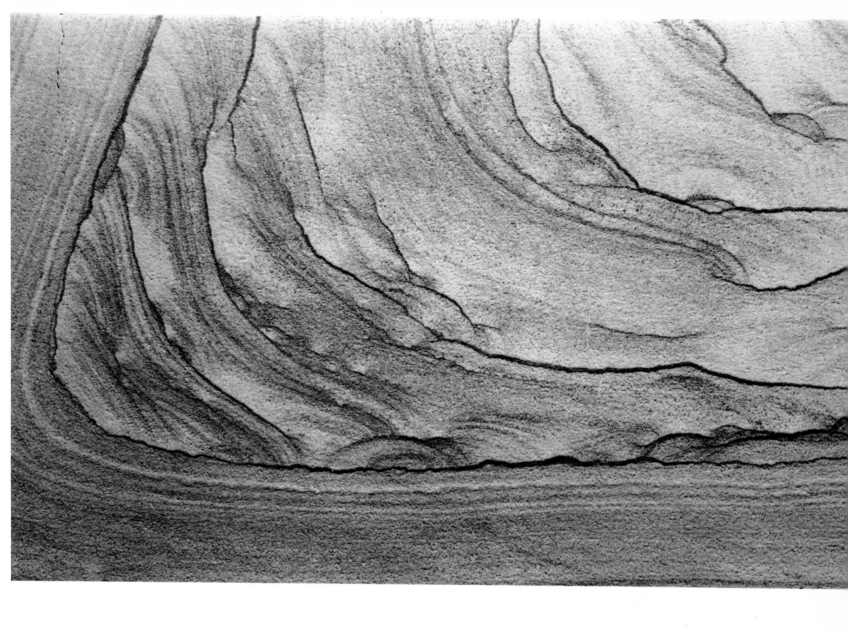

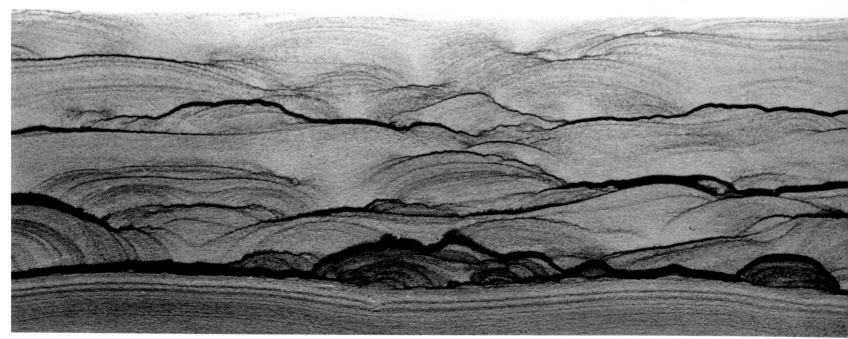

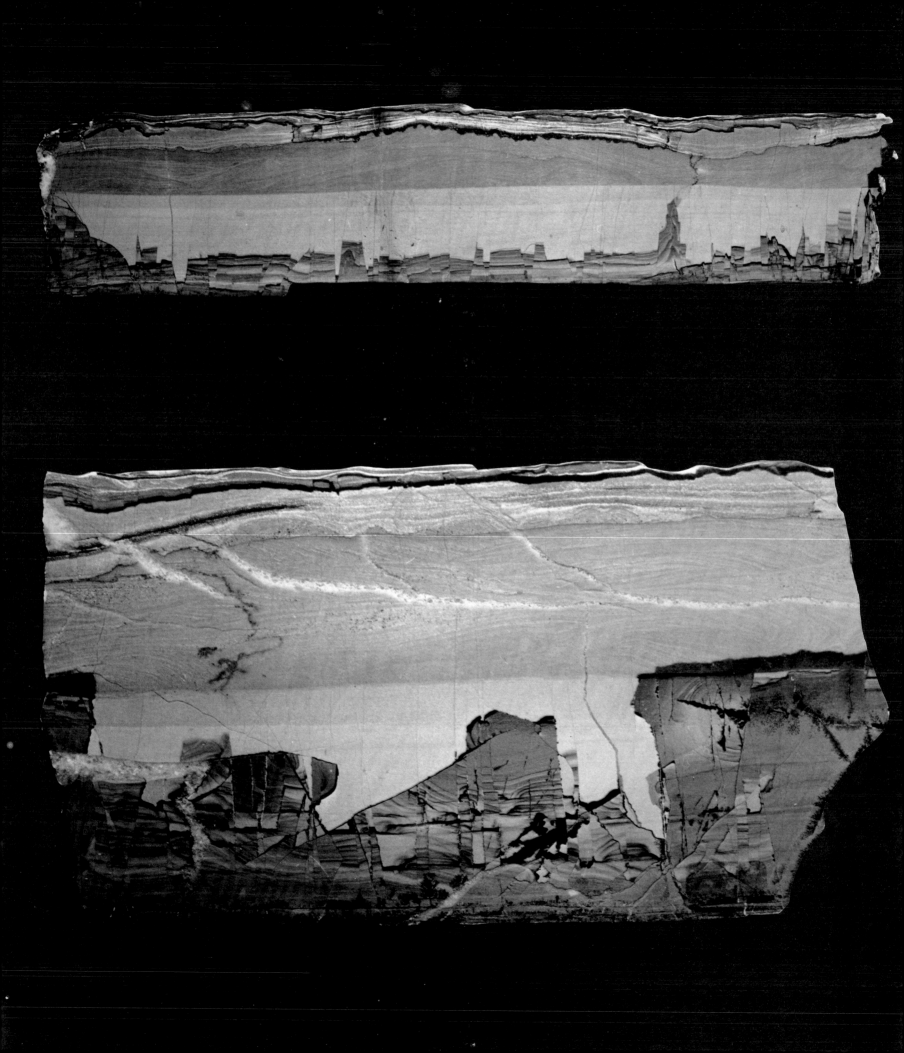

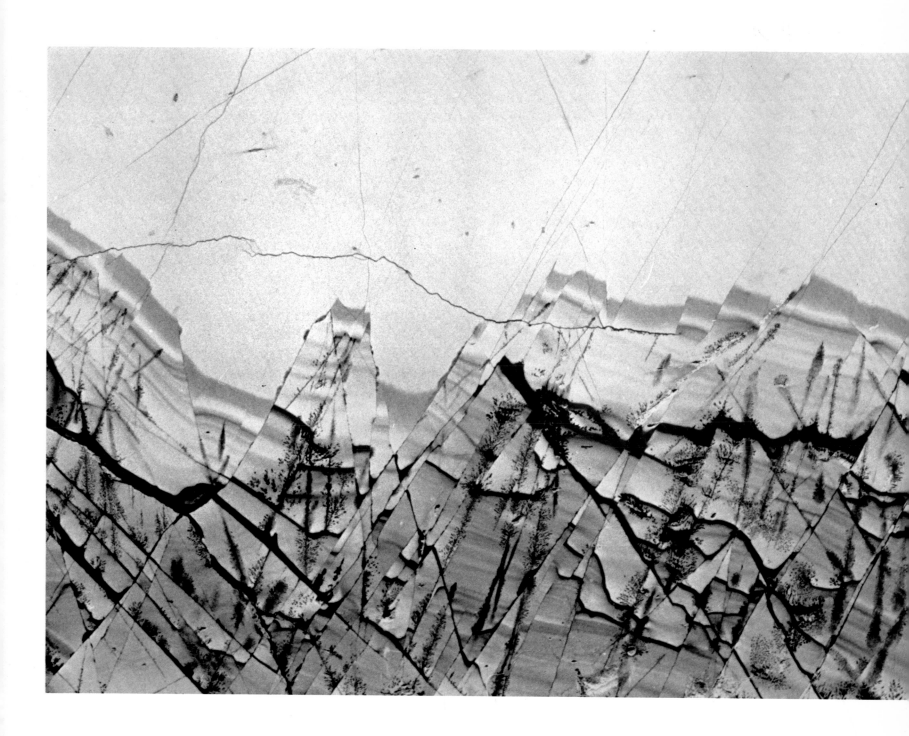

These fascinating views of canyons, mesas, and buttes are not cubist renditions of Western scenery, but cross sections through Italian marble slabs derived from mud and limestone sediments. Their infinite richness of form never tires the mind, and the longer you contemplate their intricate designs, the more you see until at last you feel as if you were actually walking those stony paths, exploring, discovering, enjoying.

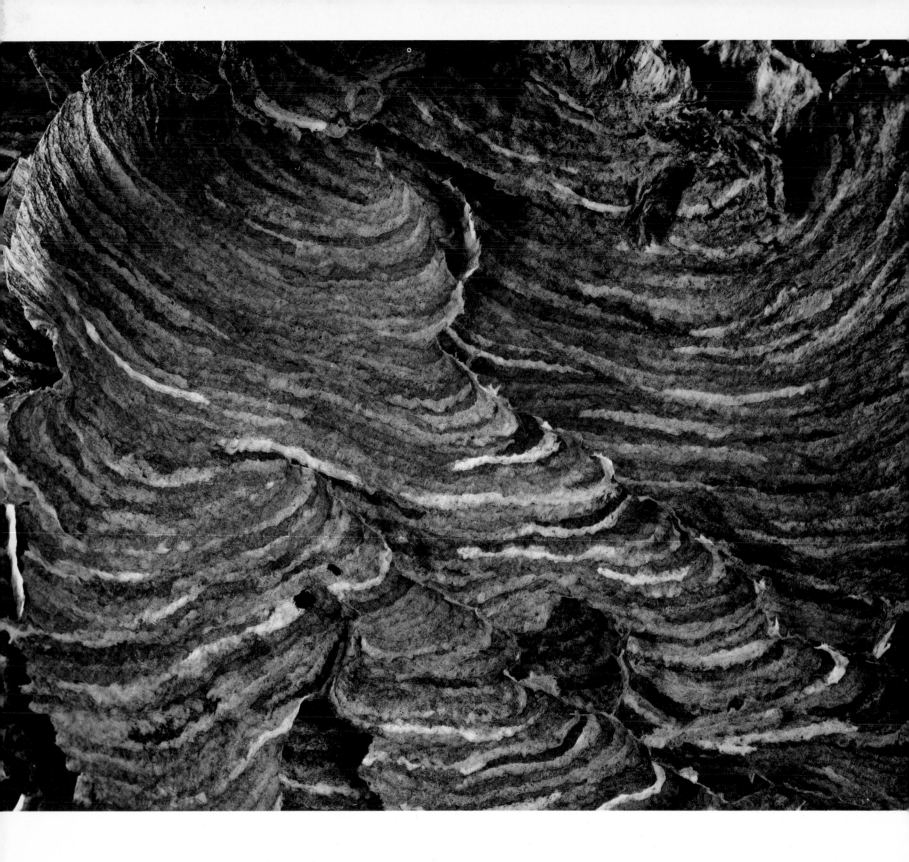

Close-ups of the paperlike substance that forms the wall of a nest of white-faced hornets. Differences in color are due to differences in the type of wood the insects used to manufacture the pulp for the construction of their nest. Contemplating designs like these always makes me wonder to what degree nonrepresentational modern painting is indebted to nature.

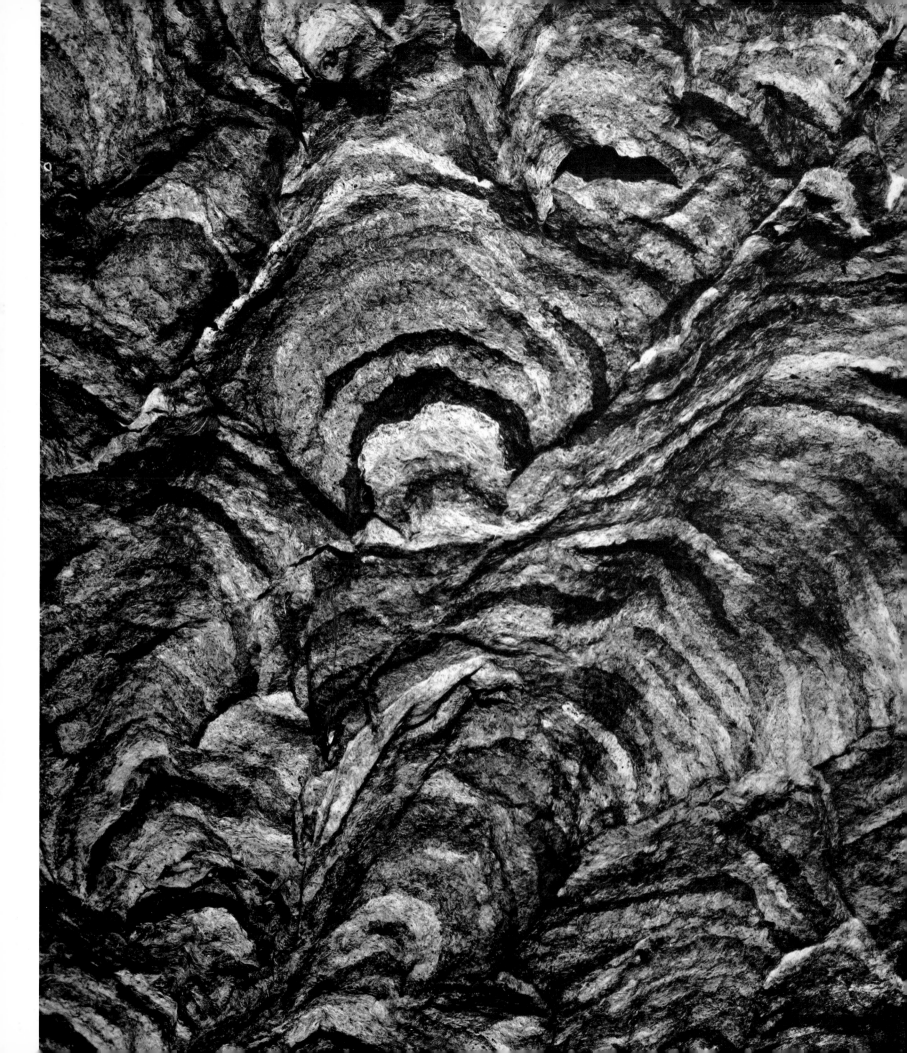

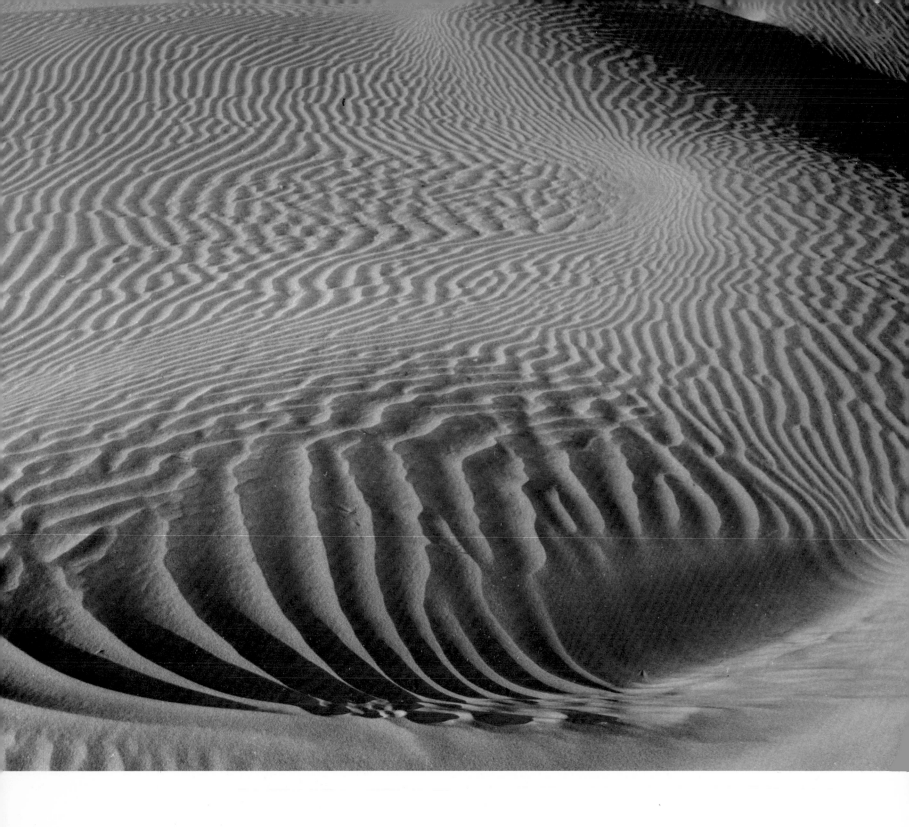

Above: Texture of a sand dune in California's Death Valley; the area shown is approximately ten feet wide. *Right:* A ventifact—a sandblasted stone—from Death Valley. Both surface structures are the result of wind action which, in the first case, ripple-marked the sand, and in the second example, eroded the stone surface by selectively removing the softer particles first, an effect that may have been aided by leaching. In either case, the result is a strongly organized pattern I find aesthetically attractive.

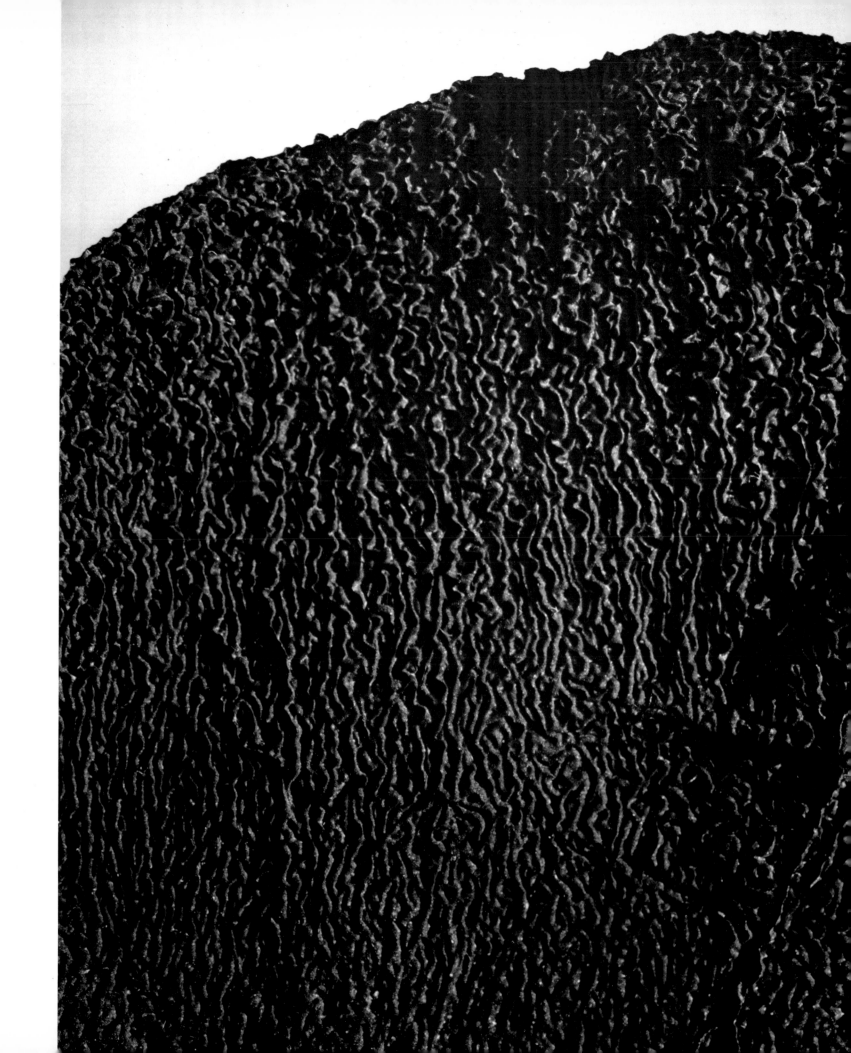

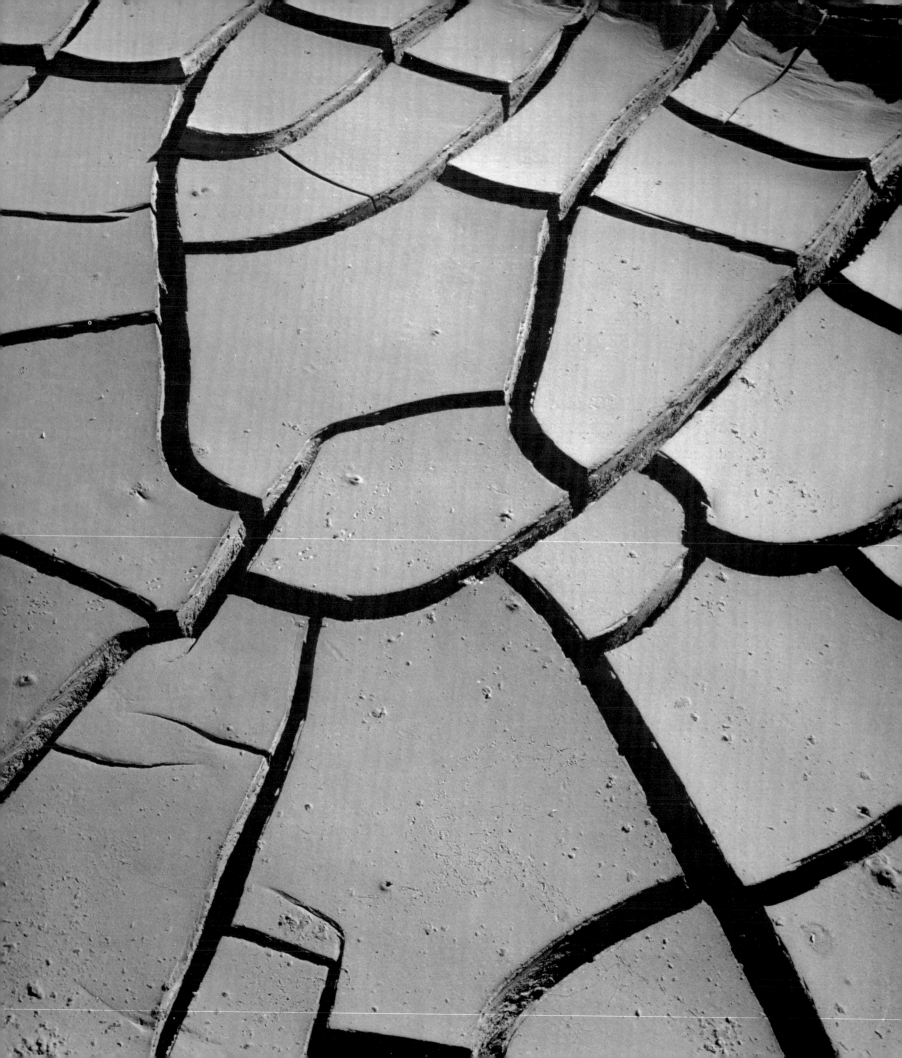

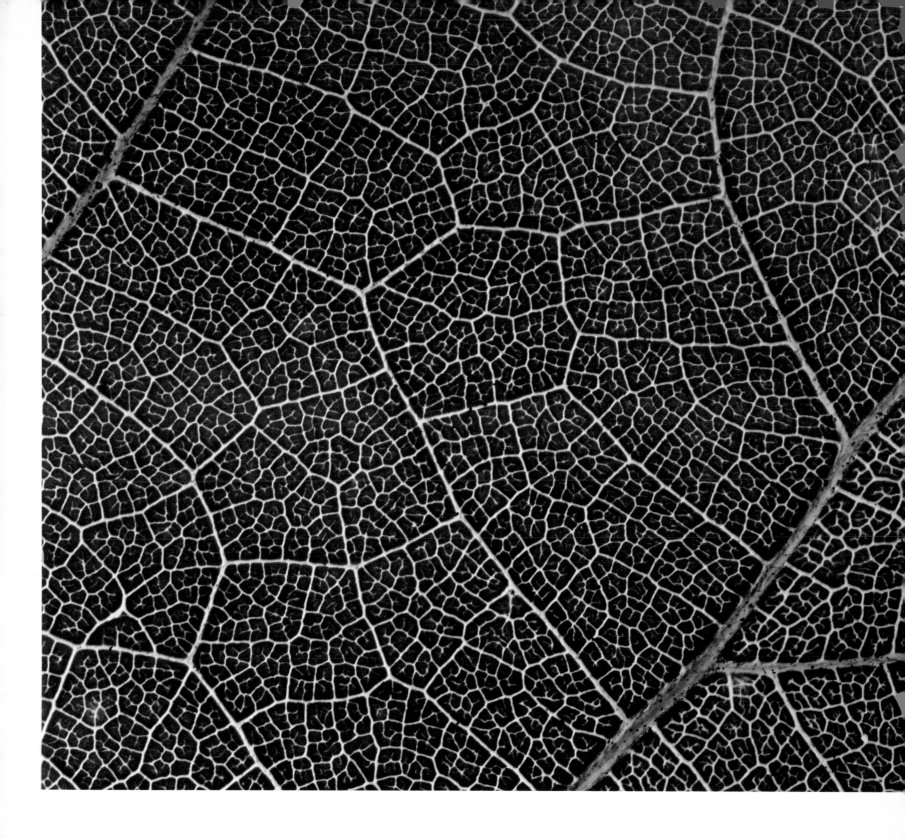

Left: Mud cracks on the bottom of a dried desert lake. *Above:* Detail of the venation of a leaf. Is it just another "coincidence" that the cracks and veins form the same pattern of polygons, including details like distinction between a few major and many minor cracks or arteries? Or are there basic laws involved—laws of stress and strain, laws governing the arrangement of molecules, or other, so far unknown laws pertaining to the organization of matter?

159

VI Ornamentation

The purpose of ornamentation is to improve the look of things. Man is an inveterate ornamenter as indicated not only by almost all his artifacts, but also by his often compulsive tendency to decorate. Most people cannot see a plain wall or surface without experiencing an almost irresistible urge to "beautify" it, superimposing a geometrical arrangement, a floral pattern, a colorful design, filling walls with paintings, shelves with ornaments. Even animals seem to be receptive to the lure of ornamentation, as suggested by the ornamental feathers of certain species of birds, confined to the males, which seem to exert a powerful attraction on the females. But what is the purpose of ornamentation in cases in which the decorated animal lives in permanent darkness or has no eyes, as is the case with many shells?

In nature, of course, what is popularly called ornamentation is usually not decorative at all but functional, its purpose being either camouflage or mimicry. The beautiful soft shades and patterns of many mammals, ground-nesting birds, flatfishes, and insects make them blend to an uncanny degree with their immediate surroundings; as soon as these animals stop moving, they virtually disappear. And in cases in which the ornamentation consists of brilliant colors and flashy patterns, it often serves as a warning to potential enemies: watch out, I taste bad, I am poisonous, I carry a mighty sting. In still other cases it makes a harmless insect look like a dangerous or unpalatable one. But what about the beautiful ornamental patterns of many butterflies (see pages 81–87), or those of the shells shown on the following pages?

Of the purpose of these designs, science admits, we know nothing. Nor do we know, for example, why a certain group of scales on a butterfly's wing is red while the adjacent one is blue. Or why the linear design of one species of shells is zigzag while that of another one is wavy and that of a third one assumes the form of straight bands. Again, we can only say that nature asserts itself in ornamental design as profusely as it does in texture, structure, and form. All else is conjecture.

This lack of understanding, however, does not have to deter us from enjoying these beautiful manifestations of nature — appreciation is not dependent on knowledge. It is in this spirit that I present in the following some of the mysterious ornaments of nature.

Right: Lioconcha castrensis Linné, a two-inch shell from the Indo-Pacific ocean.
This shell varies enormously in design, and no two specimens are ever exactly alike.
To me, it brings to mind spruce trees on the slope of a snow-covered mountain.

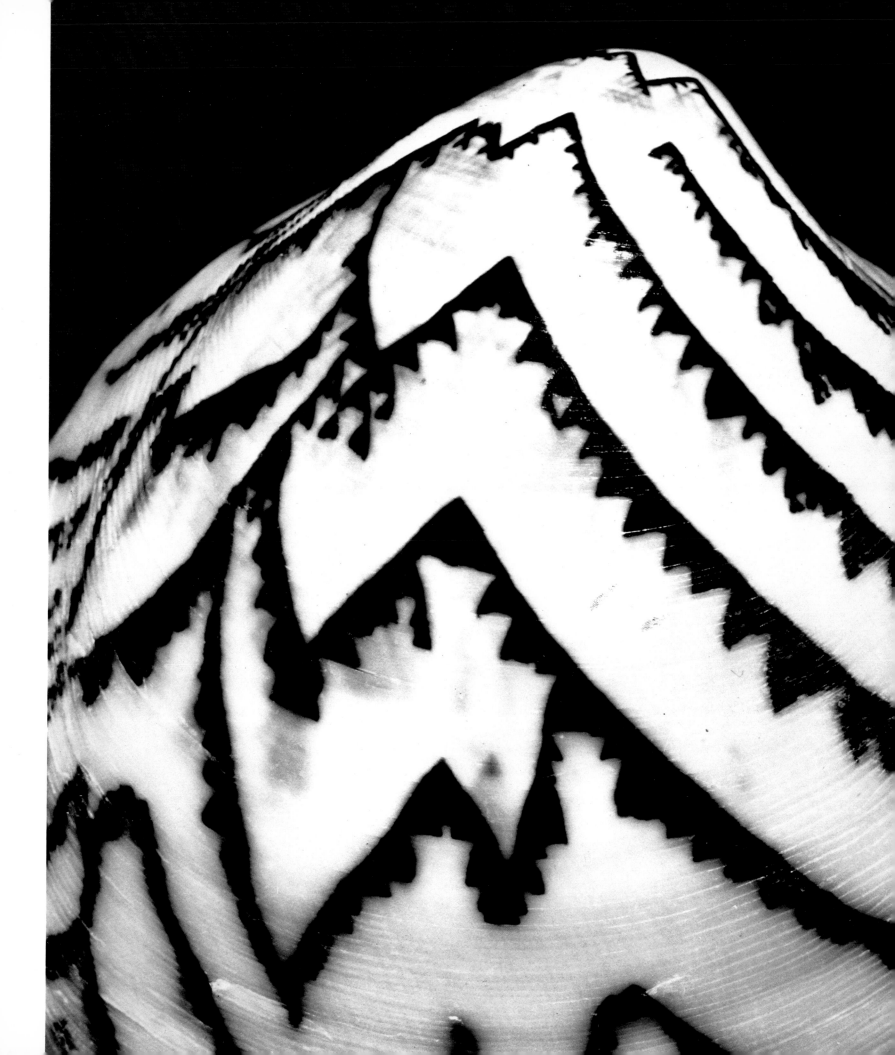

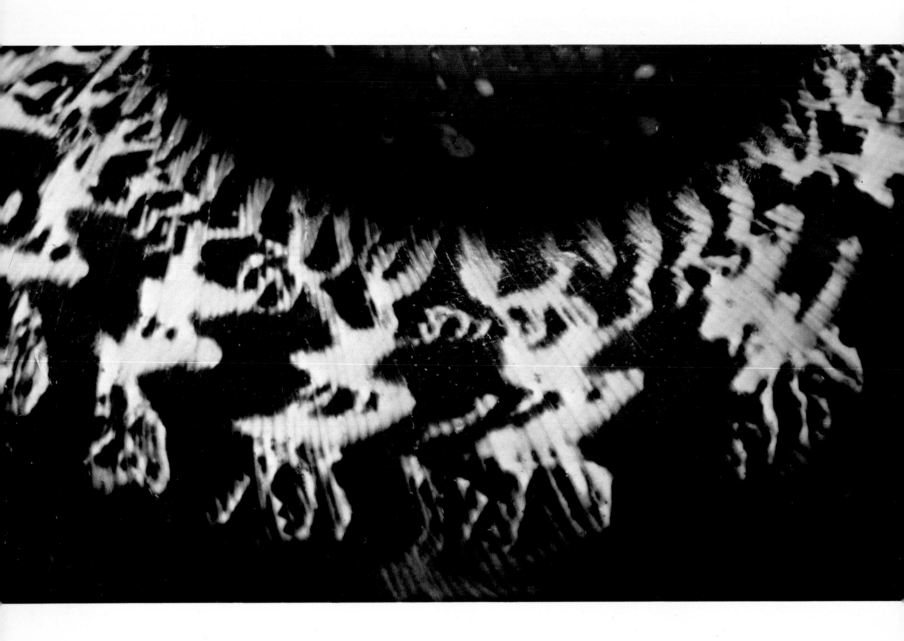

Above: Turbo petholantus Linné. This ornamental design reminds me of the frieze of a Greek amphora — a procession of grotesque centaurs joyously carvorting at a festival. *Right: Amoria undulata* Lamarck. Its abstract linear design suggests paintings by Bridget Riley — but nature, of course, was first.

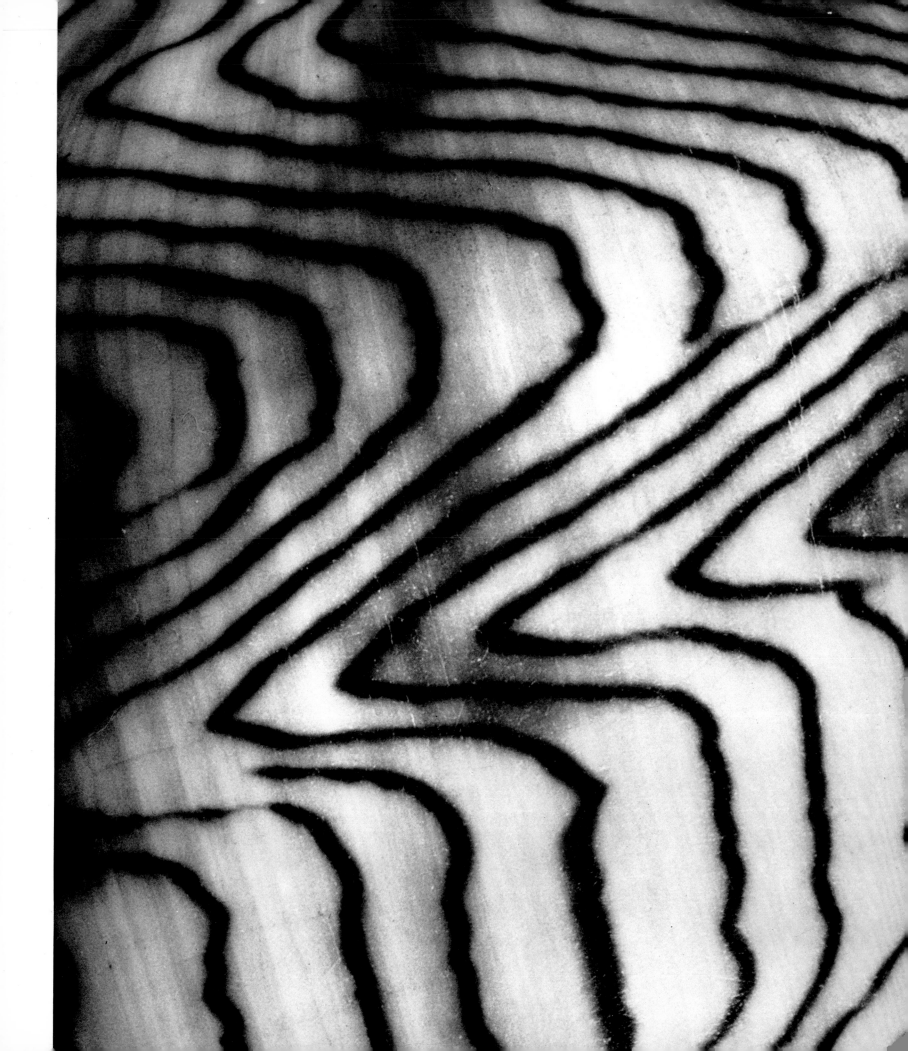

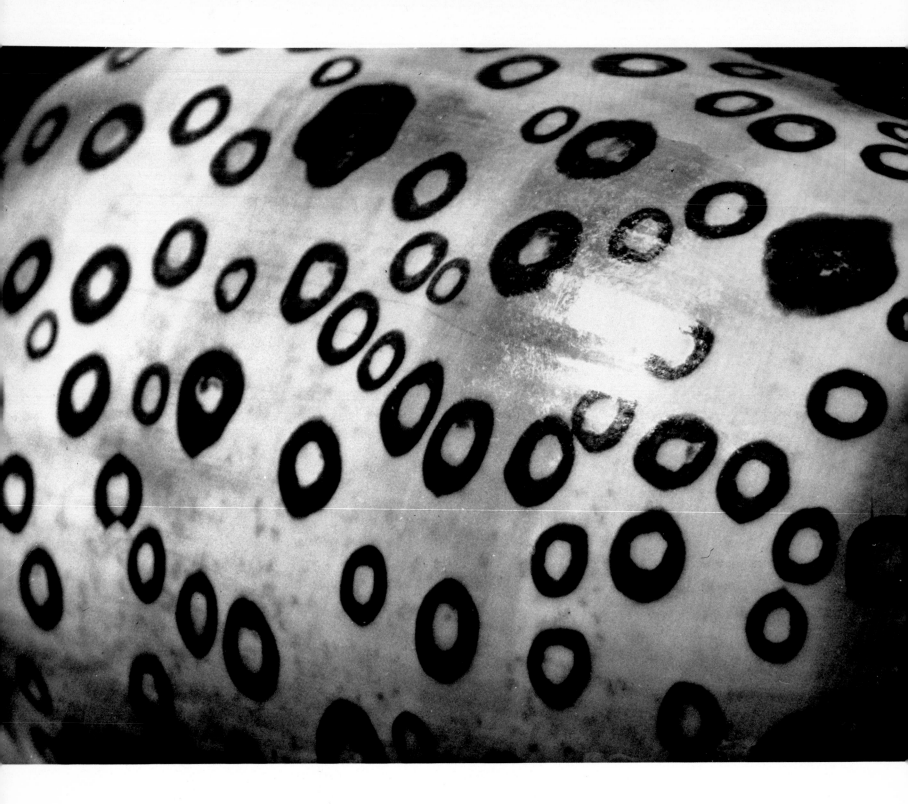

Above: Cypria argus Linné. Not only as far as design is concerned, but also in regard to form, this beautiful cowrie shell from the Indo-Pacific ocean reminds me of a Mexican clay piggy bank, the only thing missing being the slot. *Right: Conus ebraeus* Linné, an inch-and-a-half to two-inch shell from the Indo-Pacific ocean, features a design of classic simplicity. What is the mysterious mechanism that directs these tiny animals to produce these sophisticated designs?

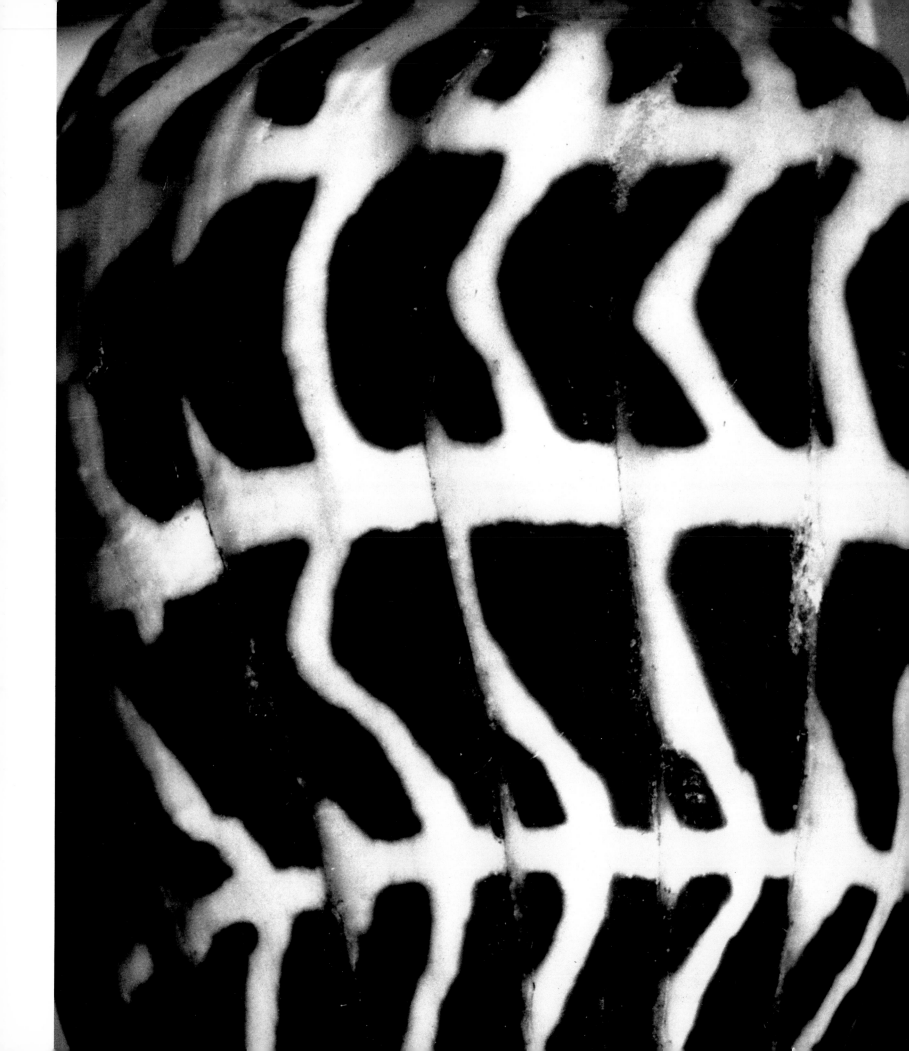

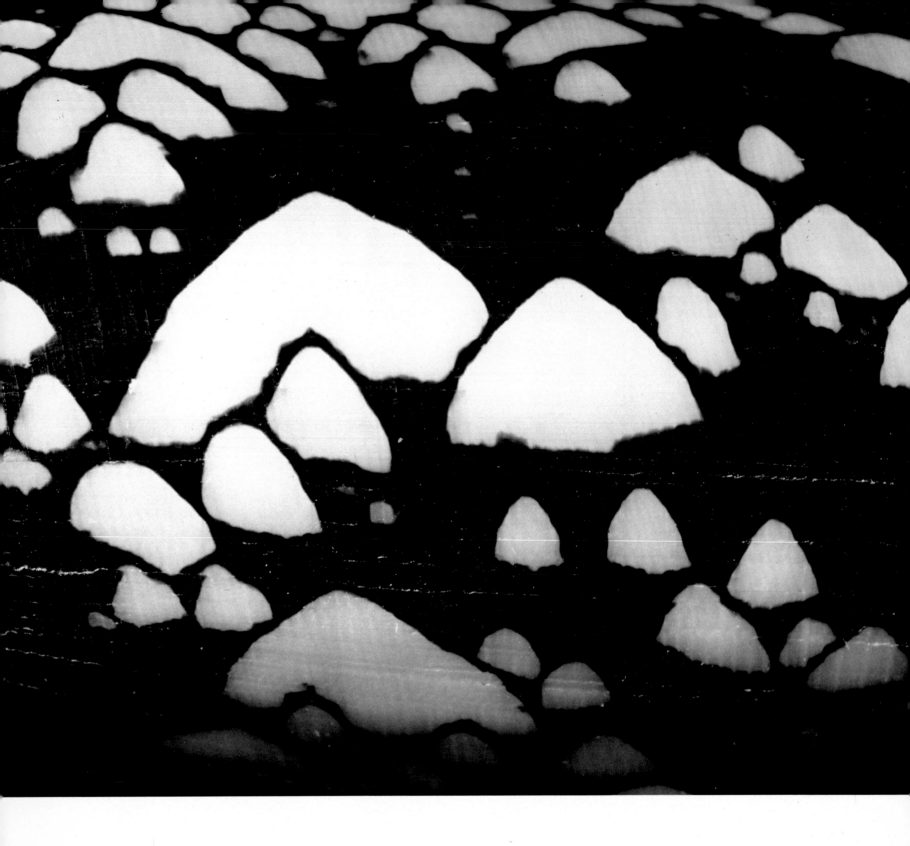

Above: Conus aulicus Linné. I see barren islands, I see icebergs floating in a polar sea. . . . *Right: Olivia porphyria* Linné, from western Mexico and Panama. In my opinion, this is the most beautiful of all the ornamented shells. It is hard to believe that a mollusk less than three inches long should have produced this rhythmic pattern, this powerful, linear, abstract design. The mechanics—the how?—of its creation are only partly understood, its purpose—the why?—not at all.

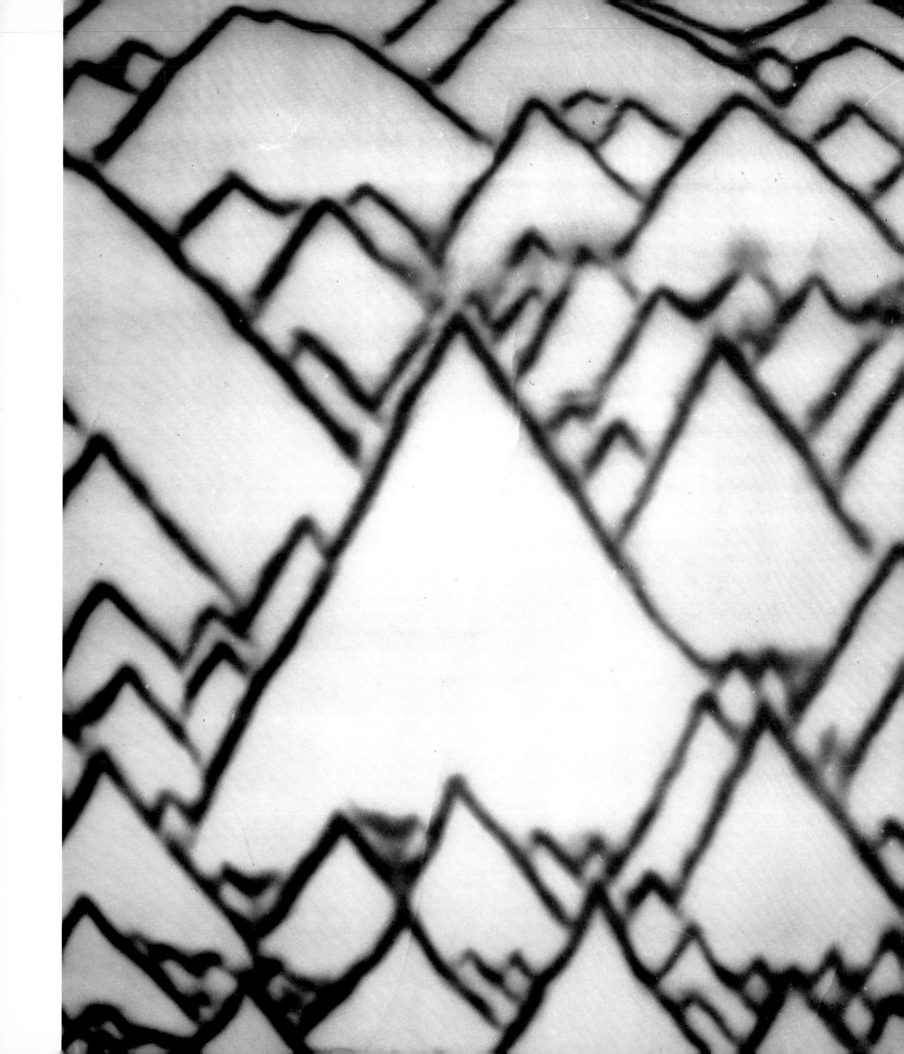

Man's craving for beauty is as old as humanity itself. The oldest known burials contain evidence that red ocher was used as body paint. Ice Age tools of bone and antler show traces of ornamentation. No wonder, then, that this urge to beautify also extends to the human body, manifesting itself in four specific forms: painting, tattooing, scarification, and adornment with extraneous objects, such as feathers, jewelry ranging from nose rings to solitaires, false hair, false eyelashes, false breasts. Today such cosmetics as lipstick, face powder, rouge, eye liner, eye shadow, mascara, and nail polish are used all over the world. Sailors and longshoremen still practice tattooing, and not so very long ago German students deliberately scarified their faces in ceremonial saber duels.

That the roots of these forms of body art reach down to the very beginnings of humanity is evidenced by innumerable statues that have come to us through the ages. In the following pages are photographs of sculptures of women which, in my opinion, are objects of nature in the same sense as the nests of birds or hornets, beaver dams, spider webs, and other animalistic artifacts because they are the subconscious—I am almost tempted to say the instinctive—expression of unsophisticated people who fashioned these statues for ritualistic purposes in accordance with timeless traditions. Simultaneously, despite a certain degree of stylization and abstraction, these figurines are documents insofar as they represent the feminine ideal of their time as seen through the eyes of the male—humanity contemplating itself, woman as object of worship and art.

Opposite page: This inch-high ivory carving from the Aurignacian Period is between 20,000 and 30,000 years old. Mouthless and silent, with eyes deeply sunk below the brow, it has a timeless expression that casts a fascinating spell. The portrait of a girl, a woman, a seeress, it seems to personify all the sorrow of the world, arising from the wisdom of the transient nature of life. And yet the severity of this little sculpture is relieved by a worldly touch. Already, in this oldest of all the known likenesses of a human being, there is evidence of man's irrepressible craving for beauty: the hair arrangement or headdress is patterned in a geometric design, the very first manifestation of conceptual abstract art.

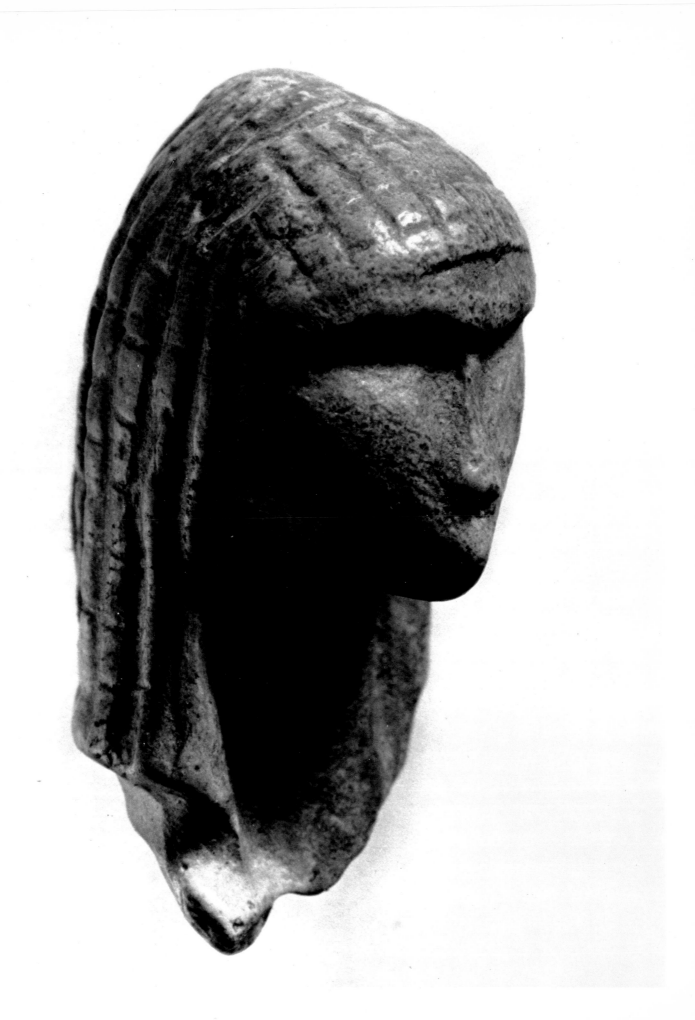

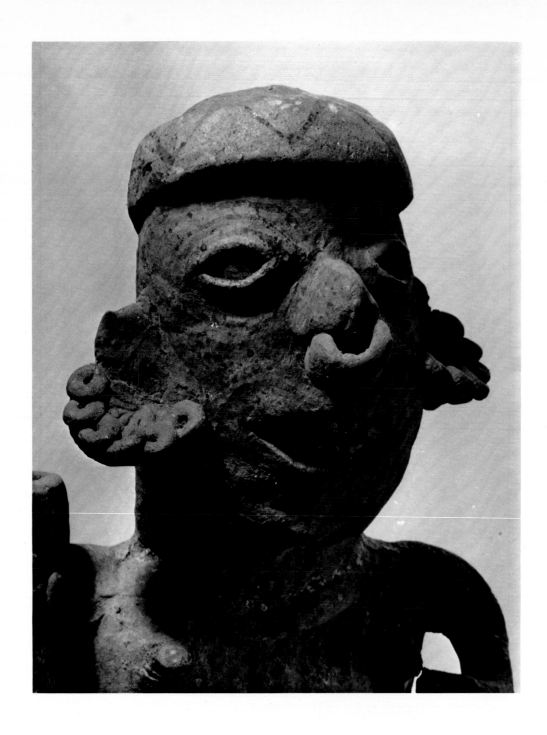

The concepts of beauty and art vary with time and place. Among the Aztecs, nose rings and large, ornamental earplugs apparently were the height of fashion as exemplified by this little pre-Columbian (Nyarit) female figurine from the West Coast of Mexico (Peabody Museum, Cambridge, Massachusetts; C-100 40). *Right:* Wooden carving from the Baule tribe, Ivory Coast, Africa (University Museum, Philadelphia, Pennsylvania, 29-12-68). Ornamental cicatrices covering the face, neck, arms, and body, and an elaborate hair arrangement testify to an overwhelming need to "beautify" the female body. If this kind of scarification seems barbaric to us, let us not forget that "beauty is in the eye of the beholder."

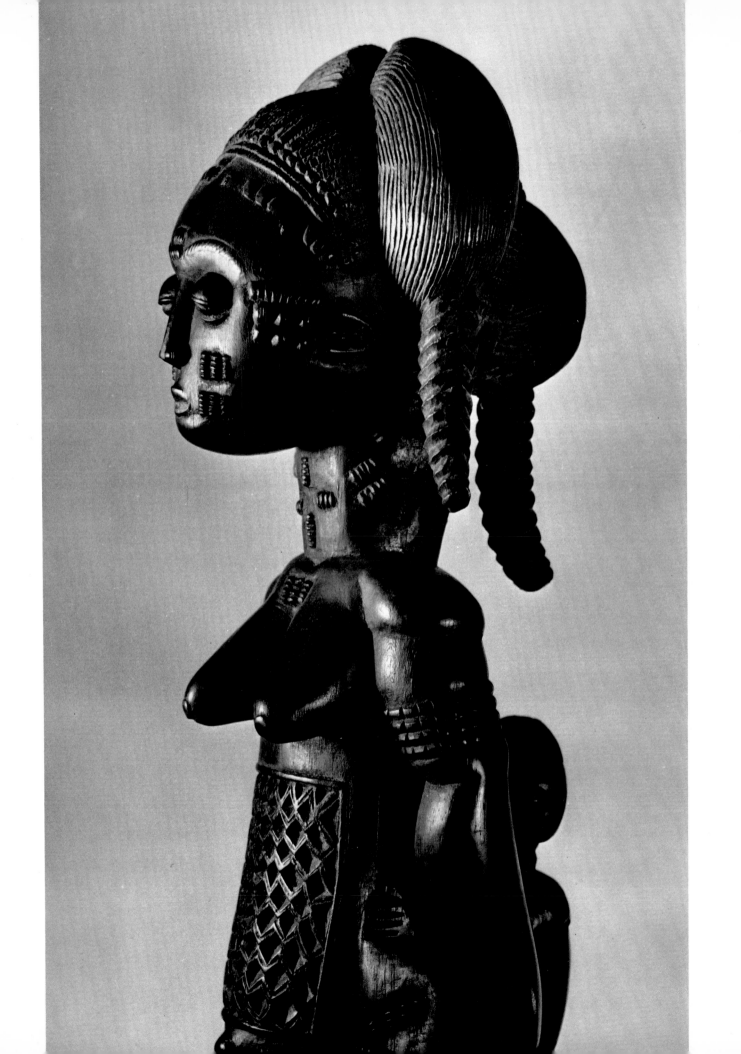

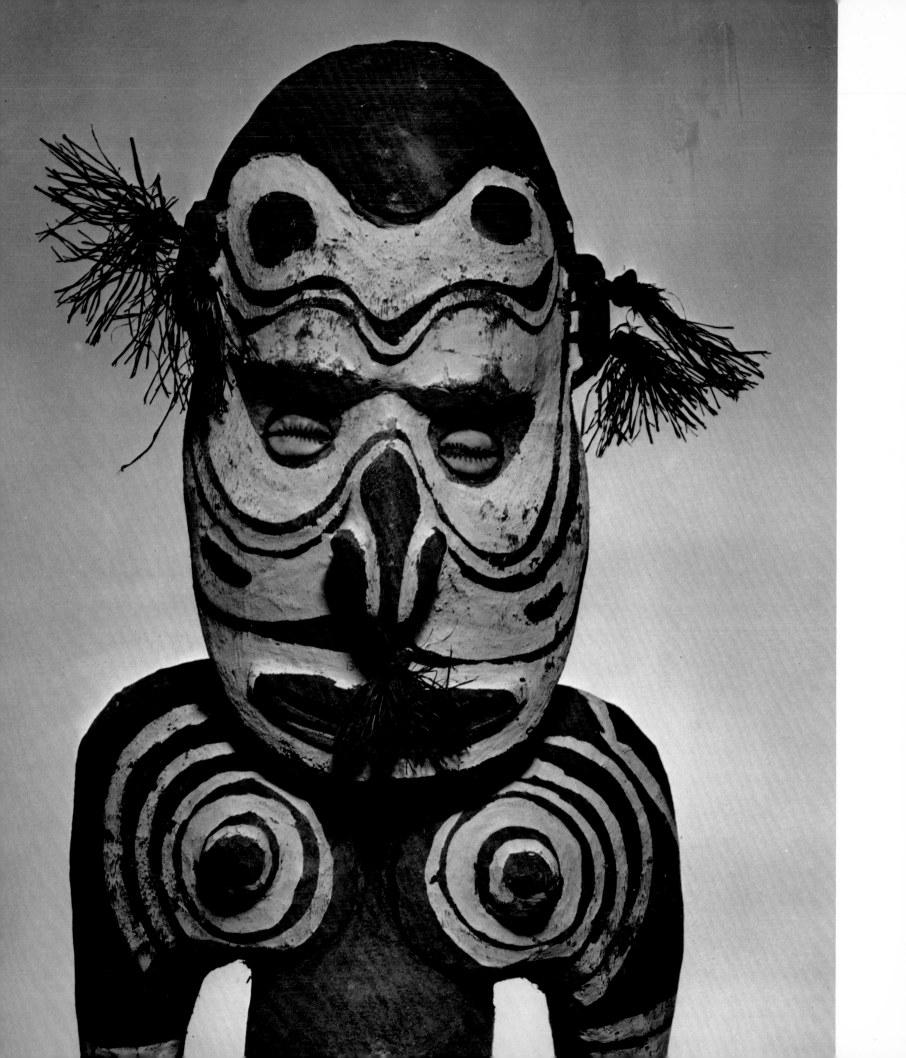

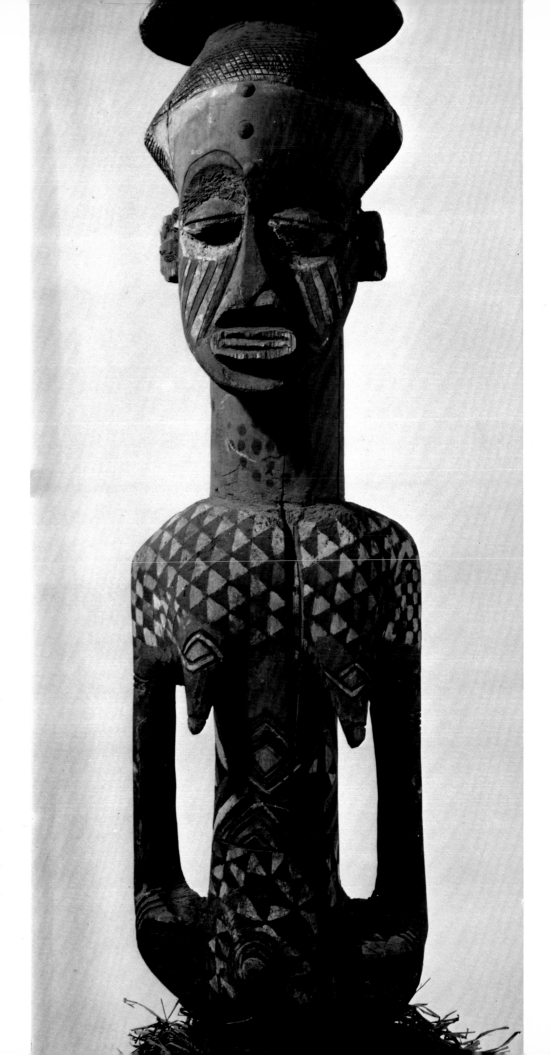

Left: Wooden carving from Tchambuli in New Guinea (American Museum of Natural History, New York; 80/7430). *Right:* Wooden figurine from the Bakuba tribe, Central Congo (American Museum of Natural History, New York; 90-0/5308). These nineteenth-century female statuettes, despite the fact that one comes from the South Pacific and the other from Africa, are spiritually related in their approach to beauty and art, forerunners of our modern ladies who, with face powder, eye shadow, lipstick, and rouge, still practice the ancient art of body painting, although on a more restrained level.

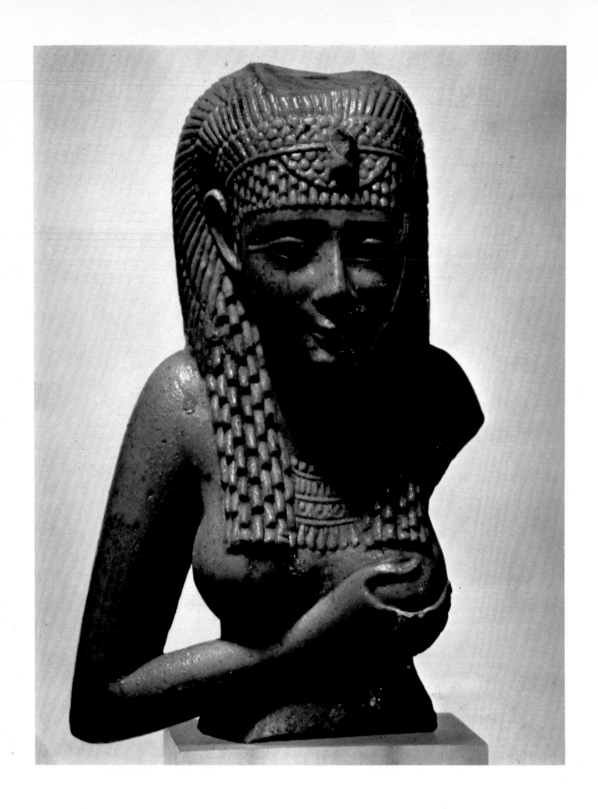

Above: Glazed earthenware figurine from Egypt, 26th to 30th Dynasty, 663–341 B.C. (Brooklyn Museum, New York; 37-332-E). *Right:* Bronze statuette of Parwati, India, fifteenth century (Museum of Fine Arts, Boston, Massachusetts; 21-1832). Although separated from each other by twenty centuries and thousands of miles, these two magnificent statues have many features in common: the large, expressive eyes, straight nose, fully rounded breasts, narrow waist, and richly ornated headdress and necklace—beauty attributes that are still valued highly today.

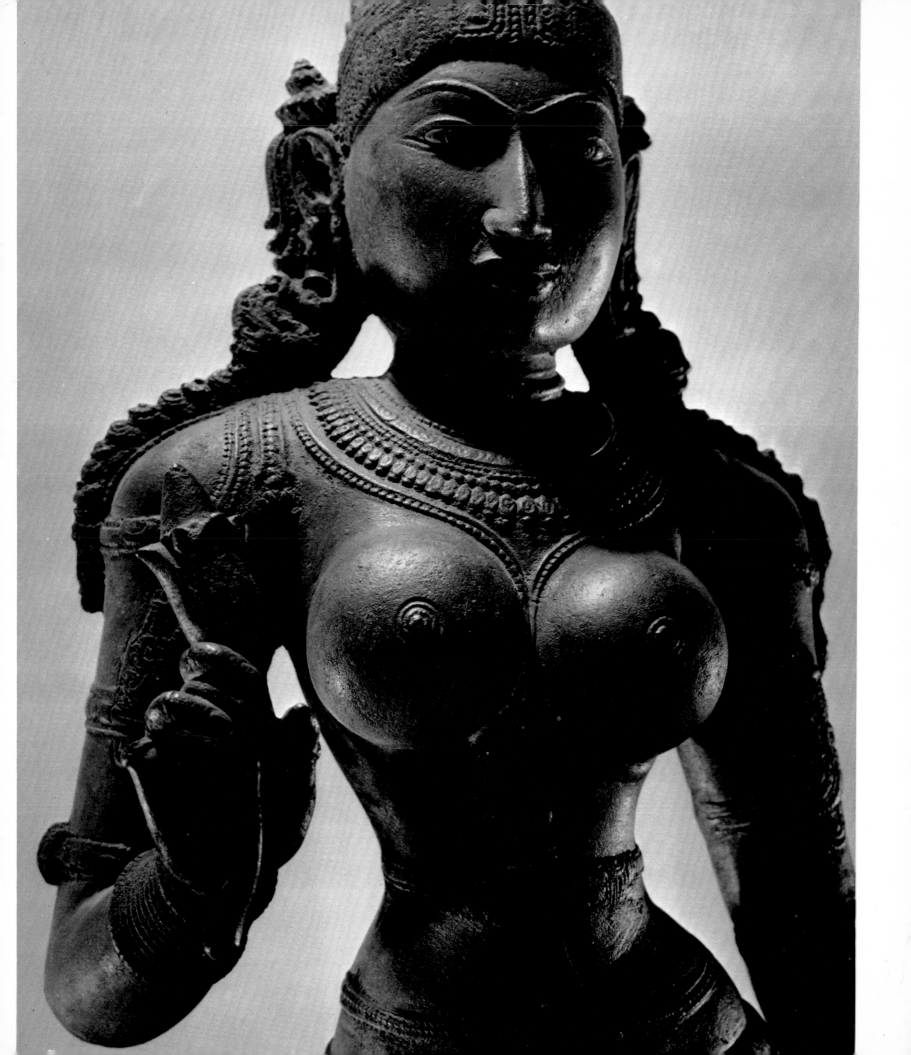

Epilogue

Reviewing in my mind this collection of photographs —objects of nature and their relationship to works of man—I realize more than ever the total interdependence of all things natural and artificial, living and inanimate: how man's work, from technology to art, is based on the materials, designs, and laws of nature; and how the course of nature in turn is influenced by the attitude and the actions of man. Sometimes these relationships are subtle and difficult to trace; at other times they are glaring: Man deforesting the land creates deserts; polluting the waters, poisoning the air, and exterminating entire species of animals and plants, he destroys the harmony of nature with catastrophic results. But precisely the fact that man is able to "upset," "control," and "subjugate" nature leads many people to believe that he is a superior being endowed with godlike powers, standing above nature's laws.

This is a potentially fatal fallacy. Man is and always will be only one aspect of nature, in equal partnership with animals and plants. Protecting the animals and plants, he safeguards his future; misusing and destroying them, he assures his doom. Today the truth of this is almost universally acknowledged, yet few feel the need to act accordingly. Selfishness and greed are rampant. People don't care and often don't even know what they destroy. Money for destruction—euphemistically called development or defense—is available in limitless amounts; for conservation it is grudgingly doled out.

A large number of books on ecological subjects have been written by informed, concerned people, perhaps too many—the public is nearing the saturation point. A new approach seemed indicated—hence this book. It shows the interdependence of man and nature in a different light, with emphasis on the relationship between nature, technique, and art. The approach is low-key—instead of stressing impending disaster, I chose a positive approach, hoping to open the reader's eyes to the beauty of ordinary things— familiar objects of nature which nevertheless can become an endless source of joy and inspiration to anyone who cares. This seems to me the key word: CARE. Things for which people care become precious; they will be appreciated, guarded, preserved. If I can convince even a handful of what Loren Eiseley calls "the World-Eaters" of the need for conservation by showing them that not only our civilization but our very existence depends on taking care of our world, then I feel I did not create this book in vain.

Lillinonah, June 1974 Andreas Feininger

176